LIVING WITH
PATTERN

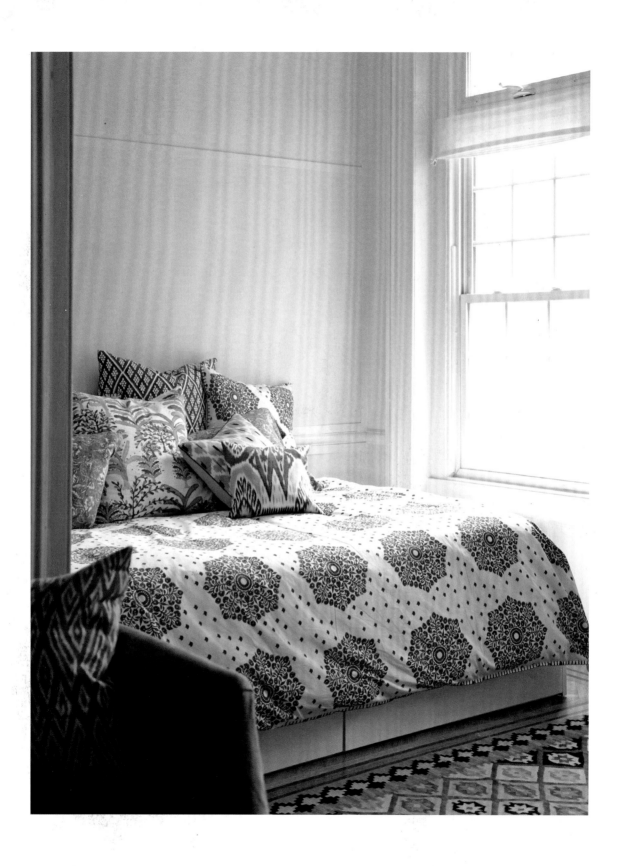

REBECCA ATWOOD

LIVING WITH

PATTERN

Color, Texture, and Print at Home

PHOTOGRAPHS BY EMILY JOHNSTON

CLARKSON POTTER/PUBLISHERS
New York

Published in the United States by Clarkson Potter/Publishers, an imprint of the
Crown Publishing Group, a division of Penguin Random House LLC, New York.
crownpublishing.com
clarksonpotter.com

CLARKSON POTTER is a trademark and POTTER with colophon is a
registered trademark of Penguin Random House LLC.

Library of Congress Cataloging-in-Publication Data
Names: Atwood, Rebecca, author.
Title: Living with pattern : color, texture, and print at home / Rebecca
 Atwood.
Description: New York : Clarkson Potter, 2016. | Includes index.
Identifiers: LCCN 2016008549| ISBN 9780553459449 (hardback) | ISBN
 9780553459456 (ebook)
Subjects: LCSH: Repetitive patterns (Decorative arts) in interior decoration.
 | Color in interior decoration. | Texture in interior decoration. | BISAC:
 DESIGN / Interior Decorating. | HOUSE & HOME / Decorating. | ART /
Prints.
Classification: LCC NK2115.5.R45 A88 2016 | DDC 701/.85—dc23 LC record
available at http://lccn.loc.gov/2016008549

ISBN 978-0-553-45944-9
eBook ISBN 978-0-553-45945-6

Printed in China

Book design by Danielle Deschenes
Cover design by Danielle Deschenes
Cover photographs by Emily Johnston

10 9 8 7 6 5 4 3 2

First Edition

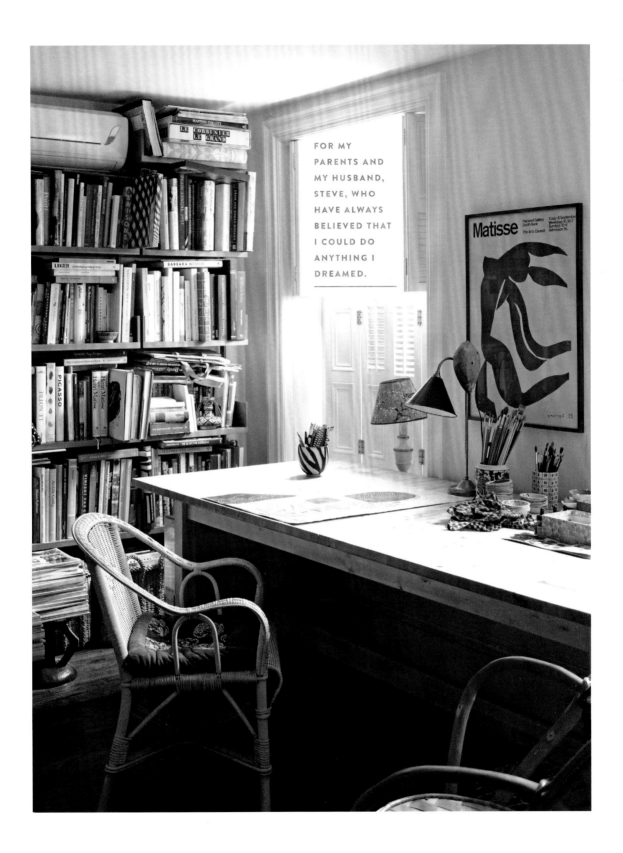

FOR MY
PARENTS AND
MY HUSBAND,
STEVE, WHO
HAVE ALWAYS
BELIEVED THAT
I COULD DO
ANYTHING I
DREAMED.

CONTENTS

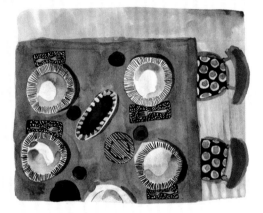

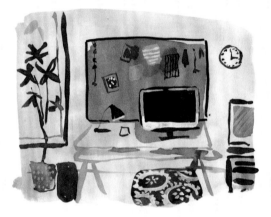

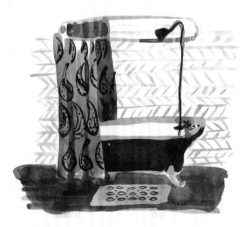

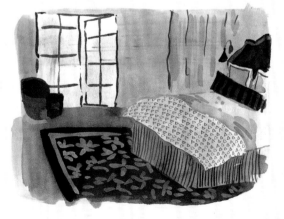

INTRODUCTION

M Y VISUAL WORLD is all about noticing small but exciting details.
I grew up in the restaurant my parents own on Cape Cod. Even while living in front of their business, my parents worked dedicatedly to make our house a home. Running my own company now, I know just how much of a feat that is. Packed with heirlooms, handmade goods, and collected objects, our home was full of character and love. Vintage dresses from the twenties could be found in the attic, beautiful hand-painted china was used for family dinners, home-sewn floral curtains hung in the windows, and color-blocked quilts stitched by my mom covered our beds. It's these particular pieces I remember most, and these that best tell the story of our family.

We lived a short walk from the beach. Early September is my favorite time of year to be there: most of the tourists have gone home and the water is still warm. For a few years, my parents took us to Truro, on the outer Cape, where we rented a little cottage with pull-string lights and no television. My two sisters and I enjoyed just running around and being crazy kids by the beach. The colors and textures of this landscape are so ingrained in my sensibilities—the simultaneous lightening and darkening of the sky at dusk, long curved beach grass, scrub pine trees, pale sand, heavy rocks smoothed by the ocean, and delicate shells that are somehow intact despite the rough waves: these snapshots form the basis of my palette today.

As a child, I was always drawn toward creating images, colors, and environments, and I explored these interests through drawing, painting, and working with my hands. It was a natural progression for me to study at Rhode Island School of Design (RISD). When it came time to declare a major, I initially debated studying apparel design, but ultimately I chose painting. Both of my parents always said to us, "You are going to work hard, so you better love what you do." Coming from a small town where my knowledge of art was based on local seascapes, Monet, and Van Gogh, at RISD I was exposed to a much wider world of art than I had known even existed. I slowly began to explore textiles as well. I painted pieces inspired by vintage lace my mom had kept, and then began painting knitted structures I made myself. When it came time to look for a job, textiles seemed a practical path, and I found the home industry more appealing than apparel. My early career—designing home products for Anthropologie and then consulting for a small UK/NY-based firm—opened up a world of pattern and fabric making that continues to fascinate me.

I also began my own collection of fabrics just like my mom had done: silk scarves from my great-aunt Libby, flea-market linens, embroidered and woven fabrics from trips to India, printed fabrics from London, and samples of my own work. I enjoy learning about the textiles of different cultures, finding out how they're made, and then finding ways to layer them into my life. So much attention and detail is put into pieces we use every day—I began to fall in love with this storytelling nature of patterns. For example, some quilting patterns represent life's milestones, like marriage, or reference different periods of time in our history. *Bògòlanfini*, commonly known as mud cloth, is made up of marks that hold meaning for specific communities in Mali that symbolize the earth and life. In India I saw firsthand the process of creating a block print: the printing block is hand-carved by an artisan, dipped into pigment, and pressed into the fabric, revealing subtle variations in the pattern's repetition. I also saw multicolored fabrics screen-printed (each color a new screen), detailed designs hand-embroidered, and other hard goods hand-painted and metal-etched. In Portugal, I visited ceramics factories and saw technology combined with traditional hand-painting and glazing techniques. We can be so removed from the processes of how a product is made; it's important to remember that even beyond the embedded symbolism of imagery or patterning, there is the story of how something is crafted.

While designing patterns, products, and collections for retailers, I began to realize how much I missed that hands-on approach. Eventually I thought about starting my own line to create goods that emphasize thoughtfulness and the feeling of something truly considered and distinct. I wanted to slow down the design process and really love every object I put out into the world—to own those decisions about how and where it is made. I began by dyeing my own fabrics and became obsessed with modifying shibori, a Japanese dyeing technique in which the fabric is manipulated into a three-dimensional shape prior to dyeing. Even now, years later, I still love how the dye finds its way into the folded, bound, or stitched form to leave a pattern—much like the tide leaves a rippled pattern on the sand when it goes out. From there I started printing my own fabric. I had never been the most precise printer, but I began to use that to my advantage, letting the dye bleed a little bit to give everything a softer edge. The painter in me wanted every piece to be unique. Working to create my own fabrics, not just design them, brought me back to what I find irresistible about them. Every day I hope the energy and love I put into a piece comes through for the people who use it.

Ultimately, you want your home to be livable, layered, interesting, and most important a reflection of your personal history and dreams. We are all filled with contradictions, and that's what makes life interesting. Pattern can reflect your particular oppositions, interests, aspirations, and views of the world. Pattern can be personal and genuine, not just trendy. You know your story—it's your point of view, experiences, and life—but you may need help realizing how to celebrate it. This book is for you, to encourage you to explore your story and create a home that is rich, multidimensional, and truly your own. Pattern can quickly overtake your overall vision, so I'll show you what you need to know to visualize it with ease and evolve it over time.

In writing this book, my ultimate goal is to create a helpful and inspiring resource on color, texture, and pattern. This book is neither filled with bold, overly patterned spaces, nor is it broken up by generalized, impersonal aesthetic labels. It *is* designed to help you reflect your unique viewpoint. You don't need to be an interior designer—but you do need to learn what you like. The trick no one tells you is that there's no formula. You just need to keep your eyes open and get specific about what you really love. The best homes are unique and filled with pairings only the person who lives there would choose. Pattern can be more than just decorative—it can be practical. Depending on your needs, whims, and personality, you will use it in different ways. This book is meant to guide you and open you up to new ideas, but it is by no means a rulebook. While you'll find a lot of my opinions here, I want you to trust yourself and come away with the tools to find what *you* want your space to feel like and how to make it a reality.

Part 1 is your primer and reference guide for the rest of the book. This section will help you identify your point of view and understand the basic principles of design and using pattern. You'll define your story, learn to keep track of what you love, and then explore color, texture, scale, and basic pattern mixing. You will gain an understanding of what makes combinations sing visually and how to personalize them to your specific preferences. With this information, you'll have a strong foundation for the ideas, tricks, and projects in the rest of the book. Even if you read nothing else, the primer will give you a framework for the big concept of pattern.

From there we will head into the home, moving room by room, stopping in every nook and cranny to look at styling in a real setting. Here pattern will be linked with purpose—a

key to achieving a space that works. We'll visit homes that inspire, put together by designers, artists, photographers, and other creative people. Throughout each chapter you'll find practical advice on how to translate these looks into your own home. At the end of the living room, dining spaces, and bedroom chapters you'll find sections that show you how to style focal points within the space. In total we visited twenty-two different homes in writing this book! It was incredible to see how people use pattern in ways that are truly their own. All of them have different aesthetics and homes, but each tells us something valuable about visualizing our unique stories.

The third section of the book includes projects to help you visualize your own story. These are all projects I would make myself. I hope that you find them helpful in creating meaningful pieces for your space.

At the back of the book you'll also find several resources. First there's a guide for dyeing and reupholstering, which you'll want to reference for several of the projects found in Part Three. You'll also see a linen care guide with green laundry tips from Method Home. Lastly, I've included a resource guide with my favorite places to shop. I hope you'll find this section practical and useful throughout your experience with the book.

This book is your road map to incorporating livable pattern into your life in an authentic way, and you can approach it however you'd like. Maybe you just want to browse this book brimming with visuals, so peruse and see what speaks to you! If you are looking for a firm grasp of some of the foundations of design and pattern, start with Part 1. If you're looking to just dive in and start making changes to your space, jump to the projects in Part 3. Getting hands-on can inspire more interesting results than anything else. Or maybe you want the full experience of reading from beginning to end. Regardless of your approach, you can come back to this book over time. Whether you're moving into a whole new space, working on one room in particular, or revisiting somewhere you've been for many years, I hope this book continues to inspire and excite you throughout all of the different chapters of your life, giving you a new outlook on pattern in and out of your home. Creating your space is a journey—and I can tell you from all the homes we visited that people rarely feel like their own home is done or perfect as is!

PRIMER

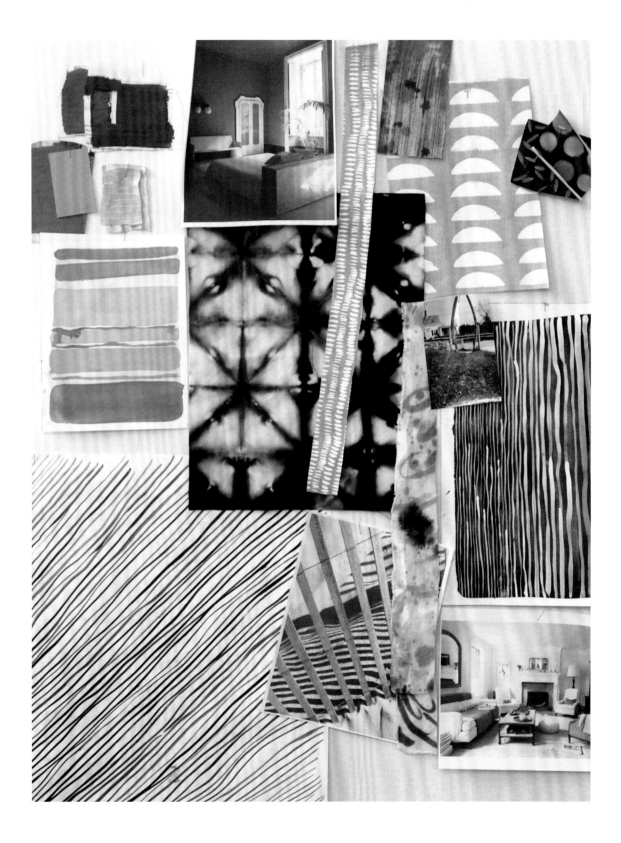

FINDING YOUR

STORY

YOUR HOME is your space to shape and should be a reflection of your life and interests. An impactful tool, pattern can translate your story into your environment. I want to expand your ideas about what pattern can be and look at how it can range from the design on a fabric or object to the repetition of architectural details. Here we'll look closely at how to find inspiration and define your story. Then we'll look at the dynamic relationship between color, texture, and pattern, before moving to building a palette and pairing patterns to make a cohesive collection. By starting with these basics, we can really dive into your interests and tastes to start using pattern in ways you hadn't imagined. Let's *see* your story.

YOUR STORY, YOUR TOOLBOX

You are shaped by where you've lived, what you've seen, and what you've done; your story is composed of your whole life. Your distinct point of view is what makes you interesting—and that should be celebrated. The first step in expressing all of these things is figuring out exactly what they are.

Who am I? Where have I been? What do I love? When I started my own textile line, these were the first questions I asked myself. While I live in a hectic city, I grew up in a small coastal town. This opposition is a key element in my life. The deserted beaches and shifting light of the off-season are why I'm interested in muted but chromatic palettes, soft natural textures, and coastal references. My visits to the Cape now are my time to slow down and look; I might find significance in the leopard-like spots on a crab shell, the ridges of the sand at low tide, or the sun-bleached wood grain on a dock. My daily life in Brooklyn is of equal importance. Here I notice the contrast between graphic criss-crossed shadows on the sidewalk, the gridded window frames in my studio, or the contrast of a woman in a blue floral dress against a shiny reflective building.

I am always looking for inspiration, and I find patterns everywhere I look. Patterns are all around, but sometimes you have to seek them out. They can be quiet, industrial, mysterious, bookish, romantic, and just as unique as you.

Your story is a way to remember what you love; realizing its components is the first step to surrounding yourself with meaningful patterns, objects, and environments. The overlap of your collected experiences is where things get interesting. The contradictions, the way time has changed those memories, and how you want your life to move forward can all be expressed in your home. It's not about collecting empty souvenirs or following trends, but rather about bringing in elements with meaning.

So where do you begin? One of my favorite ways to get inspired is to get out of my daily routine. *Experiencing* is always more exciting for me than sitting at a computer looking at images. Make a point to spend a weekend noticing the details. Go to a museum exhibit and look at the colors—imagine how a painting or sculpture was made. Try a new restaurant and pay attention to how the food is plated. Check out a local high-end boutique. It may be the color of piping on a shirt, the way a glaze is painted on a plate, or even how the items in the store are styled on the shelf. Explore your neighborhood and take pictures of what interests you or write yourself notes. Don't forget to look at the small things: the shape of a leaf, the intersection of two colors, or the texture of a surface. When you're home, remember the shapes, different items, compositions, and colors you noticed while exploring. These discoveries are cues to what you're really drawn to. You could take the same walk as a friend and notice totally different things. This process is all about getting to know yourself and what you love— and you may be surprised! Your interests will evolve with time and become more refined, so this exercise of looking should become a constant part of how you view the world. Make it a practice and find time for it in small doses through the week.

Once you're actively exploring your surroundings and have awakened your observational skills, get introspective and investigate your past. Remember, your personal history is a great source of inspiration and the foundation of

your story. Go through your old photos and revisit different periods of your life. Pull out the ones that have special significance to you now. Talk to your friends and family about your shared memories. Recollecting your past allows you to connect differently with your present. Take out a box of old stuff kept from your childhood. Visit your relatives and see what they kept. Perhaps you'll find something as tangible as an old rock collection and remember how fascinated you were with the crystalline structures and elemental patterning on speckled stones. It may be a stamp collection that recalls your love for history, storytelling, and small, detailed patterning. While not every memento or dream from your

RESEARCH IT

Many libraries and museums have great online sources that catalog their visual resources. The New York Public Library's Picture Collection is a great place to search for unique images; there are binders full of them grouped by category. If you can't make it in person, they have an online version as well. A few other online resources include the Metropolitan Museum of Art, the Victoria and Albert Museum, and the Museum of Modern Art.

www.digital.nypl.org/mmpco/index.cfm

www.metmuseum.org/collection

www.collections.vam.ac.uk

www.moma.org/collection

childhood has a place in your life today, there's something to be said for the basic interests you explored then.

Reminisce about the place you grew up. Whether it was a small town, a big city, or someplace in between, it shaped you. You may think of it fondly or never wish to return, but that says something about who you are and what is important to you. Remember your favorite places in some of the locations you lived: a museum, a friend's house, a park, a swimming hole, or a building with unique architecture. Recall the places you've traveled. It could be a favorite camping vacation and how you loved looking up into the trees and seeing the stars at night. Or maybe your first trip abroad sparked your interest in new cuisine. It might even be someplace you never visited but always wanted to. Think about all the places you've been and what you connected with there.

With these memories and experiences fresh in your mind, look around your home and observe what speaks to you and what doesn't feel relevant anymore. Is there a piece of clothing that exemplifies your personal style, a book that you've read several times, a piece of art that you love, or even something as simple as a mug that makes you happy each morning when you use it? Take mental notes of these important pieces.

Lastly, start to think about where you want to go in the future—your dreams are a part of your story. Surrounding yourself with items that speak to where you're headed help make it a reality by serving as a reminder for what excites us. If you're considering a move to the West Coast, perhaps you should choose a pattern that speaks to the relaxed vibe and sunny weather you associate with that area. If you live in a small town but love the sophistication of London, pick a pattern that has its design origin in that city. You'll know the history of it, and it will feel even more personal because you put in the research. You'll be reminding yourself daily of that goal. Be aspirational, and remember that less is more—that is, if you're more specific with what those items are. Keep your eyes open all the time, and be decisive about what you really like. Perhaps you hang a print from an artist you love if you can't afford an original. Or you save for just one handmade ceramic piece that you really love—it doesn't need to be a collection. One piece can have power.

There are many ways to record the things that you're drawn to, and none of them is right or wrong. This piece of the process is personal, too, but I have some tips. I like to keep a mix of physical and digital. Pinterest is a great place to track online sources, as it allows you to link the images to their original articles, which is a great convenience if you need more information down the line. I also like that it allows you to see all the images together and how they visually relate.

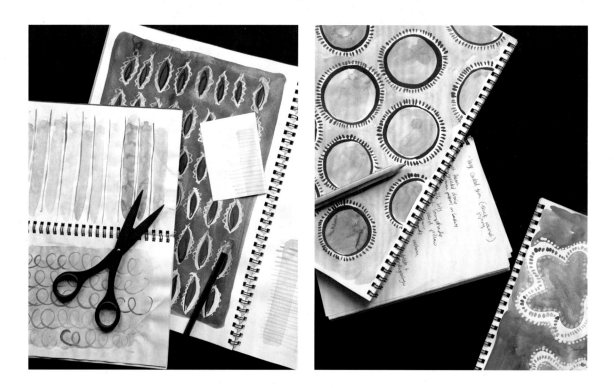

The most important tool, for me at least, is to maintain a sketchbook or notebook. Recording helps us remember, even if we don't have time to look back later. In addition to drawings and paintings, hold on to clippings from magazines, photos you've snapped, patterned wrapping paper, and fabric swatches. Include notes and observations, pieces of packaging with colors or graphics you like, hangtags with interesting type, postcards, and quotes that have meaning to you. Consider this collection a place to document ideas and interests. There are no rules, so have fun! Don't worry about being neat and perfect; it's essential to give yourself freedom and to allow inspiration to guide you. Put down ideas, color combinations, or imagery you're unsure about but still interested in. You don't need to know how you might use the concept or even to think it's a great idea at the time. Simply collect, keep track, and be inspired.

The next step is to start a physical mood board, which I always do when I'm beginning a new collection of designs. This exercise is about focusing the inspiration you've been collecting for a specific purpose. It is the time to find your overarching creative direction. Visually organizing your inspiration enables you to physically map out the visual relationships. You will be able to see the connections between disparate things that interest you and how they could work together. For instance, you may discover that a photo of your favorite bold sneaker looks fresh against an all-neutral space with tailored, vintage-inspired furniture. This realization could encourage you to mix a sporty graphic textile with a Louis XVI dining chair.

Gather your inspiration and pin it up in an arrangement that's pleasing to your eye. The type of project you're working toward may inform what type of imagery you pin up, but the two do not need to directly correlate. If you are working on a bedroom, you may want to have a few bedroom images that speak to you, but it could be that you actually have an image of a Moroccan outdoor space that embodies the relaxed vibe you want, along with a street-fashion image that has the colors you're looking for, and a blown-up image of a leaf that references the type of patterns you are drawn to for this space. It doesn't need to be literal in the beginning. Focus first on the feeling and then, after, think about application.

Let the mood board evolve naturally over time. A week or so allows enough time for you to observe the visual interactions and see what you truly like, but it isn't so much time that you lose momentum. For that week, move items around, add new ones, and even pare down. Keep the board somewhere that you'll notice throughout your regular routine, even if just in your periphery. This positioning will enable your mind to absorb it subconsciously.

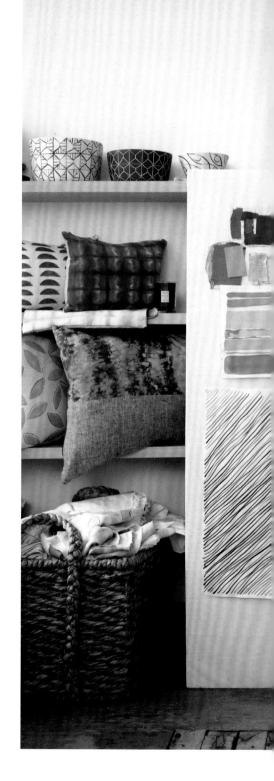

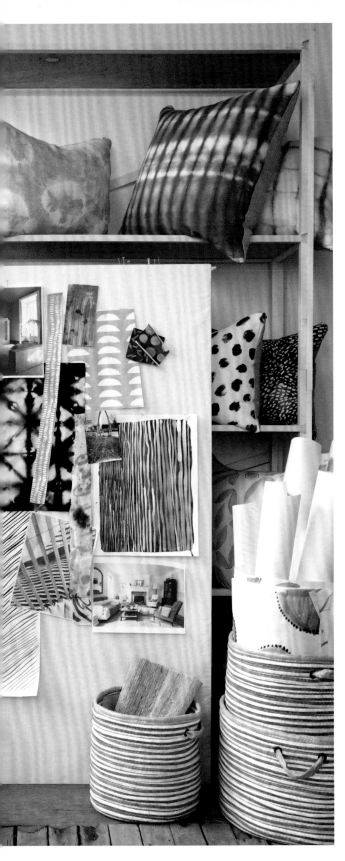

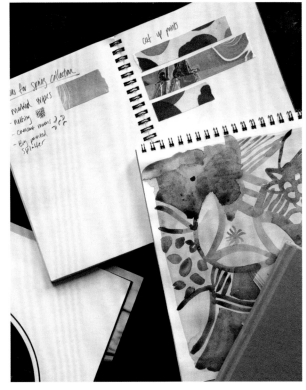

KEEP NOTEBOOKS IN DIFFERENT PLACES WHERE YOU
SPEND TIME SO YOU ALWAYS HAVE ONE AVAILABLE
WHEN THE MOOD STRIKES.

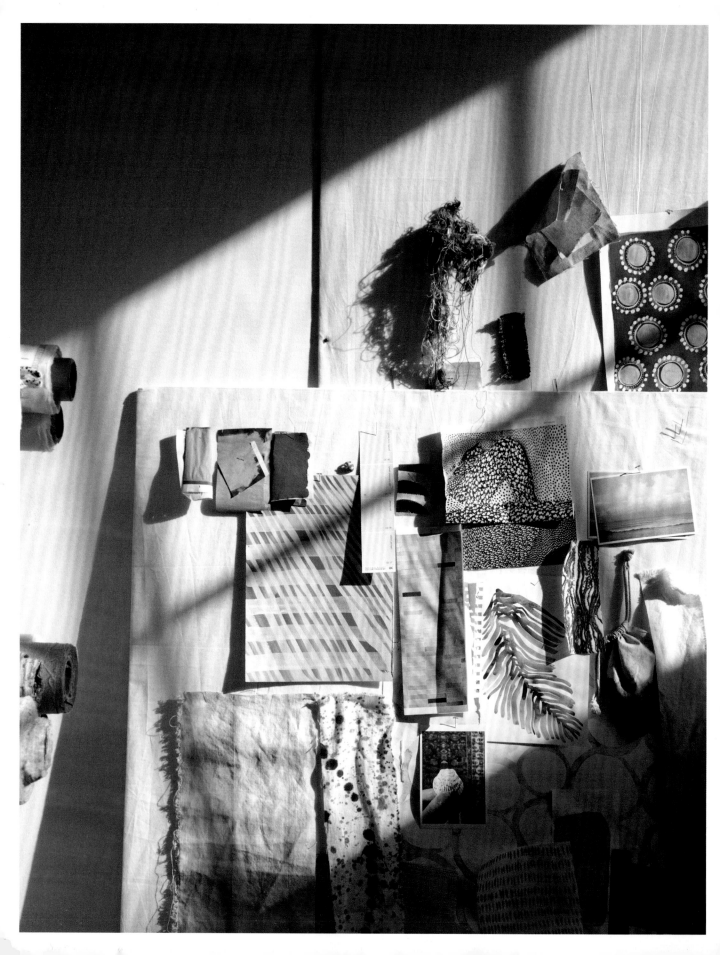

Next, make time to go through everything on your board and give it a good edit. Be ruthless and specific. Do you really love that image? What do you love about it? Write down what it is. Perhaps you like the color or the shape of a motif. Begin to look for relationships among the items you've collected. Maybe there is something that you truly love, but it just isn't working with everything else. Sometimes you have to eliminate the thing that started it all and save it for something else. I keep old inspiration tears from magazines, print-outs of images I found online, design ideas, paintings, and other ephemera in boxes and drawers, ready to go through when I'm starting the next project. Something old could lead me to a brand new idea. Other things may never translate into anything tangible, and that's okay, too.

As you edit you'll start to notice themes. It could be something as simple as the fact that you really love stripes (I do!), and from there you can start to think about nontraditional ways to use them. Maybe you paint stripes across your ceiling, layer striped rugs, cut up a traditional stripe and then reattach it in an offset placement, or pipe your pillows with striped ribbon. The possibilities are endless.

Editing out the excess allows your clearest and most interesting ideas to shine, and that clarity is critical to the success of what you're creating. Even if you take only these initial research steps, you'll learn a lot about yourself. With time, you'll find ways to slowly incorporate this process into your life—finding your story is a journey, not a project with an end date. You'll try things out, you'll experiment, and you'll change what you're doing. None of these ideas needs to be permanent; thinking of your home as an ever-evolving reflection of your story relieves a lot of the pressure. Use your newfound clearness to edit what you already own, inspire new choices, shop better, and hone your home to reflect you. To successfully translate your story into reality, you'll also need a few design tools to achieve it, which we will cover next.

YOUR STORY

Keep your eyes open and notice the world around you.

Collect memories, notes, photos, and visuals of what excites you.

Keep a notebook with your ideas.

Research your interests further.

Remember your personal history.

Think about your dreams and where you want to go.

Create a mood board, then edit your board and notice the themes.

C O L O R

NOW THAT you're beginning to identify your story and interests, let's review some basic principles that will help you with the editing process and achieving *your* look. Color is the first step. It is one of the most powerful visual tools we have for influencing the mood of a space. It has an unconscious emotional pull, which is why it's so important to have a basic understanding of how it works.

COLOR BASICS

Everyone has colors they are more naturally drawn to—time and again you'll pick those colors even when given all the choices in the world. Look in your closet, your home, at your collections, and magazine tears, and begin to notice what your colors are. You can make those colors work better for you if you understand the principles of how color works. This will allow you to pair them better and place them within a space with more ease.

While there's no wrong way to think about color, it's important to remember that there are existing structures for how it can interact, both physically and visually. Remember the basic color wheel from grade school? It lays out a visual structure for how colors relate to one another. To start, we have our primary colors: red, yellow, and blue. These are the colors that can't be created with paint, but when mixed together with each other in the right way, they produce all of the other colors on the wheel. By mixing primary colors in pairs you achieve secondary colors: orange, green, and purple. You can see how they fit in between the primary colors on the color wheel. Now that our color wheel is filling in, we can start to see a range of analogous colors, or colors that are next to each other. Sticking with this formula of mixing analogous colors, we can continue to fill in the spectrum with tertiary colors. This is where it starts to get good. The wheel is now making room for more nuanced colors and starts to differentiate between colors like red-orange and yellow-orange. This analogous color mixing can continue infinitely; sometimes the quietest differences in color can be the most interesting!

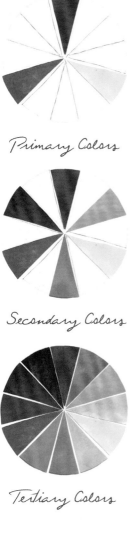

Color Wheel

Primary Colors

Secondary Colors

Tertiary Colors

The color wheel also shows the important relationship between complementary colors, which are directly across from each other. You can see that this principle applies to everything from a true blue and its complement of orange, as well as a tertiary red-purple and its complement of green-blue. *Complementary* is a term often used colloquially to say that two items look good together, but the term *complementary colors* actually means two colors with the greatest contrast. When they are combined as paint, they cancel each other out, producing a chromatic black or gray hue. When placed next to each other they pop—and sometimes the relationship can be so intense that the colors even appear to vibrate.

From here you can also see that each color has its own scale of light to dark, also called value, and how strongly its hue is represented, or its intensity. The variations within this range are where you can really see all the possibilities for creating a mood.

Complementary Colors

Value

USING COLOR AND BALANCING

When you begin to focus on colors, you'll start making design decisions that pull a palette together. This process can be the trickiest part of all, as it is truly subjective and the place where you need to develop your own instincts and trust them. The magic that happens when you find the perfect pairing of colors isn't purely scientific. Some will tug at your heart more than others, and there may not be a concrete reason that explains why you love something. Explore it. The first step in understanding how to make that magic pairing happen is to learn about your specific tastes.

As you group the colors in your collection together to organize them, perhaps you'll discover that you prefer your reds to have more blue in them than orange, or that you like your blues with green undertones. Play with different combinations.

Do you prefer pairing blue with a gray or a tan, or something in between the two? If you find yourself really drawn to a vibrant shade like purple, it may need to be balanced with grays, sand, a less saturated lilac, and navy to make a more subdued palette, or you may want to bring in other jewel tones that have a similar saturation to create a bolder, richer overall feeling. Saturation is a term used to talk about the intensity of the color. Experiment and track the combinations you love in your notebook. Attach a snippet to a page and note what you like about the combination. You can also record this digitally by taking photographs, but realize that photos won't always accurately depict colors.

DID YOU KNOW?

Colors have different meanings all over the world. For example, while white is a typical bridal color in Western culture, in many Eastern cultures it is the color of mourning. In Rome, Egypt, Persia, and much of Europe, purple was considered the color of royalty because it was so expensive to make; thousands of mollusks were needed to create just a small amount of purple dye. Research the colors that you are drawn to. You might be surprised by what you learn!

After you've had some time to play, think about how you'll use these colors. First think about what you are working on. Your color needs are different, depending on whether you are decorating a whole apartment, creating a fresh start for one room, designing an accent piece, sewing a quilt, making drapes, or choosing a new serving bowl. Consider if you want the mood to be soft and serene, warm and dramatic, or bright and cheerful. Identifying the purpose and vibe of the project will help you pair color combinations with intention, especially if you've given thought to how specific colors make you feel.

To help you understand how to build a palette, I will take you through the three basic sequential models of color palettes: neutrals, warm and cool color, and full multicolored palettes. Understanding the first two models will teach you how to successfully pull together a more complex multicolored palette. The following color-palette examples are my personal favorites of these categories and are all based on special locations and memories. When you do this exercise for yourself, start with imagining a place that embodies the mind-set you are trying to achieve. Getting *specific* with your intention and desired mood empowers your color choices.

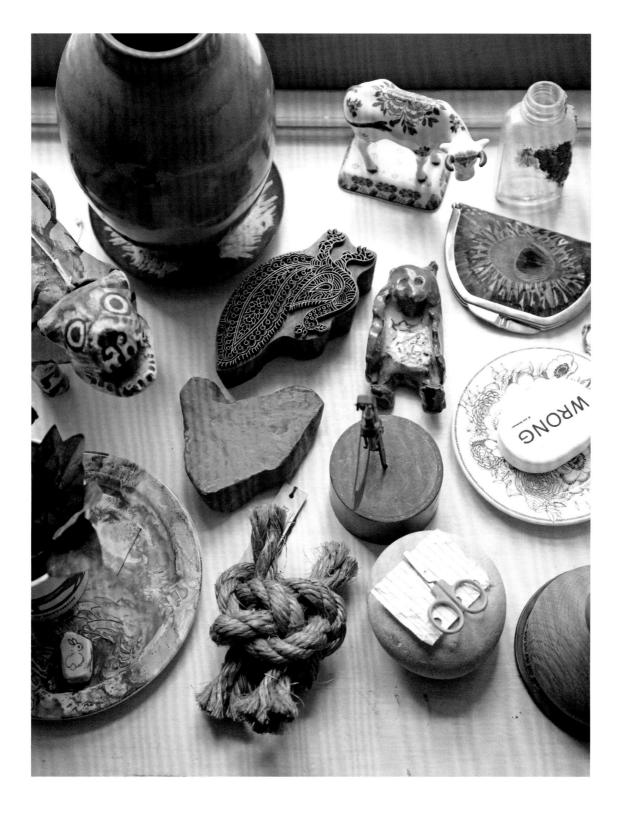

NEUTRALS

Neutrals may seem bland at first, given a cursory glance, but they're essential to design. Think of neutral colors as your foundation or the base that holds everything else together. Any multi-colored combination needs neutrals to ground it and keep it from feeling too crazy—even if it's just one or two colors within a pattern.

On their own, neutrals can also create a whole world of interest because you've narrowed the focus. Think about trying to paint a white egg on a white backdrop. If you were to set up this still life and really look at it, you would find you needed to mix many colors—from blue, orange, yellow, purple, and even green, but in a very narrow range of pastels—to achieve the subtle variations in color. Focus in and you will see neutrals have their own intricacies. On a broad level, they are split into warm and cool; warm neutrals have under-tones of red and yellow, whereas cool neutrals have undertones of blue and green. Let's take a closer look.

WARM NEUTRALS

Combine soft ivory with sand, taupe, nude, a hint of blush, and even bring in a warm rich brown tone to add depth. Everything is subdued and muted but simultaneously complex. This palette focuses on the subtle differences in the soft sedimentary hues and references the sandy colors of an off-season day on Cape Cod. It is a lovely scheme all on its own, if you're looking for a calm but warm vibe, or it is a great base to build upon.

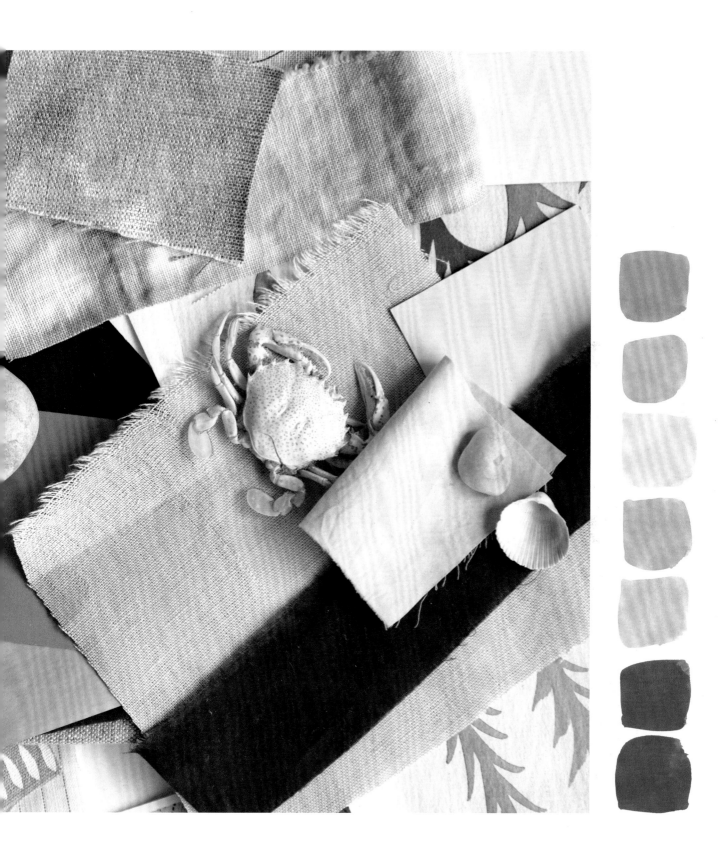

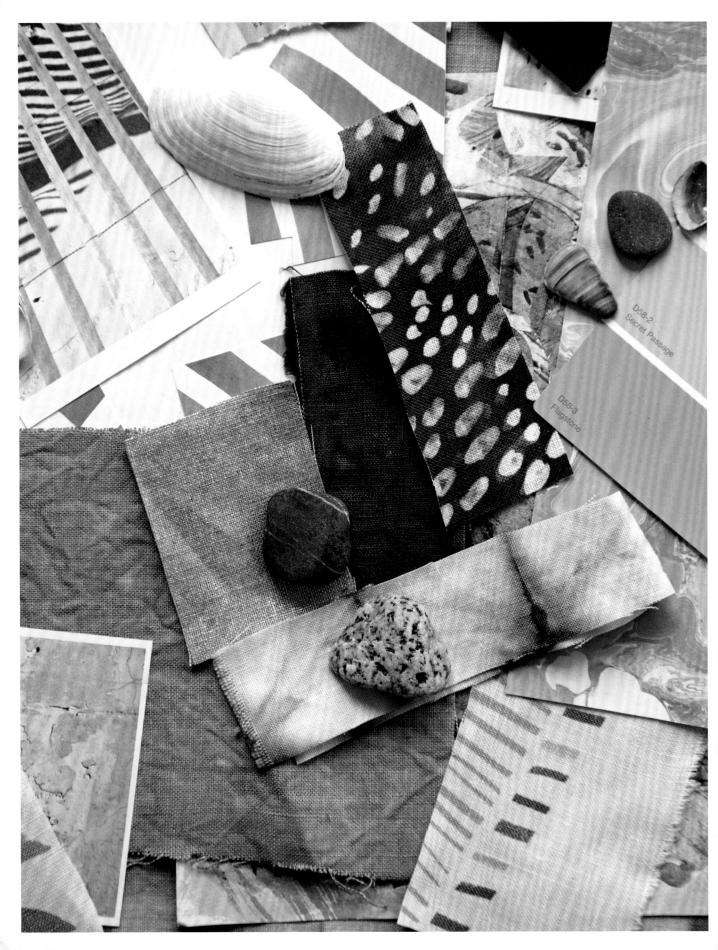

COOL NEUTRALS

Start with soft dove gray and add slate, stormy gray, and deep blue-blacks verging on indigo. A touch of a blue-purple hue adds just enough color to keep the palette from being too flat. This more moody scheme also has complexity to stand on its own, revealing the beauty in cool gray hues, or to act as a foundation for more color, just like the warm neutral palette. It's a great example of how monochromatic can be interesting. The dark blue-blacks reference wet rocks on a jetty, on a gray, slightly overcast afternoon by the beach. The touch of blue-purple that enlivens this palette is pulled from the inside of a mussel shell.

ADDING INTENSITY

Now let's open up the range of hue and value. The next two palettes build on what you've seen in the neutrals model, still exploring the concept of warm and cool, but with more strength. You'll see that knowing when to tone down and when to intensify can be crucial; I always experiment with several shades of a hue to see what works.

WARM COLOR

Start with the foundation we created in the warm neutral color palette, but add in soft tangerine, a seashell pink, a soft pink-violet, and a touch of a copper-rust hue. I picked these new colors thinking about what the sun setting would do to the original warm palette. Everything intensifies just a bit, and the saturation is pumped up.

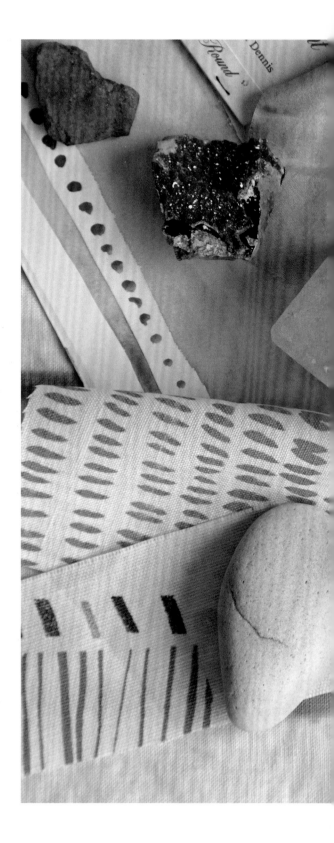

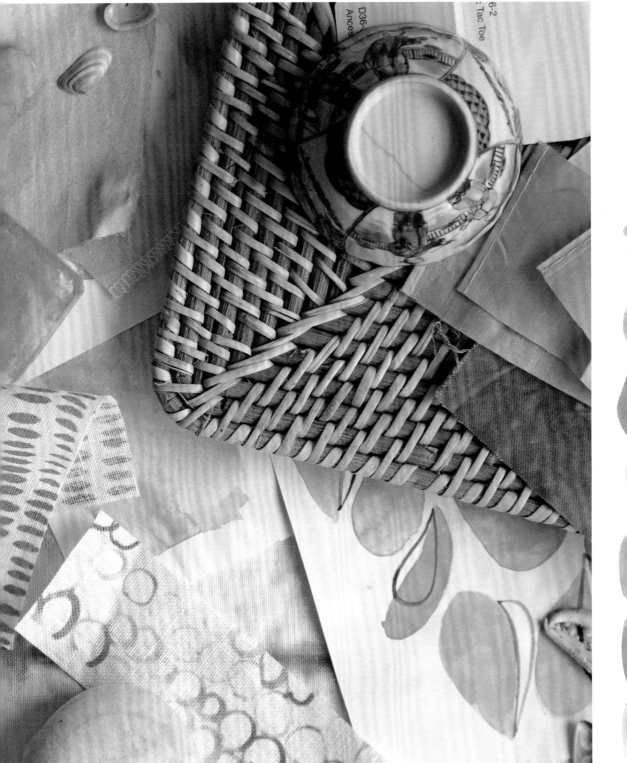
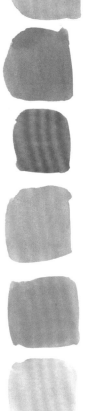

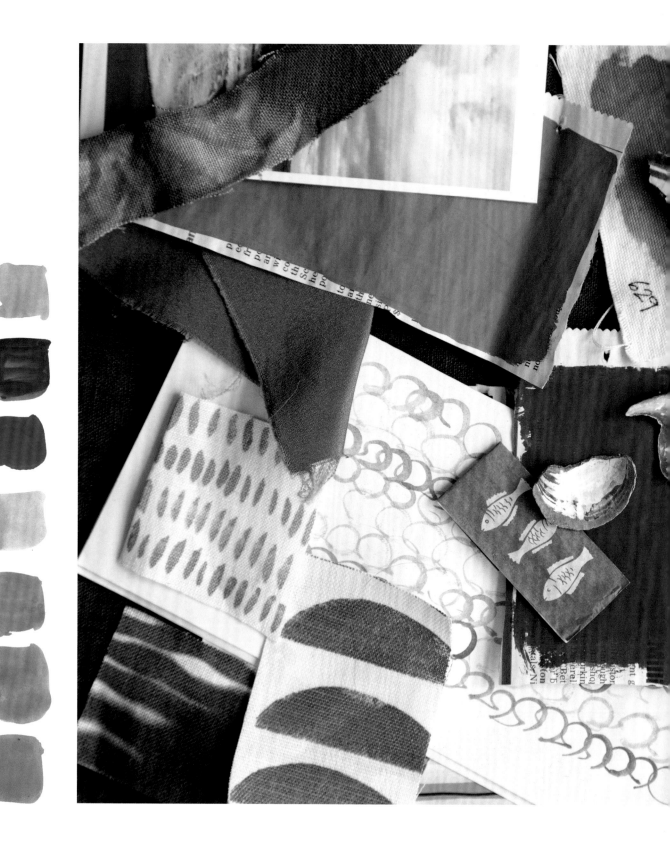

COOL COLOR

Expand your cool neutrals with icy pale blues to deep dark indigos—the colors of the sky at dusk when the incandescent lights come on. Bring in bright green as a pop of color—but, since it is a concentrated hue, using it in small doses is the key to balance.

THE FULL RANGE

Bringing together a multicolored palette will build on the elements from the past two models. Here it's about the foundation of neutrals plus a mix of warm and cool colors within one palette. Let's look at four different color schemes with unique moods to show you a few ways of creating a dynamic palette.

RICH GREENS WITH JEWEL-TONE ACCENTS

Green and navy hues are the base of this palette. These base colors are all of a similar value, and they remind me of a rainy, humid landscape at night with the dark grass and deep blue-black trees and sky. The brighter jade green brings in a luminous feeling that is accented with other jewel-like hues of ruby, orange, pink, and a lime green. Use those colors as accents in small amounts so they're not overpowering. To ground this color palette, you need soft natural linen, warm brown, and clay colors.

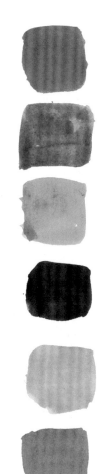

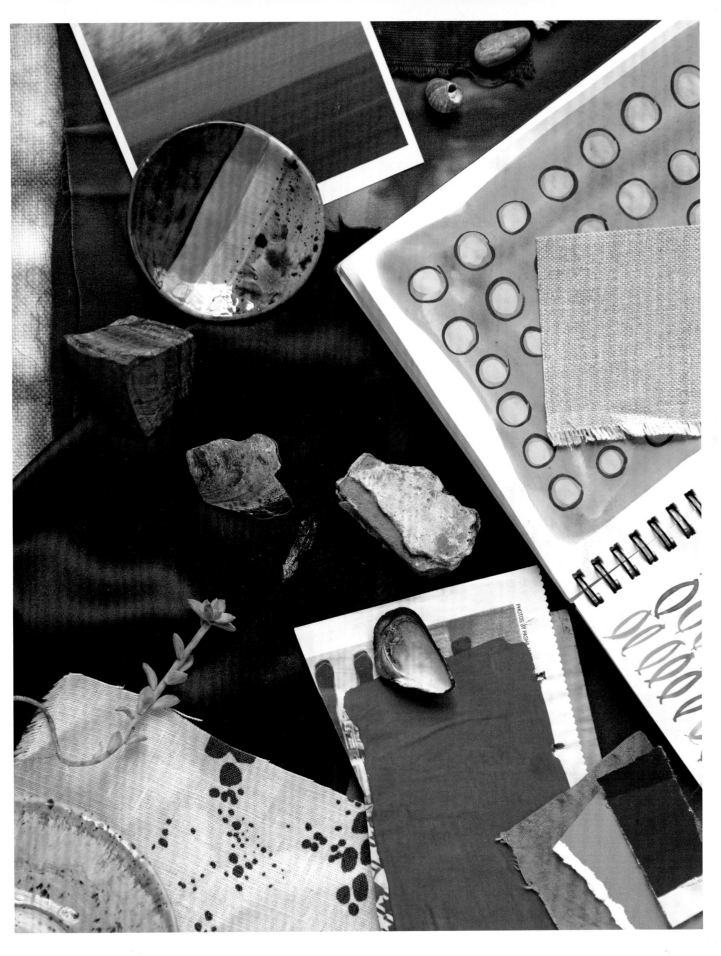

PHOTOS BY PASHA

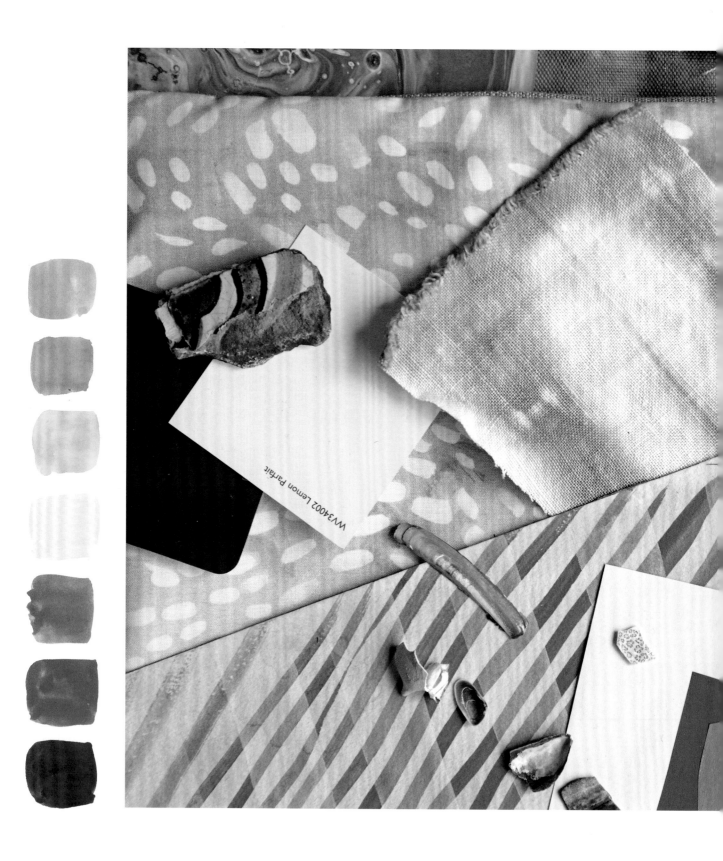

VV34002 Lemon Parfait

A POP OF YELLOW

This palette explores a mostly neutral color story with soft sandy colors, subdued lilac, washed navy, and clay tones that have a hint of pink. The yellow and small amount of cerulean blue add a welcome brightness and remind me of a hot summer sky. Use this idea with any "pop color" that you really love—ground it in neutrals and let the hue really shine. The key with a pop color is to accentuate it as a focal point, but remember that you don't need a lot of a bold hue to make an impact. Play with proportion.

BLUSH, TOMATO RED, AND BLUES

A touch of a rich tomato red paired with a softer coral and rose blush is the base for this palette— a range of one warm hue. Mix these colors with an array of blues and chromatic neutrals. The gray in this story verges on lilac, and the taupe has a tint of rose to it as well, which help them relate to the other colors. The orange in the red and coral highlights the blues, making them pop (remember that orange is the complement of blue on the color wheel). Inspired by the crisp air of late-summer afternoons, rosé, and a simple panzanella salad, this is one of my go-to palettes.

MUTED PURPLE, CHOCOLATE, AND PEACH ACCENTS

This cozy palette is all about playing the rich red-purple hue against the warm brown tone. Together the colors feel complex and full-bodied and give one another balance, like a cold fall day by the fire. Soft orange pairs well with this peach and adds a unique but flattering combination with the range of purples. The soft gray from the stamped ink drawing gives a cool note that, when paired with the white, acts like a cool breeze and keeps it from feeling too dark.

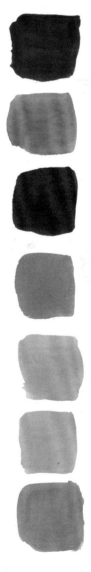

se each example as a framework for creating your own palette from colors you love. To start from scratch, choose a palette of five colors. Then pick two colors that you feel look good together. Think about what you are drawn to and get specific by referencing places and memories. For example, it's not just green—it's the green of the leaves when they first appear in early spring. Depending on the mood you're trying to achieve, you may want colors that are complementary to create contrast, or colors with more in common that create a softer look. You can't really go wrong. With the remaining three colors, aim for two neutrals and one wild card—perhaps you'll use it only as a small accent. Play with swapping out one color for another or creating a bunch of new palettes. This exercise helps you learn what works for you. Be sure to push yourself and try new things or odd colors—you may discover a new love for a color when you find the right pairing for it.

YOUR COLORS

Notice the colors you're drawn to.

Remember the importance of neutrals.

Play around with new color combinations using your collection—building from neutrals, to warm and cool colors, to true multicolored palettes.

Experiment with how proportion controls mood.

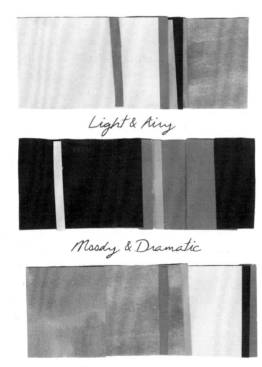

Light & Airy

Moody & Dramatic

Bright & Cheerful

Seeing colors interact is fascinating. The balance of the colors used within one palette can drastically change its feeling. Let's look at a palette of blue-black, sky blue, denim blue, cream, sand, tangerine, and dove gray. As you can see, by using more of the cream, sand, and dove gray, a little of the blue, and very little of the other colors, it becomes light and airy. A moody dramatic vibe sets in when you shift the emphasis to the blue-black, denim blue, and dove gray; however, focusing on the tangerine and sky blue creates a bright and cheerful vibe. Proportion with color is all about tweaking the levels to achieve the feel you want. Shifting the relationships between colors can be a great way to do so while still using what you're drawn to. If there is a color you absolutely love, but it doesn't help build the mood you're interested in, consider how it could function as a small accent and what other colors can do to change its feeling.

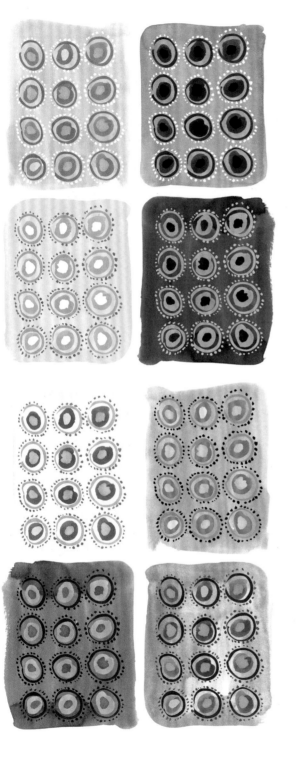

To give you an idea of the power color pairings can have in application, I've taken one pattern and recolored it in each of the initial palettes I described so that you can see the effect on the overall mood. Watch it become soft and quiet, fresh and sprightly, dark and mysterious, or rich and vibrant. White or light-colored grounds tend to feel fresh and airier, whereas darker-colored grounds feel richer and more appropriate for cooler weather. Even if it's just a two-color print, reversing the placement of the colors can be dramatic. Limiting your color palette allows you to make smart choices about how and where you use color. When you're just starting out, try simplifying by looking for patterns with fewer overall colors. If you're more comfortable with the complexities of color, push yourself and experiment with unique combinations. If your home is already filled with many two-colored prints, consider how the addition of a third, fourth, or even fifth color would change things.

BUILDING YOUR BASE WITH

TEXTURE

BEFORE WE dive into pattern, we must first cover texture. Texture is essential to your pattern palette just as neutrals are essential to your color palette. Think of texture as the base of your pattern palette, or as monochromatic pattern.

The first textures to consider are the existing ones in an environment—the architecture of a room. It could be the molding on the walls, the tiles of a backsplash, a pressed-glass pattern on your shower door, even your old metal radiator. Maybe it's the wood grain of your floorboards as well as the patterning of the layout—gridded, herringbone, or chevron. Crown molding, paneled shiplap walls, spindle banisters, wrought iron railings, rustic ceiling beams, and wooden shutters are all different striped patterns. A staircase is a fun geometric made of bars and dashes; windowpanes and cabinets are different takes on a grid. It can be as subtle as the finish of a ceramic tile versus the matte paint on the wall. These textures are the foundation of any environment. Some will be preexisting elements you're not able to change, and other times you can alter these finishes, or choose new ones if they're lacking.

CREATING TEXTURE

How can you work with these established textures? Build upon their structure and bring in pieces that speak to the bigger picture you want to create. If there are textures within the architecture that you love, then play them up. This emphasis could come from repeating other textures that reference them, or highlighting them by contrasting another very different texture. For instance, you could highlight the old crown-molding detail you love by wallpapering a hallway with a lattice design. Choosing a pattern with architectural structure accentuates this detailing and continues the story in a different way. Both choices are traditional, but they can be more contemporary depending on how clean the designs themselves are.

Ultimately the textures you choose will be able to go with anything else you layer on, but certain subtleties can make the base more dynamic while still addressing your personal taste. Flecked stone, jute, unfinished wood, grass-cloth wallpaper, and rough canvas feel more casual and earthy, while polished cement, marble, textured glass, brushed metals, and silks feel more urban and refined. Investigate different materials and brainstorm how you can use them. You may want to be consistent with the vibe or perhaps consciously choose casual textures to create contrast with luxurious textiles so the overall energy isn't too opulent.

Every foundation of texture should have some contrast within its assortment. Varying finishes is one way to create interest right off the bat. Look for a mix of shiny versus matte, hard versus soft, chunky knits versus fine wovens, or rough versus polished. Bring in elements that speak to nature, as these textures ground your space, giving it weight and a sense of place. They make an area feel complex and considered, as opposed to starting with a white box. When you've thought through the texture basics, even a sparser but true pattern will still make the room full. Texture is also a great starting point for thinking about the kinds of patterns you'll use to build upon the environment.

Don't forget to think outside the box. Think about texture from a bird's-eye view as well. Your furniture and objects build the surface of your home, and many objects have textural or three-dimensional patterning built in. Think about a metal chair with a gridded pattern, or a wooden bench with slatted panels, or the curled and crossed patterning on a rattan peacock chair. Dresser or cabinet knobs are their own subtle dot pattern; the legs of a stool are a deconstructed stripe. Then go small and notice the textural patterns in a woven basket, a macramé wall hanging, a faceted water glass, a scalloped plate, a tufted chair, the leaves of a plant, or a punched metal lantern. Texture isn't just the surface of your home but the objects you bring into it.

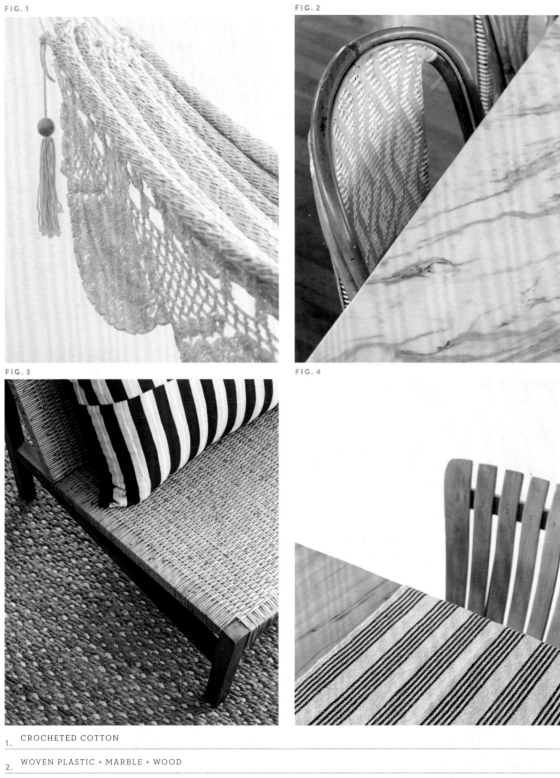

FIG. 1

FIG. 2

FIG. 3

FIG. 4

1. CROCHETED COTTON

2. WOVEN PLASTIC + MARBLE + WOOD

3. SISAL + RATTAN + STRIPED LINEN

4. SLATTED WOOD + WOVEN STRIPES

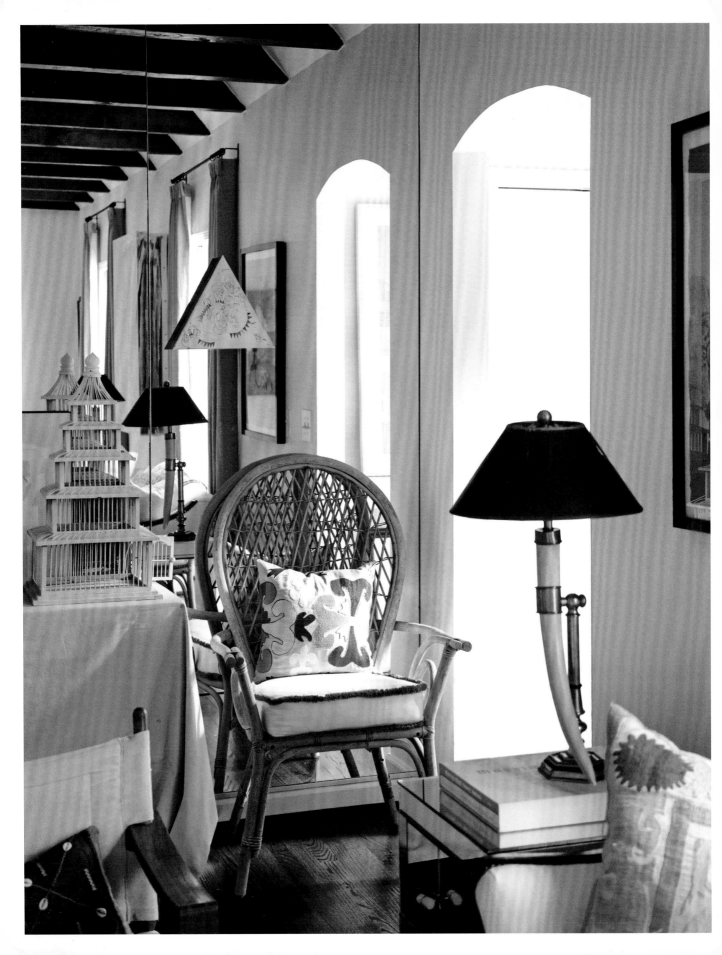

The repetition of objects you style into a space also can form patterns. Typically three items make the pattern clear, but a pair of chairs in a living room can be effective while several lined up on a deck form a clear sequence. Nesting tables are an obvious example of this concept, as the exact motif is replicated in a descending scale. Another easy example is the creation of a three-dimensional stripe concept using the spines of the book to create a pattern. Bottles, jugs, potted plants, candlesticks, or canisters lined up next to one another form a pattern of their own, too. Look at the silhouette your shapes create as well as the negative space between them. Think about how lining them up or a more scattered and organic positioning around the room will make an impact.

Displaying your dishes, glasses, and mugs on open shelving is also an opportunity. How could you hang objects on the wall? Arrange all of your artwork and photos together on the wall and you have a gallery wall. It's been done thousands of times but can still feel relevant if you use items that are really personal. You could expand this concept with a collection of mountable objects such as plates, hats, or baskets, positioning them in a dotted or structured pattern. It can be something as small as rocks on a windowsill. Once you start looking, you'll see these natural patterns and textures everywhere.

YOUR TEXTURES

Review existing architectural elements and surfaces.

Decide if you want to contrast or highlight the existing environment.

Create interest through varying textures.

Think of the repetition of objects as textural patterning.

TELLING YOUR STORY WITH

PATTERN

NOW THAT you have an understanding of how colors affect one another, how colors influence pattern, and the importance of texture and placement, let's look at how different patterns interact with one another.

More often than not, paired patterns become more dynamic than just a single pattern standing alone—and they feel more personal. They can also offset environments and objects. While a ticking stripe may be classic on its own, it becomes more modern and edgy with a 1980s-inspired geometric print. Are you drawn to florals? Get particular: English country rose or graphic 1960s geometric florals? Think of the patterns you pair as describing the different elements of your personality. If you lean toward an English country rose but it feels just a bit too sweet for you, offset it with a pattern representing another part of your personality. If you're more bright and cheerful, consider Mexican embroidered Otomi textiles; the bold embroidered animals will bring levity to the floral. If your taste is more modern, then pair it with a large stripe or an abstract print; the clean lines will make the floral feel more contemporary.

Select your pairings in order to elevate each individual pattern, allowing the combination to become something much more personal and extraordinary. Let's look at how you do that.

SCALE AND PROPORTION

Two key elements in mixing and matching patterns successfully on a technical level are scale and proportion. We can't really discuss one without the other. While the word scale can describe the scope of how something is used, here it will mean the physical size of a pattern; I'll use the term proportion to discuss how much of a pattern we're using. Scale and proportion are tools for creating drama within a space.

Before thinking about the individual piece you're applying pattern to (or purchasing already patterned), consider the bigger picture of the pattern's purpose within the room. Choose larger-scale patterns for items or areas you want to be the focal point and draw someone toward, and smaller-scale patterns for ones you want to recede into the space or even hide or camouflage. This highlighting or minimizing through pattern can help define the purpose you have for the space and subliminally inform people how to interact or use the space. For example, accentuating a pair of armchairs with a bold pattern will encourage people to sit there.

The sense of an object's or a pattern's scale is directly related to the size of the room and the other objects in it. Consider the room as a whole to understand what the scale actually is within the particular context. A pattern you may think is medium to large in scale may feel gigantic when used on a bigger piece or in a small-size room, and even more so if all of the other prints are small scale. A larger space will be able to accommodate larger patterns more easily and will actually need them for balance. In that case, you may need to go bigger than you think. Remember that it's okay to buy pieces over time and let the space evolve naturally. If you want to try something unexpected, go for it—you have to start somewhere.

PATTERN 40 TO 60% OF
YOUR ROOM. BREAK UP
THE PATTERNED AREA INTO
THREE PATTERNS, WITH
A 60/30/10 PROPORTION,
OR FIVE PATTERNS WITH A
40/30/20/5/5 PROPORTION.

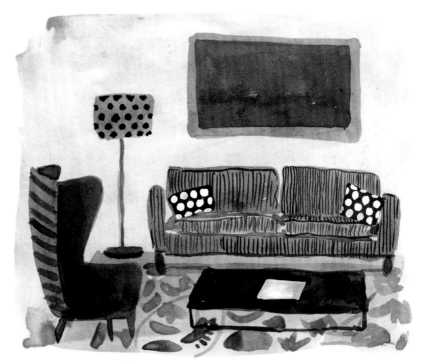

60% Floral Rug, 30% Striped Sofa, 10% Dotted Accents

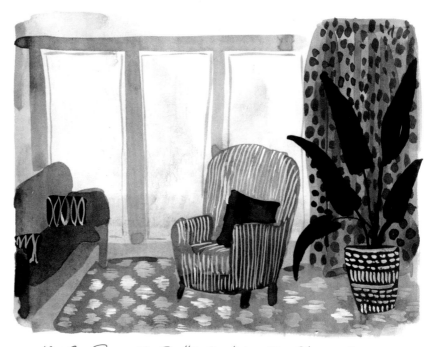

*40% Geo Rug, 30% Dotted Curtain, 20% Striped Chair,
5% Geo Pot, 5% Decorative Curtains*

The easiest and most cost-effective way to understand scale prior to purchasing is to bring home swatches and samples to help you visualize. Look at the patterns from a distance. A small- or mid-size pattern might look busy and complicated when viewed up close and on its own; however, when you pull back and envision it in a space, it may become less bold and more textural. You should, of course, love it up close if it's something you're going to be cozying up to, but bear in mind the bigger picture. Knowing what scale or pattern works in your space will enable you to find something you love that also works within the context of the room. You can experiment with bringing swatches of various-size patterns, regardless of whether they're the ones you like best—it's an important and helpful exercise and may give you a better understanding of what you need to look for.

Proportion should also be considered when deciding how much of a room should have pattern versus solids or textures. I suggest 40 to 60 percent of the room be patterned. This proportion gives you enough excitement but also enough rest—and remember you can and probably will build the level of pattern over time, so you don't need to hit this number right away. The unpatterned portion of the room is made up of solids, subtle shifts in surface texture, and repetition of shapes. Keep in mind that all of the surfaces and objects in the space are an opportunity for pattern.

Now, how will these patterns interact with one another to create a visual balance?

An assortment of small-, mid-, and large-scale patterns is essential to creating interest and leading your eye around the room. Grouping items in odd numbers is a well-known interior-design concept, an established theory on creating a visually pleasing display, and a formula that's easy to follow. Start with three to five patterns. Your collection should include at least one large-scale print, plus a mix of at least two other mid- to small-scale prints. I like to think of the large-scale print as the "hero print"—it's the one that has the most impact. Think about it like this: the largest print creates a little drama, whereas the others support your story, but depending on your space and taste, the print with the most narrative quality could be an accent, while the large-scale print would be something more livable that you won't tire of.

Mid-Print Scales

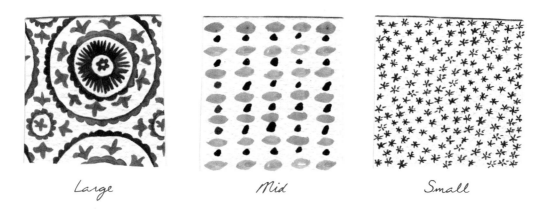

Large Mid Small

Scale may also change the meaning or interpretation of a pattern. Blowing up a classic toile pattern to a large scale makes it feel more modern, as it's unexpected. You normally think of toiles as detailed, figurative designs with fine line work, but that idea changes completely when it's enlarged. A plaid increased in scale becomes color blocking. Smaller-scale prints are a great way to try out a pattern that is a bit more playful but can still read as sophisticated. A quirky print with animals in it may seem naive at a medium or large scale, but shrunk to a small size—and in the right rendition—it can feel refined. A guest might not even notice the animals until they see the piece up close. Even a floral print at three different scales can have subtle shifts in the way it's perceived: an oversize print feels graphic and more abstract; as a mid-size print it starts to appear younger and more playful; and reduced to a mini scale it can seem sophisticated but whimsical, like a Liberty London print.

BALANCING YOUR PALETTE

As you put together your pattern palette, you'll also begin to figure out the balance of each within that assortment. If you used them all in the same quantity, the space would feel hectic. Create a visual hierarchy. Traditionally, the larger print would be used in the largest proportion, followed by the mid scale and then small scale, but that's not always the case. I find it helpful to go back to the bigger picture and think of what you want to highlight or recede within the space. If you're starting from scratch with a room, you can be very calculated about your choices. If you're working with an existing room, have a look around and see what's working so far and how the addition or subtraction of other prints can help create balance.

Scale becomes easier to understand when you're thinking about a particular item, rather than the whole room. You'll be naturally inclined to choose a smaller pattern for a dining chair and a larger pattern for a sofa simply because of the size of the object. Don't be afraid to exaggerate the opposite and go for a big, bold pattern on a dining chair or a pillow. This deliberate burst can be amazing, but be selective when cropping a large-scale print, otherwise it may not look as you intended. When done right, it's a great way to make an identifiable print feel abstract—like a large floral where you can see only part of a leaf and part of a flower.

FOOL YOUR EYES

Two patterns with a similar color palette and scale will read similarly from a distance. The eye will initially see them as the same pattern, so it can be fun to play with creating unexpected interest that you only notice once you're in the room or even, for example, sitting on the sofa next to the two pillows. This trick works best with medium-size patterns, as it feels more intentional than with smaller-scale patterns and less distracting than with larger-scale patterns.

59

TELLING YOUR STORY WITH PATTERN

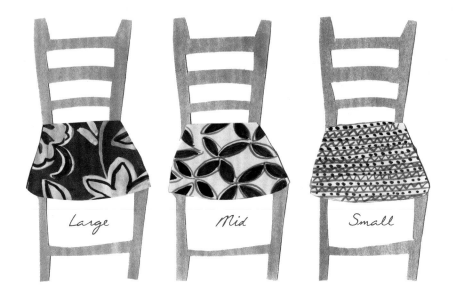

Large Mid Small

BUILDING A COLLECTION

So what will make up your collection of patterns? As with colors and texture, it's helpful to have a base that you can mix and match with anything. The base isn't necessarily the star of a story, but it is the background information needed to complete the story. For example, a large embroidered suzani fabric may be a showstopper, but without any other patterns, it loses personal context. Stripes, geos, dots, ditsy prints, and no-print prints are your pattern's basic best friends. Stripes are classic and can add width or height to a room or individual piece if used on a larger scale.

Think outside the box when it comes to dots—there are more kinds than just your standard polka dot. They can read as playful, classic, abstract, animal print, and even modern op art–esque. Ditsy prints are very small scale; the motif can be anything—floral, geometric, novelty, or abstract. No-print prints are essential to any mix and perfect for the pattern wary, as these prints have full motif coverage that creates the illusion of texture and, from a distance, they can almost read as a solid.

These basics, also called coordinate prints, can and should tie back to the colors or theme of whatever more dramatic piece you're including. If you're newer to pattern, interesting coordinates are a great place to start. Keep a record of any basic patterns you fall in love with by putting small swatches in your notebook or taking pictures of them. Often you start a pattern scheme around one larger-scale fabric, or even a painting, that has many colors in it and then build with smaller-scale base fabrics from there so that they move back to the overall theme and palette. If, however, you find really unique coordinate fabrics that tell a story on their own, they can also be the starting point for your pattern palette.

Stripes

Geos

Dots

Ditsy Prints

No-Print Prints

Dots

Consider the general mix of the type of patterns you're using and their overall feeling. Are they all basics? Then you need to add more personality. Does the mix feel too romantic? Then you may need to add in something masculine or bold. As with individual colors, it's about balance. Each pattern has its own connotations and subtexts that create meaning when gathered in a group. You want to be sure to represent the many parts of your story as you make your selections. Remember, it all starts with what you're drawn to and what looks good to your eye.

On the following pages we're going to get into the specifics of mixing patterns, focusing on the tactile experience of being up close with the patterns and how they tell a story with their meaning. Sarah and Renée from Anona, a Philadelphia-based print studio, help show how all the information works together. They create original artwork and sell pieces from their archive of vintage clothing and fabrics to commercial clients. We pulled pieces from their archive to show you some inventive pattern mixing.

FLORAL REMIX

Here we've taken a rather traditional floral print and given it complexity through an eclectic mix. Alone, the blue florals might feel sweet and pretty, but including the darker blue and the two-tone adds layers to the palette in a way that keeps it from becoming too "matchy." The classic striped-dot print on the wall—the basic here—plays well with the florals, and is complemented by the soft pale pink and blue woven piece coming in at the top center. The oversize blue floral suzani fabric adds needed texture to the all-print story.

For added depth to an otherwise traditional mix, we've included a bright Hmong textile (bottom center) for embroidered texture, and a quirky evil eye ceramic to give it an updated feel. The black and red stacked books provide this light story with a little more weight and balance, as non-patterned objects are an important part of any palette, too. This mix is all about updating a classic by finding something special to give it a little more interest.

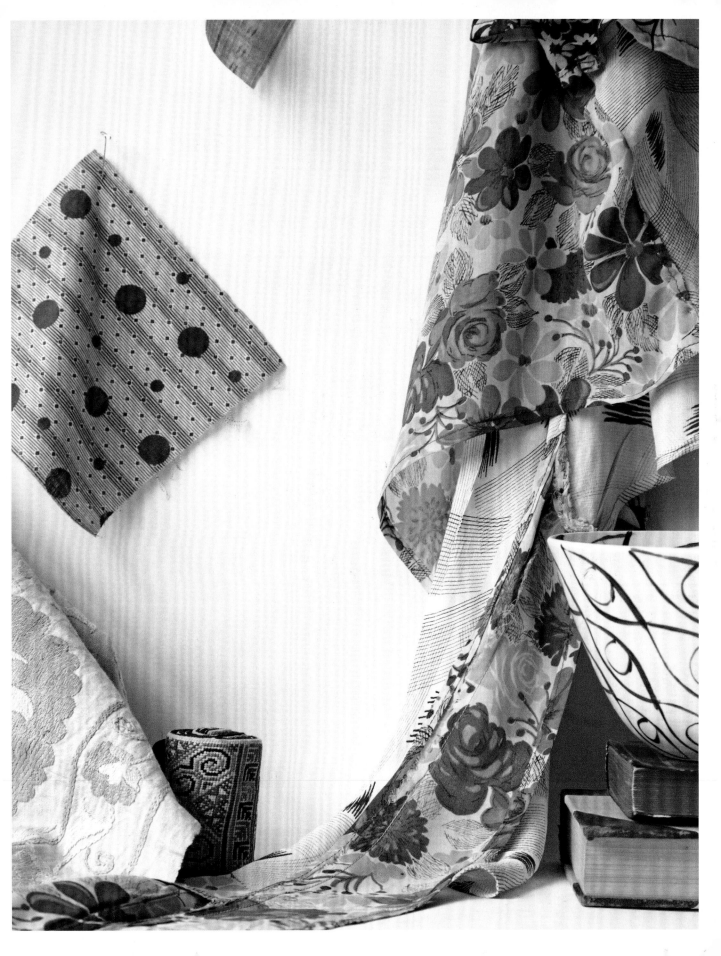

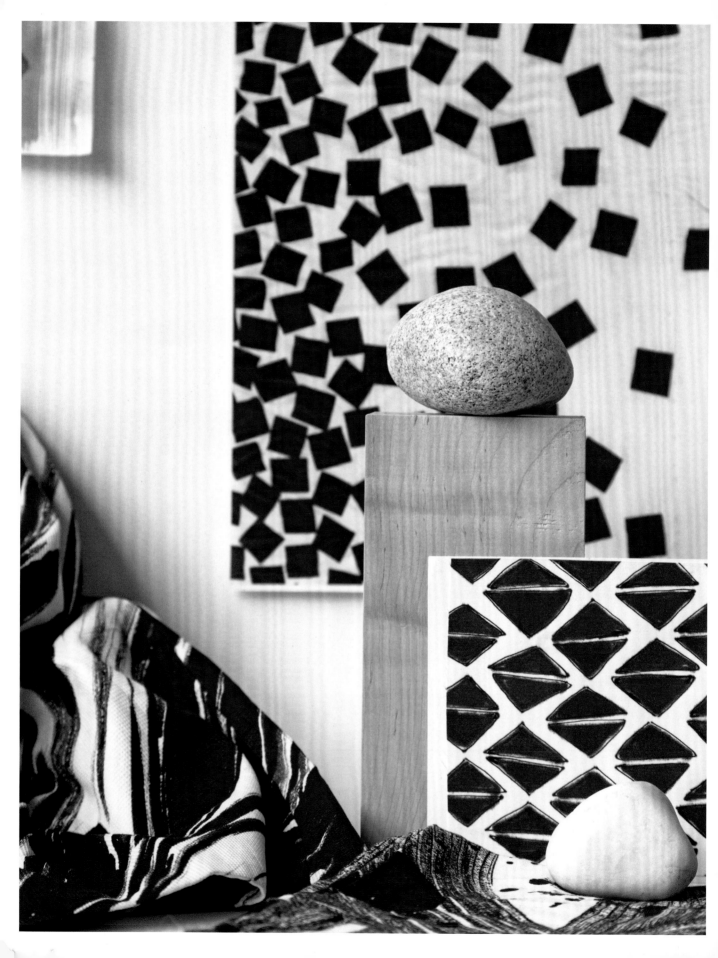

BOLD GEOMETRICS
MEET PAINTERLY

One of my favorite pairings is to mix something graphic with something free-flowing. This classic black-and-white palette is a good example of how easy these crisp and loose prints mix. The trick is to keep the color tight. It may not seem like much, but just that hint of a gray painted stripe in the top left corner, along with the natural wood and stone textures, help soften this high-contrast palette, all the while allowing the patterning to relate.

The rectangular areas that the patterns fill plus the block of wood also translate this graphic concept in a more abstract way, contrasting against the irregular shapes of the rocks. The small triangular geometric print in the foreground also has a hand-drawn look that helps tie together the clean boxes in the background with the brush marks in the foreground. Remember, proportion is key!

SHIBORI AND
HAND-DRAWN GRAPHICS

This mix is all about one big, looser shibori panel and the smaller coordinate prints. It's a great example of how strong coordinate prints can build a story without a bold, multicolored large print. In the foreground is a throw with a printed ikat design that feels like a more graphic interpretation of the shibori pattern at the top left. Those two elements complement and contrast each other nicely.

The other prints in this story act as supporting characters. The copper dashed pattern reads as an allover texture that relates to the natural wood and coral because of the marks; also, the coloring and subtle metallic are ikat inspired and echo the quilt on the ground. The stripe and brushstroke feel painterly, repeating the looseness of the shibori panel. The textured coral piece and the smooth white rock that's peeking into the composition on the bottom left have a visual tension because their placement creates energy, much like a printed pattern. Remember to think about object placement—not just prints—as patterning. The overall arrangement of the fabrics, coral, and wood create a composition as a whole, too.

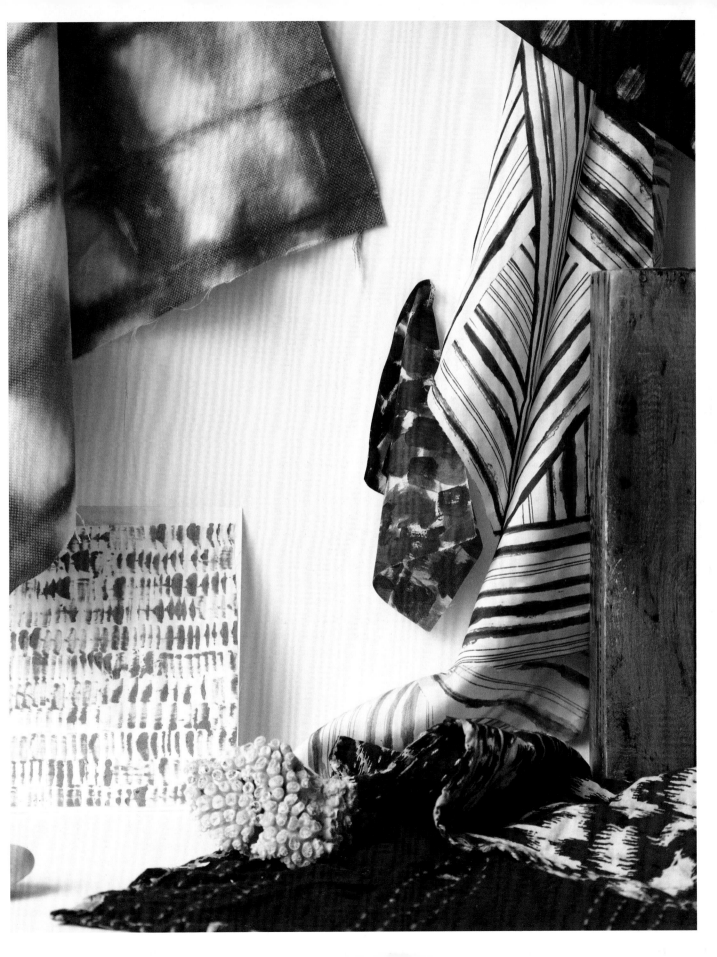

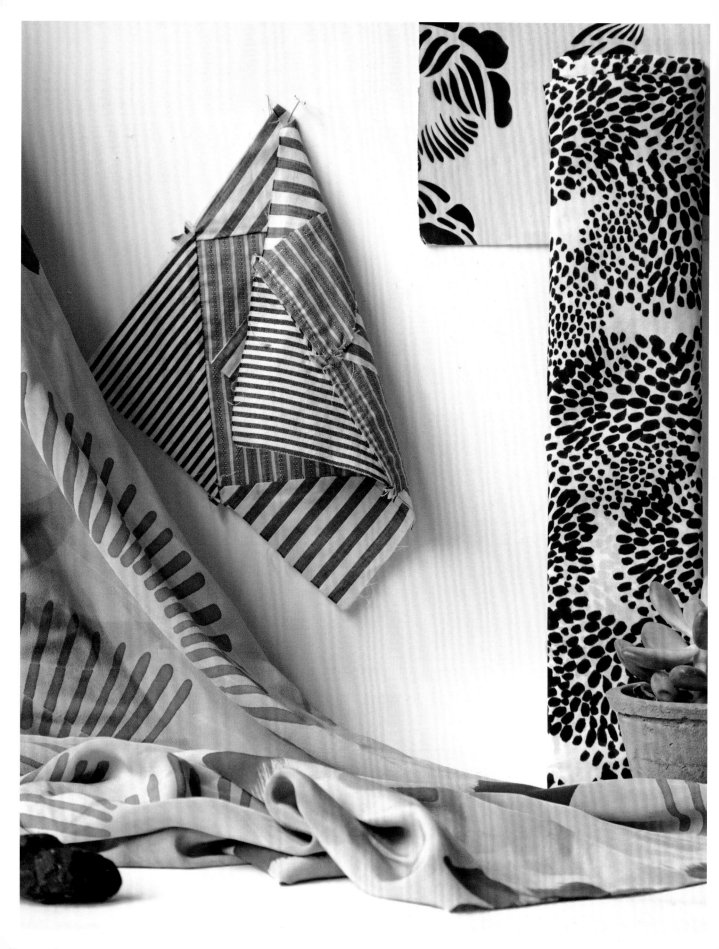

STRIPED QUILT SQUARES
WITH ABSTRACT FLORALS

The soft peach fabric with green eyelash marks on the left is a vintage piece that is full of personality. I usually have luck finding great fabrics like this at thrift stores. Here it's paired mostly with black, cream, and white to keep it from becoming too soft and sweet. The striped quilt square is a great example of one way to mix basic stripes; here they are used in different directions to create a whole new pattern all their own.

The two other prints work well together as they are both graphic abstract florals, which relate to each other and to the striped quilt through their palette. Notice how white and cream cohabitate as the value of the light color shifts throughout the scheme. The different materials also help them work well together.

WOVEN GEOMETRICS
WITH DENIM TEXTURES

The base for this print mix is all about the subtle shifts in denim. A woven ikat adds a subtle touch and complements the bolder pieces by adding some contrast with a softer edge. The woven bottle holder has a great geometric pattern that connects with the painterly red geometric print in the back through both color and line. The geometric nature of the textured woven floral is thanks to the construction of the fabric. This woven theme continues with the ikat fabric directly behind it.

These items all play on the textural element of the pattern and the underlying structure of how they are made. Lastly, we've added a loose splatter fabric in the top left corner to freshen up the story. Without it, the grouping feels a little static and more predictable because all of the other elements are based on a grid. If your concept has become stale, consider including something with a very different feeling. Put it in the room or hold up a picture of it, and consider how it interacts with the other elements.

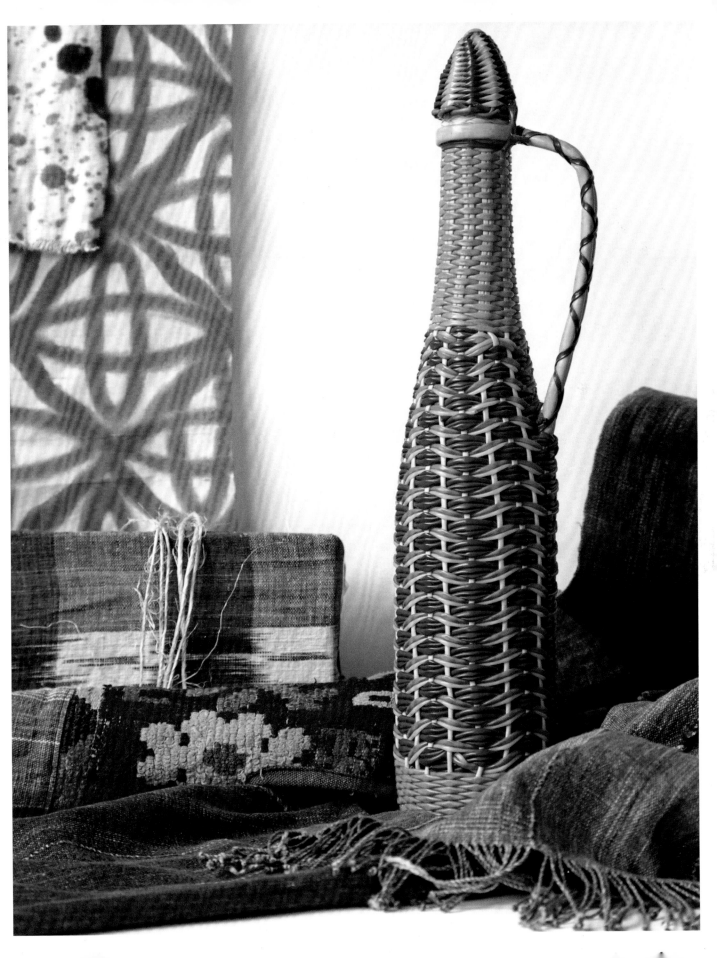

NATURAL TEXTURES, BATIK, AND INDIAN FLORAL

Batik prints like the one represented in the center are always full of interesting textures and tones. The earthy feeling reminds me of a flecked piece of dense granite, which is similar in character to the natural wood, ceramic, twine, and stone pieces in the front.

Bring similar natural textures into a room easily by adding a sisal rug or a marble or stone mantel. The intricate Indian floral is a nice complement to the other pieces; it coordinates the rich mood by adding more dense coverage but also provides a feminine touch—without it this pattern palette would feel overly earthy.

These mixes are simply meant to inspire combinations that are as unique as you are. I encourage you to gather objects from your home, clothing, swatches, magazine tears, and such to start piecing together your own vignettes. It's a great way to hone your pattern-pairing skills on a playful scale. Bringing things you love from different areas of your home that might not normally sit together may reveal a new way of looking at what you already own. Hold them up at arm's length, or attach them to a wall and stand back for a full view. Now that you've identified your story, started collecting your inspiration, and understand pattern, texture, and color basics, in the next section you'll dive deeper into the rooms of your home and put these concepts into practice.

YOUR PATTERNS

Get particular with your pattern choices.

Choose large-scale patterns for items you want to highlight and smaller scales for things that need less attention.

Mix the scale of prints within your assortment.

Bring home swatches to decide on scale.

Consider the application and the crop.

Build your base with coordinate prints.

Balance the vibe of one print with another. Pairings make for a unique point of view.

Create a story with the mix.

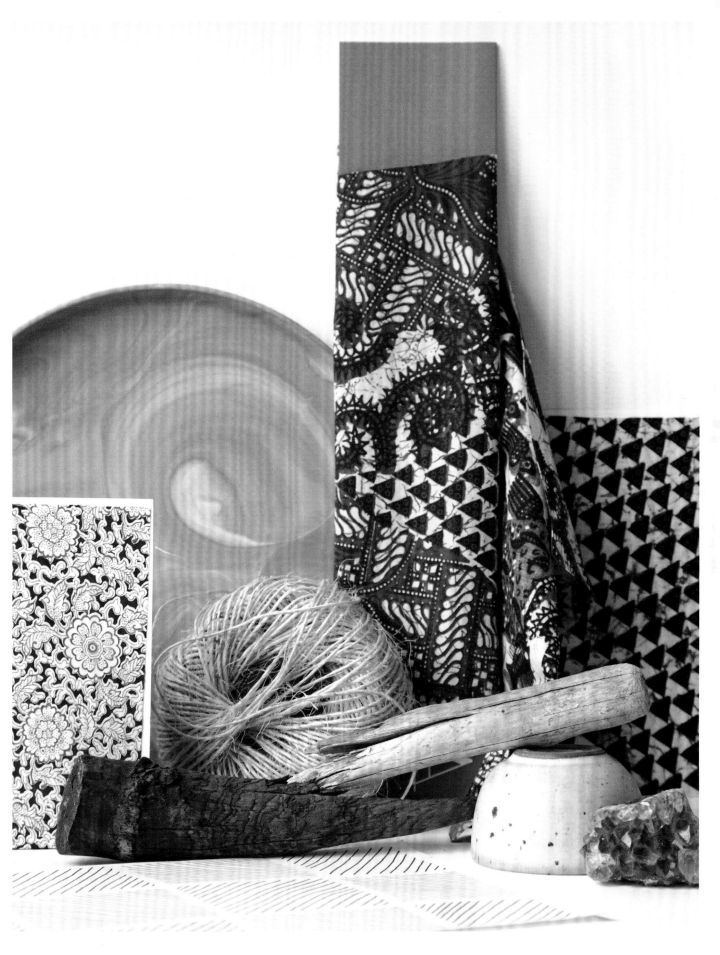

PART TWO

HOME

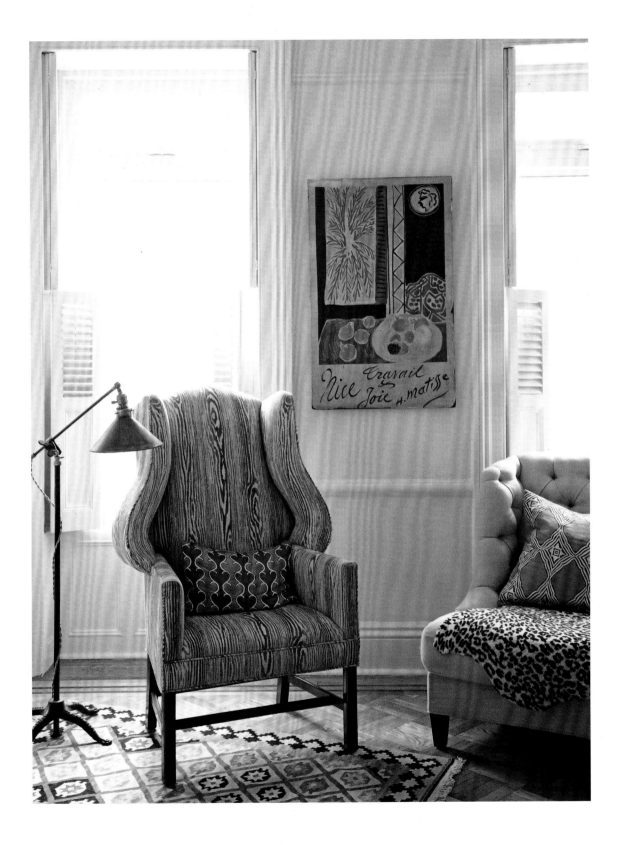

THE
ENTRYWAY

T HE FIRST steps through the doorway set the tone. This is your chance to welcome not only family and friends to your home but also yourself.

Getting into my own space at the end of the day is something I always look forward to. Passing through the rickety black iron gate and climbing up the well-worn steps to our second-floor apartment, I'm familiarized with the idiosyncrasies that make this place my home. Once inside, I'm comforted with smells, textures, colors, and patterns of my choosing. Even if you haven't defined a "proper" entryway, once you step through the doorway, whatever you see leaves an impression. While this space is definitely about utility, it doesn't have to lack personality. Think of it as the first glimpse into your story. Your entryway sees the goings and comings of all the family, friends, and loved ones who visit. Bags are dropped, shoes removed, coats discarded, keys tossed, and stresses of the day unloaded. It is a small space, often forgotten, but it's also a space that can change your mood and mind-set.

In this space, pattern has a definite purpose: to welcome. Pattern is the best tool to create a warm and friendly environment, so it's perfect here. Any entryway, no matter how small, can benefit from the welcoming power of pattern. Think about how you like to greet people and what you want your first impression to be. This space should emit and reflect the feeling you want to evoke when you walk through the door.

This chapter features seven homes that welcome with pattern in different ways. Looking at these distinct styles will enable you to pick and pull what resonates not only with your life but also with your space to create an entryway that offers genuine hospitality. This is the space to initiate generosity toward yourself and your guests.

CREATING COMFORT

Providing comfort is a basic way to offer a welcome in any situation. A place that addresses our basic needs and the excess stuff we all have creates comfort and eases our transition from outdoors to home. Thinking about your essential requirements for the space is the first step, and the second is to highlight those pieces with pattern to draw people in.

My husband and I often work long days, so when we come home we want to feel relaxed. This means casual luxury, personal pieces, and truly practical furniture that doesn't just look good but stands up. The ease of using a space is a key aspect of comfort, but it's equally important to be surrounded by patterns that speak to you. I wanted a spot to drop my bag and take off my shoes, so a bench was the natural choice. I highlighted it by covering it in a fabric I really love. The swirling marks remind me of the ocean and make me feel at home. Finding prints that bring you comfort is a great way to define your entryway. The fabric I used is also a great example of a no-print print, but it still draws us in with the vibrant but neutral navy hue.

The next addition was a patterned rug. Soft browns, muted teal, and subdued pinks create a nice base and expand the complexity of the color palette. I wanted a pop of color to enhance the vignette and add some cheer, and I needed extra storage, so I opted for a basket in a bright pink. It accentuates the muted colors in the rug as well as the pattern. A nice trick when pairing patterns is to find a simpler version of a larger-scale pattern. It can be a loose relationship, but the subtle repetition helps tie them together.

The piece that elevates it all is the mirror: it's oversize, with a subtle faceting detail that references some of the rectangular shapes of the space. Its scale creates impact and everyday luxury that makes this space sing.

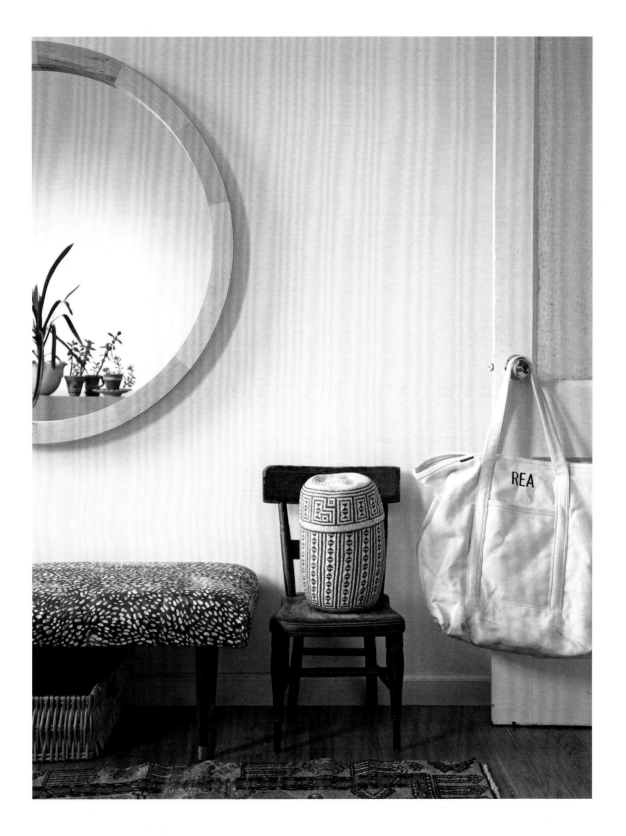

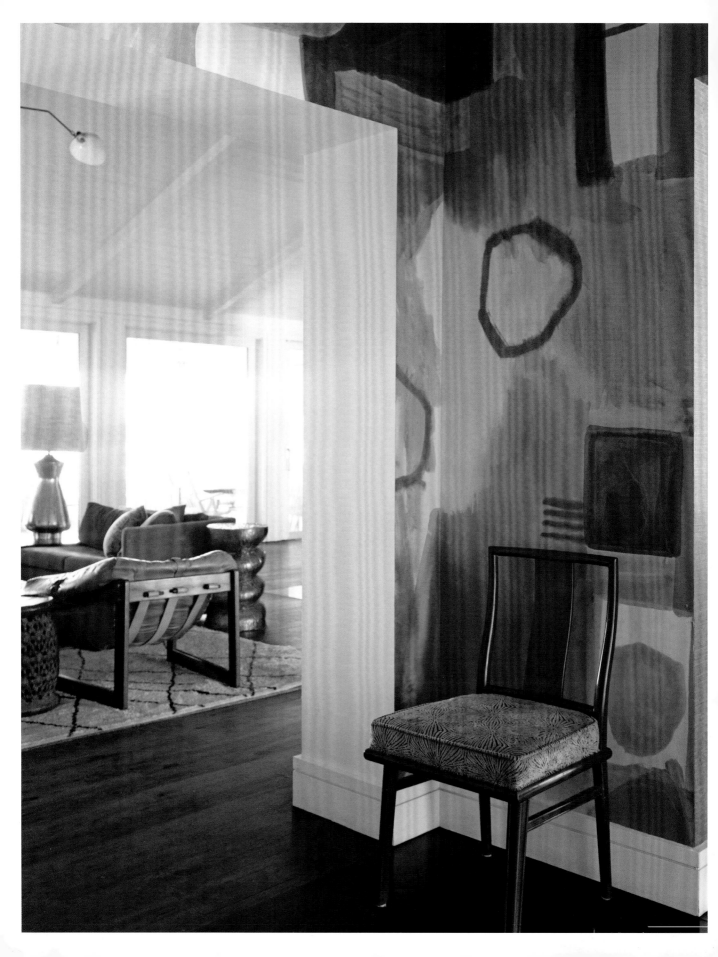

FINDING A TRANSITION

The entryway is the first sentence in your story. There are no rules except the ones you make as you create the visual vocabulary for your home. Angie Hranowksy is a sought-after Charleston-based interior designer known for creating high-impact rooms with traditional roots and a modern twist. She redefines what you may expect from a space and makes unique pairings look easy. Here Angie transformed her client's entryway with the use of wallpaper.

This space opens to several rooms in the home—without the wallpaper you might miss the entryway. Its pattern defines the space without relying on any objects or furniture. It envelops you and brings you into a world of abstract shapes, lively color, and fun. This striking environment introduces you to the spirit of the home, setting the tone. The pattern is a graphic geometric and abstractly represents the furniture layout in the next room: it would be difficult to forget the abstract shapes within the vibrant wallpaper as you take in the clustering of furniture in the living room. The wallpaper introduces the space and gives an aesthetic framework for viewing the rest of the home. You'll see this graphic geometric concept represented in a different way in the bathroom later in the book (pages 192-193).

MAKE IT
YOUR OWN

Pick a pattern with an all-encompassing feeling that will help create a new world—your world.

Look for a large statement piece that speaks to the décor in the rest of your home in an overarching way. This design element should feel like the first sentence in the story of your home.

Patterning just one small wall can create a strong feeling even if you lack space.

Introduce a color scheme you may expand upon in rooms that follow.

A POP OF PERSONALITY

If choosing just one pattern to introduce your home feels challenging, then you can use a curated group of objects that showcases your personality. Injecting your story into the entryway, however big or small, will welcome your visitors, as it is a representation of you. They'll feel at ease, allowing them to be themselves, too.

Sally King Benedict is an abstract painter who is fearless with her pattern choices. She and her husband met while living in Charleston, South Carolina, and decided to move back to Sally's hometown of Atlanta after the birth of their son; being closer to family was important. Their home still references the coastal vibe of Charleston. A constant collector unafraid to trust her taste, Sally is always on the hunt for pieces that speak to her.

Sally's entryway is a perfect example of how she mixes her interests with ease. She focuses the space on a pair of chairs in a fuzzy, blue Missoni chevron pattern. They are wild, unique, and certainly not everyone's cup of tea, but they look amazing in her space because she really went for it. She clearly loves these chairs—that's what makes it all work as she expresses her personality. When you have a bold pattern that speaks to one part of your story but may be overpowering on its own, you balance it with other parts of your personality. While Sally is fearless, she's also feminine. A soft pink pillow is an unexpected complement and makes the space feel more sophisticated. One of Sally's pastel seascapes highlights the softer tones from the pattern in the chairs and calms the space. A pineapple painting symbolizes hospitality and adds another quirky touch.

If you're going to go bold, go bold! Don't be afraid to experiment and show all who enter your home what you love. Your entryway is a great place to test ideas. Start by adding a small vignette. You'll gain confidence that you can then bring to larger areas.

MAKE IT *YOUR OWN*

Go with a grouping of objects versus one bold pattern, as it allows you flexibility to evolve and change the space by simply swapping one object out for another.

Soften a loud "pop" with other pieces, objects, and prints.

Be daring and remember you can always make changes. This is an area of your home that you walk through—you don't stay in it for long periods of time—so you won't get sick of it as easily.

"I BUY WHAT I LOVE AND THEN
FIGURE OUT HOW AND WHERE TO
BEST INCORPORATE IT INTO MY
OVERALL DESIGN. I CAN FIND A
PLACE FOR THE NEXT BEST THING
EVEN IF THAT MEANS MOVING
SOME OF THE OLD OUT. I LIKE FOR
THE DÉCOR TO EVOLVE LIKE WE
NATURALLY DO."

—Sally King Benedict

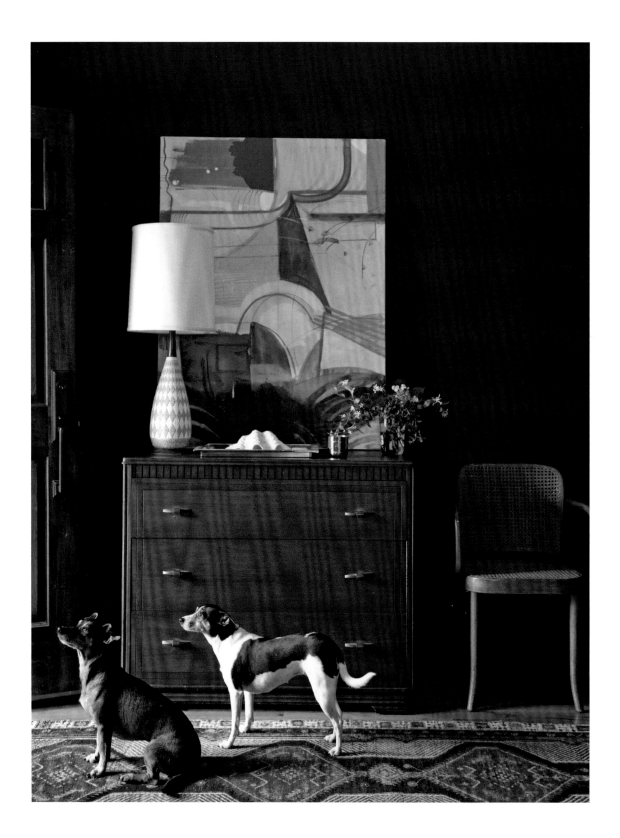

STARTING WITH COLOR

It's been seven years since Atlanta-based painter Michelle Armas started renovating her one-hundred-year-old bungalow, and it's still happily undone. She has a young daughter and two pint-size rescue dogs, and her home reflects her nurturing nature. Michelle is bright, open, and kind, and so is her art. Michelle's paintings range from the beautifully wild to the calm and pensive. Color is always her starting point, and she knows how to manipulate it.

In this space, the door opens up right into a seating area, so Michelle and her husband had to be creative about defining an entryway. The deep blue-black walls are moody but cozy. Without the addition of her painting, the space might be too dark, or feel closed and even traditional. But it's whimsical, lighthearted, and upbeat, which adds a much-needed contrast and infuses Michelle's warm personality.

Michelle also highlighted the space by the door with a rug and a few key pieces of furniture for function, which continue the flow of the seating area. The contrast of the dark walls serves to enhance the happiness of the painting, and suddenly even the motifs in the rug, which are geometric, feel buoyant. Patterns have the ability to change one another just by proximity.

High-contrast elements often need a few well-positioned brush marks or objects to tie them together. Michelle used a mid-century modern lamp with a geometric pattern that highlights the shapes in the rug as well as the light, neutral colors in the painting. The geometric pattern is an example of a coordinate print, which means it's not the main design element but a strong supporting character.

MAKE IT
YOUR
OWN

Contrast moody with cheerful for a space that feels warm, not glum.

Use accessories to help bridge the gap so that the contrast doesn't feel disjointed.

Traditional pieces can serve as a backdrop in many settings and still have a modern vibe when mixed.

A CALM GREETING

Your home should be your retreat. Leaving work and other stresses at the door is key, and creating an entryway that's calm enables this behavior as it welcomes you home. Lindsey Carter is the founder and designer of Troubadour clothing, as well as a wife and mother of twins who knows this to be true. She has a lot on her plate, but her fresh, happy, and calm style means she's always looking good. From running her own business to keeping up with her kids, she needs serenity where she can get it, and she has certainly translated that concept into her entryway.

Decorating her space with just a few well-chosen and carefully placed pieces, she creates a breezy, fresh vibe that still feels homey. The structural white stripes of the banister and subtle paneling on the walls create a soft grid for her décor to inhabit. She makes the sparse space cozier with a rug that adds warmth while remaining soft and airy through its colors and abstract motifs. Lindsey is always looking for patterns for her line of fabric and often works directly with artists to create them, so it's natural that she'd want to hang beautiful original artwork in her entryway. Both cheerful paintings pepper personality into the space without disrupting the overall calm vibe.

Lindsey splurges on one-of-a-kind rugs because, for her, there is nothing like having a large-scale pattern that is unique to your home. This Moroccan rug is a great example of that, and it's actually folded to the size of a runner. You'd never know unless she told you—and it's a great trick for rugs that are more flexible.

MAKE IT
YOUR
OWN

Start with a primarily light neutral palette and layer in soft color.

Play up the texture in the space by highlighting the architecture.

Select a luxurious statement piece to keep a more sparse space warm.

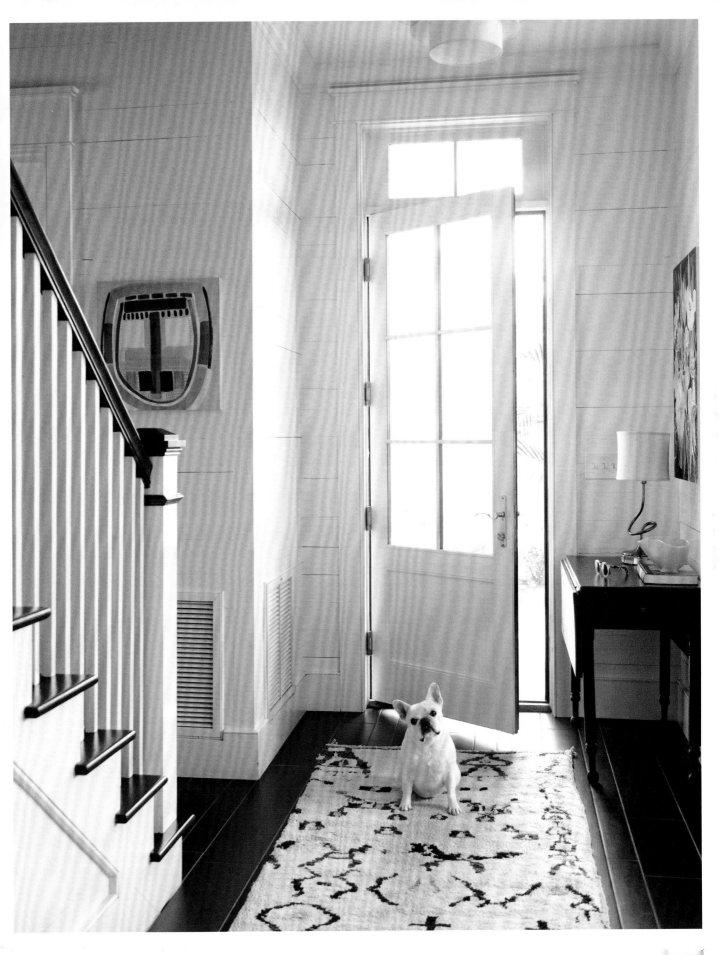

DEFINING THE FLOW

Showing you care and consider the details is another way to welcome. A visually pleasing space is easy to understand and use; pattern is your tool for achieving this.

A way to create thoughtfulness is through consistency in your design choices. Jenny Keenan, a Charleston interior designer known for creating spaces that feel collected and unique, is an expert at this. She designed a Sullivan's Island, South Carolina, beach home for NYC-based clients looking for a cool coastal retreat that's relaxed but refined.

One of the things that makes this space feel especially welcoming is that *all* of the surfaces are considered. Jenny chose to paint an overscale diamond pattern on the floor in a neutral shade. The floor is a great place for a special detail in a small space like this. The diamond shape becomes a directional element as well as a theme she uses to tie together the rest of the area on a more technical level. As you explore, you'll see diamonds in the rattan chair patterning, the tie-dyed chair seat, the front of the dresser, and even more abstractly in the ceiling lamp. Repeating small details builds consistency and comfort.

The same thoughtfulness extends to the hallway. The front space has hints of blue, which then expand into the hallway that leads into the home. Several patterned rugs form a pathway, accentuating the zigzag floor plan, and direct and encourage you to enter the rest of the house. The blue rugs create a focal point, surrounded and supported by neutrals.

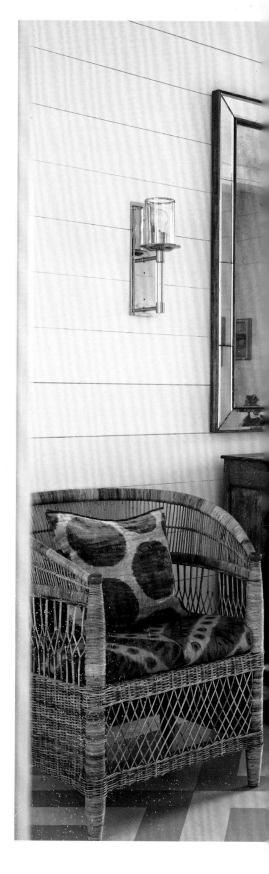

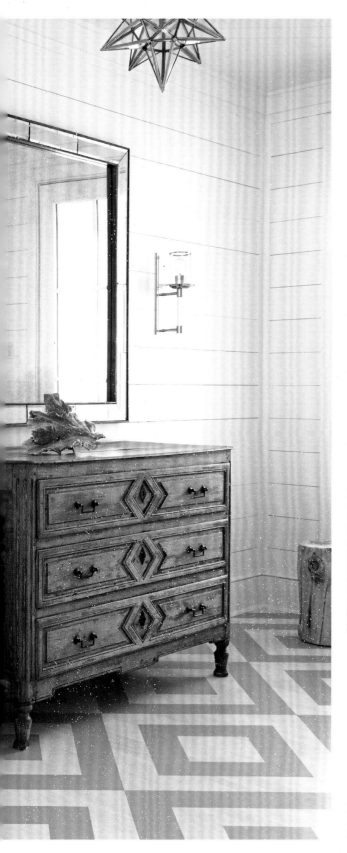

The tie-dyed seat is a nice update to classic rattan and feels relevant for a beach home. Changing the fabric seat on a chair is an easy way to add your own story to a more traditional piece. Learn how to simply reupholster a chair seat with the instructions on page 277.

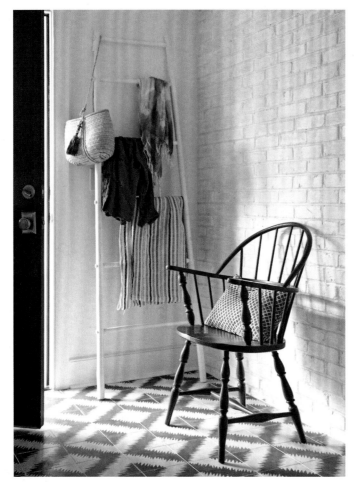

STORAGE SOLUTIONS

*Since entryways are where we tend
to dump all of our stuff when we
get home, spend some time finding
baskets, containers, magazine
racks, trays, bowls, and hooks
for storage. A ladder is another
unexpected way to display and
store items; it lets the patterning
of your hanging scarves and
accessories tell your story. Such
accents are a great way to sneak
in a little pattern and showcase
unique pieces.*

MAKE IT
YOUR
OWN

Consider all surfaces, especially
flooring, as an opportunity for
expressiveness.

Keep the majority of the space neutral,
and highlight areas of purpose with
pattern.

Repeat pattern concepts visually
through textiles, textures, furniture,
and three-dimensional forms.

Keep your color palette consistent
in spaces that connect.

While we typically think of an entryway as the area just inside the front door, the area immediately outside the door is also part of that experience. You can extend your thoughtfulness to this area as a taste of what your design plans are on the other side. Chassity Evans is a blogger, mother of two, and design lover who introduces us to her design palette on her front porch. She is drawn to graphic patterns; bold, happy colors; and clean lines that reflect her upbeat disposition. A vibrant coral door and black slatted chair hint at what's to come. She quickly identifies her palette and the graphic nature of her pattern choices.

Inside, Chassity continues her palette, but the spotlight is the patterned tile flooring. It's a unique and luxurious look that, because it's durable, is also practical for her family's lifestyle.

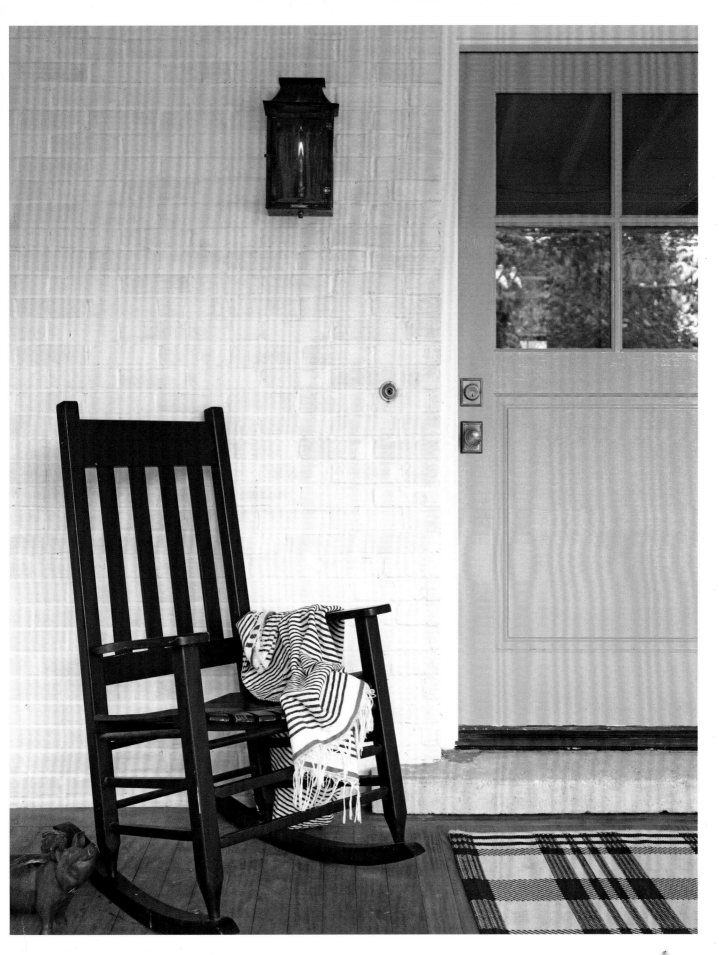

THE
LIVING ROOM

W HILE PATTERN can be unexpected in an entryway and a great way to intro-
duce your story, it can be unwieldy in the living room—but the opportunity
here is to tell your story in a bigger, fuller way and to let it shine. You have
more room to explore and play in. Together we'll review the steps to successfully layering
your story in this space.

First, define the mood and vibe. Go back to the mood board you created (see page 20),
or take the time to make one now. Identify the energy that makes you feel best. Think about
specific places, feelings, and moments in time that can guide you. The living room should be
about your interests on the broadest level, making them understandable for those who visit
and adaptable enough to change with time. It's also essential to look around the space you
have. Chances are you've already begun to build your base. After reading through this chap-
ter, you may feel inspired to buy a new piece or two, but think about what you can achieve
simply by rearranging the furniture and belongings you already own.

Adaptability is key here. My mom always was—and still is—moving the furniture
around to try out different combinations. I'd come home from school and find that she had
switched the orientation of the room away from the television by moving the armchairs in
expectation of a family gathering. She'd then ask for my help to scoot a sofa over to just the
right spot. She said her mother did the same, and I do it now, too. Of all the spaces in your
home, the living room is probably the least static when it comes to furniture. Think of its
elements as puzzle pieces that can be rearranged for different circumstances. You'll always
be moving pieces around and trying out different configurations as your needs change and
guests arrive or depart, so you'll want to keep your patterns flexible, too.

Once you identify the base mood for your living room, it's time to add textiles and
accessories. Pattern here should be vibrant and have movement and emotion. Expressing
your interests and showing off your collections will support chitchat, heart-to-hearts, and
discussions of all sorts. You want to create a space that encourages interaction while also
allowing you to unwind. In this chapter we'll visit eleven homes that exemplify how pattern
can define a space, create conversation, and engage activity.

CREATE A FOUNDATION

Olivia Rae James is a Charleston-based photographer who shoots everything from weddings to food imagery. Originally from Nashville, Tennessee, she is a romantic at heart. All of her photos focus on people and basic human connection. At the time of this shoot, Olivia and her husband were new homeowners in the midst of a renovation and focusing their energy on creating an oasis.

Their living room became a small retreat away from the construction, even if just around the corner. It is the first place in the home they had really decorated, and while minimal in style and light on traditional pattern, it focuses on texture. A sisal rug, woven chairs, a striped slated coffee table, and abstract geometric patterns build a base for the palette. Keeping things minimal is a great way to highlight the lines and patterns made by the objects. Cozy and neutral, a space like this will grow with time, just like the happy couple in their new home.

GRAPHIC PATTERNS IN NEUTRAL HUES CAN ACT AS PRINTED TEXTURE TO BUILD YOUR FOUNDATION.

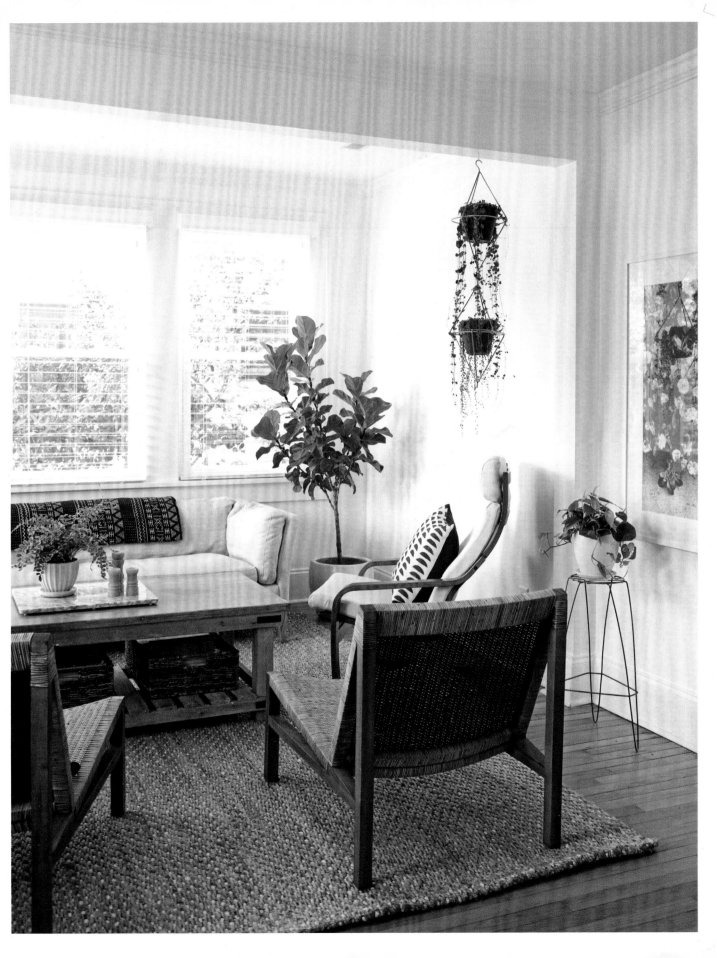

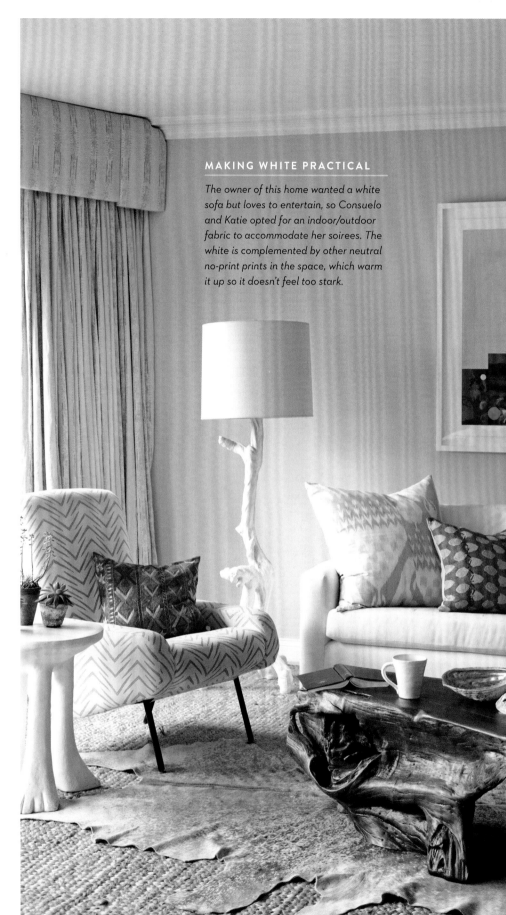

MAKING WHITE PRACTICAL

The owner of this home wanted a white sofa but loves to entertain, so Consuelo and Katie opted for an indoor/outdoor fabric to accommodate her soirees. The white is complemented by other neutral no-print prints in the space, which warm it up so it doesn't feel too stark.

Across the country in San Francisco is another space, designed by Consuelo Pierrepont and Katie Spalding of Sway Studio, that relies on the fundamentals of texture and subtle pattern to define it. The founders' philosophy focuses on intentionally layering elements that reflect the taste of their clients. They've worked with countless personalities and know the importance of building a base, which they can then translate to fit their clients' unique characters. Cohesive but diverse foundational elements define the seating area within a larger space. If your physical room includes a dining area, use fundamental patterned elements to split the purpose of the room. For example, a sisal rug—also in Olivia's home on page 95—is a workhorse in any room and an easy piece to layer further. Use a second rug, like the speckled hide here, to define a seating area. This pairing keeps the space elegant but practical, and urban but coastal—a perfect mix for Sway Studio's sophisticated but low-maintenance client who loves to entertain. Create additional textural interest with no-print prints, wood, polished stone, and woven fabrics. Define the mood further with another layer of pattern, which here mirrors the colors and shapes in the John Baldessari print.

Now, look at your own living room. Think about the existing foundation and what can be moved around to define the space for your needs, or whether there is an element that you can bring in to solidify it. You can use this base no matter what you want to do next, whether changing the mood to reflect a new outlook on life or just updating for the seasons.

MAKE IT
YOUR
OWN

Use a large neutral rug as your base and define the seating area by layering a smaller rug on top. Keep everything in place by putting a table on top of your layered rug.

Focus on texture. Look for woven chairs, baskets, textured woven fabrics, wood, and stone.

Remember that linear elements, such as the legs of a plant stand, can become pattern, too.

Keep fabric patterns simple and graphic to maintain the focus on the foundation.

DEFINE

Since the living room is one of the most multipurpose areas of your home, defining the space is essential, and it goes beyond the foundation. You may need to outline the living room in an open-concept plan, or you may simply want to mark out areas within the space for different activities, such as reading, watching television, engaging in conversation, or playing games. Pattern can do that for you by building on the foundation, unifying the space through repetition, or separating it through foils, which we'll get into on page 103. I'll take you through several rooms that wield pattern strategically and intentionally to achieve definition.

WINDOW TREATMENTS

Depending on the space and type, window treatments can take a lot of pattern. Fabric blinds are a clean, tailored look that can finish off a room. If you have a lot of windows and high ceilings, consider choosing patterned drapes. Hang them high and let them pool a bit on the floor—this look oozes luxury. If drapes feel too romantic, consider pleated, honeycomb, wood, roman, vertical, or other woven blinds, thinking about how these textures and colors will accent your space.

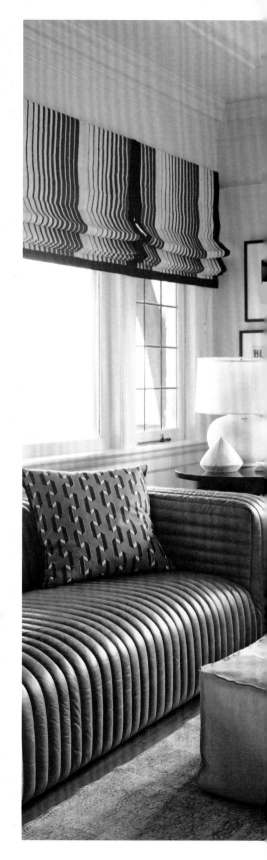

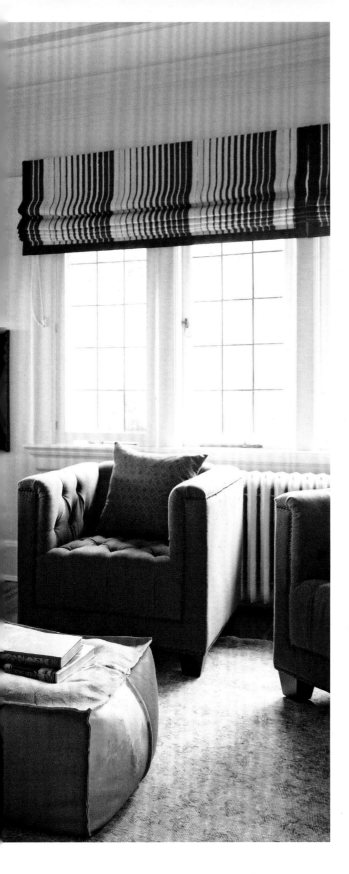

REPETITION

Pattern can help unite more sprawling spaces or make smaller areas feel more deliberate through repetition. Here we'll look at two spaces that rely on repetition to create a cohesive space. Use this tool when you have one object, piece of furniture, or design concept that you know you love—build on it to make a room.

Brian Paquette is a Seattle-based interior designer whose work is thoughtful, collected, and authentic. He often uses repetition to make his spaces instantly feel established and lived in. It's important to look for different elements that work thematically to keep the room feeling unified without being monotonous; this space uses stripes. Most obviously, you'll see the graduated stripe blinds, followed by the tufting on the striped sofa, which encourage you to look for more. Then you start to pick up the legs on the side table, the metal radiator, and decorative striped pillow that verges on geometric. Hone in on one concept you love and really think about different ways of expressing it. It could be focusing on a simple design idea, like the stripe here. Or if you love plants and being surrounded by foliage, transform your living room into an indoor greenhouse! Bring in potted plants, of course, but also woven textures that speak to the underlying structure of the plants, and tangible patterns that abstractly reference greenery. You may opt for patterns with graphic, simple leaf shapes, similar to Matisse cutouts, or painterly abstract prints that mimic the sensation of light flickering through the trees. Do your research here and explore the possibilities. To keep a theme like this from feeling tiresome, it's important not only to make sure the ways you're expressing the idea are varied but also to break it up by bringing in a mix of other shapes, patterns, and textures. Brian uses both organic and geometric shapes to break up the strong vertical lines of the space.

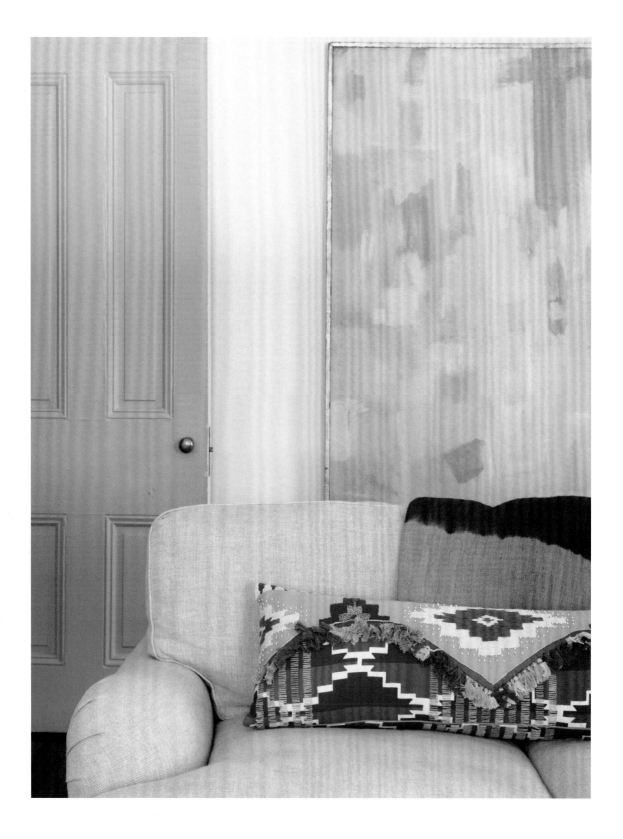

Wendy Wurtzburger Bentley and her husband Chris live in a beautiful, quirky old home in Philadelphia. Wendy previously worked for Anthropologie as head curator. Through that job she was able to travel the world, and her home is a reflection of those journeys. She has developed a keen sense of color, and interesting combinations are found throughout the house.

One of the most striking spaces is Wendy's second-floor living room. The room sings when you walk in—and pattern is a big part of that. Wendy relies on repetition here, though it's not as obvious as in the living room Brian designed on page 99. Let's break it down so you can re-create this magic in your own way, in your own home.

While many of the pieces could have been the root of this room, I believe the yellow painting, a piece by Wendy's aunt, must have been the start of it all. Wendy hung it next to the yellow door, creating an abstract diptych as a focal point. The long brush marks in the art speak to irregular rectangular shapes, emphasized by the rectangular shape of the work itself and the door. Just like that, a visual conversation of rectangular repetition has begun. The soft abstract shapes in the painting reference the patterning in the layered rugs, duplicating the concept. Even the furniture placement plays on this idea with the emphasis on rectangular forms. Wendy also repeats key colors from the painting and the door in the pillow, throw, and rug, which tie it all together. Without the unique and tight color palette, the connections wouldn't be apparent. Ultimately, this room is a very intentional exemplification of Wendy's story—a family heirloom and the pieces from her travels are united through pattern.

The key to making something striking is using it with intention. My first year in college, my drawing teacher told us, "You can do anything if it's intentional." It was a simple but groundbreaking concept to me. Think about it. If you really believe in what you're doing, and do it carefully and thoughtfully, anything works. Every object, color, line, and shape you place is a choice. You have to start somewhere, and I suggest really studying the things you already own. Understanding your pieces is the first part of combining them well. Get to know them again. Pick one piece you love the most and figure out what's going on: the overarching design period or style it fits into, the specific colors, the materials, and the shape. Then build on that. What else do you already own that can help build that story? Search for pieces that will complement it if you don't own any.

MAKE IT
YOUR
OWN

Study the objects you own and love. Figure out what theme you can build around them.

Find at least three ways to express your design theme, but keep the reiterations abstract to avoid monotony.

Translate a pattern you love in a three-dimensional format. Remember, you can position objects so they act abstractly as pattern.

Keep repetition fresh by offsetting it with other shapes, patterns, and textures.

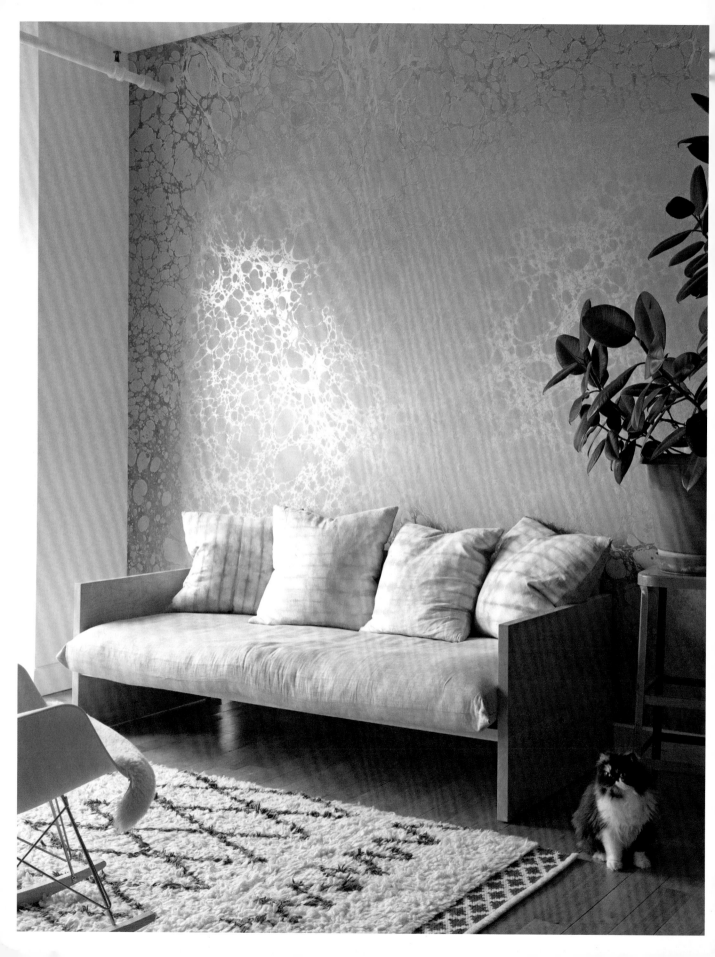

DUALITY

Duality is the division of a concept into two contrasted aspects. A foil is a narrative element in which two characters play off each other, contrasting each other, to highlight qualities and intricacies of their personality—it is a type of duality. This same concept can be translated to pattern and design to define and further explain the various stories and interests in your own life. You have many roles within your life, and they make your story. Maybe you want to explore different aspects of your day-to-day life through foils, or different aspects of what you're visually drawn to. Patterns can represent different parts of you, such as being a mother and a designer, and they also can represent different visual interests from a purely aesthetic point of view.

Nick and Rachel Cope are the creative duo behind the brand Calico Wallpaper, where they focus on techniques such as marbling. Living and working in Red Hook, a neighborhood in Brooklyn, their family includes a calico Persian cat, from whom the brand takes its name, and a beautiful daughter.

When Nick and Rachel's daughter was born, their needs changed, and they wanted the living room to function as both a lounge space and a play space. They've explored duality through two wallpapers—both featuring large-scale marble designs with metallic accents, but one is light and airy and the other is dark and moody. They are foils to each other and highlight their differences. The dark design evokes a sense of staring off a dock into water reflecting a star-filled night sky; this seating area is for lounge time—perfect for an afternoon nap or time together when their daughter is sleeping. Directly across the room from this dark seating area is a soft cloud-like space, once again defined by the wallpaper. Here they've used their wallpaper with metallic gold and soft gray-blue coloring, which feels like the sun streaming through the clouds after a storm. Comfy with a soft shag rug on the floor, this space is meant for playtime. Nick and Rachel separate and connect these two worlds through pattern—their adult designer selves and their life as new parents.

When you use foils like these, they must speak to each other and coexist in order to work. There has to be a connection. Nick and Rachel's space works so easily because, although the patterns themselves are opposites in coloring, both are marbleized. You can use different colorways of the same pattern like this, or just explore the general concept of night and day by simply focusing on the dark and light.

MAKE IT *YOUR OWN*

Go big with dual patterns to help define the space. This will create separation, but the room will still be united through a common theme.

Choose pattern that resonates with the mood of the activities you plan to do in the space.

If you choose smaller-scale patterns to express duality, be sure they are close enough in proximity for your eye to make the connection.

PATTERN CAN BE PRACTICAL, NOT JUST DECORATIVE!

If they wanted to put the television over the credenza, the wallpaper would also be a great way to camouflage it.

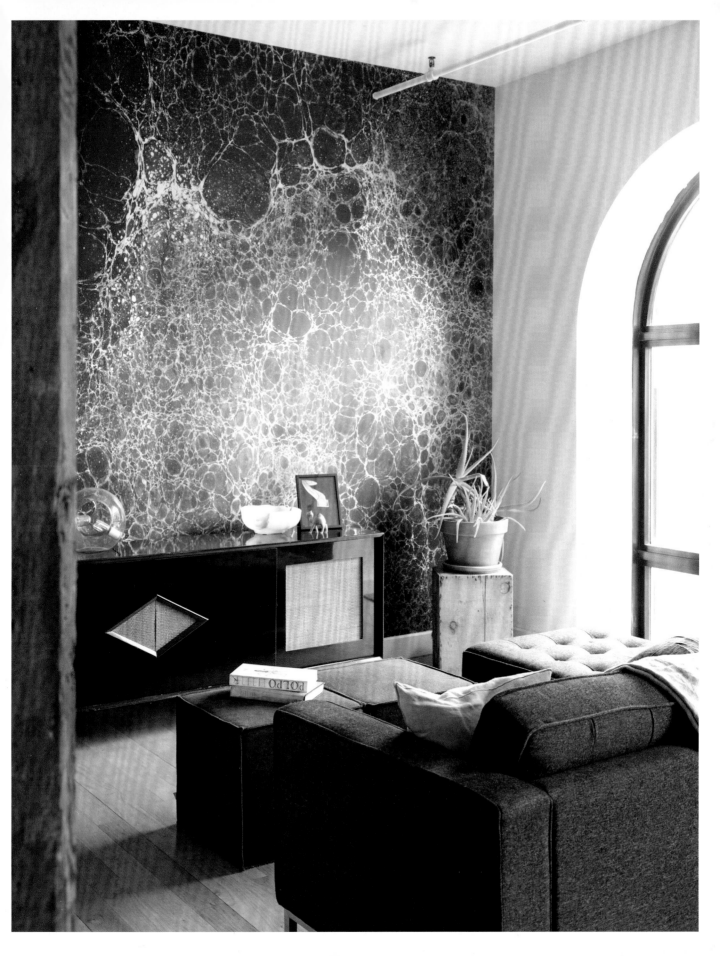

CREATE A CONVERSATION

Beyond the practical needs of defining a space, pattern can more important spark conversation and activity with those who use a space as well as the design elements within the room. Let's look at how to use pattern more abstractly in the living space.

CREATE A MOOD

Creating a mood is about building on your foundation and putting forth an atmosphere that expresses the tone you want to encourage within a space. I urge you to look at other rooms in this book that you're personally drawn to and analyze the mood. Let's look at two living spaces that share very different and distinct moods. Both of these areas build the mood with a focus on color, but pattern is also an important player.

Brian Paquette designed this moody bachelor lounge. Located in Victoria, British Columbia, this home has many spots made for cozy indoor days. This space feels like the perfect place to lounge and have fireside chats or read a good book, a feeling achieved through the room's visual mood. Color, texture, and pattern all create this vibe by conversing to tell a story—one that is masculine and rich, and speaks to the period of the home while remaining modern. Brian uses a rich color palette of dark neutrals, including a deep satin brown, charcoal black, steel blue, and ruby, to make the space dramatic. Texture comes in through wood, tile, marble, and nature-inspired prints that feel earthy but sophisticated when paired with leather, tufting, and tailored silhouettes reminiscent of an old library. The pattern is the final layer in creating the mood. Brian plays on tradition but keeps the mix modern with his pattern choices.

An abstract marble pattern that references sedimentary layers but remains graphic is used on the curtains and a pillow. It is paired with a crisp geometric, which plays off the more traditional geometric in the rug to keep it fresh.

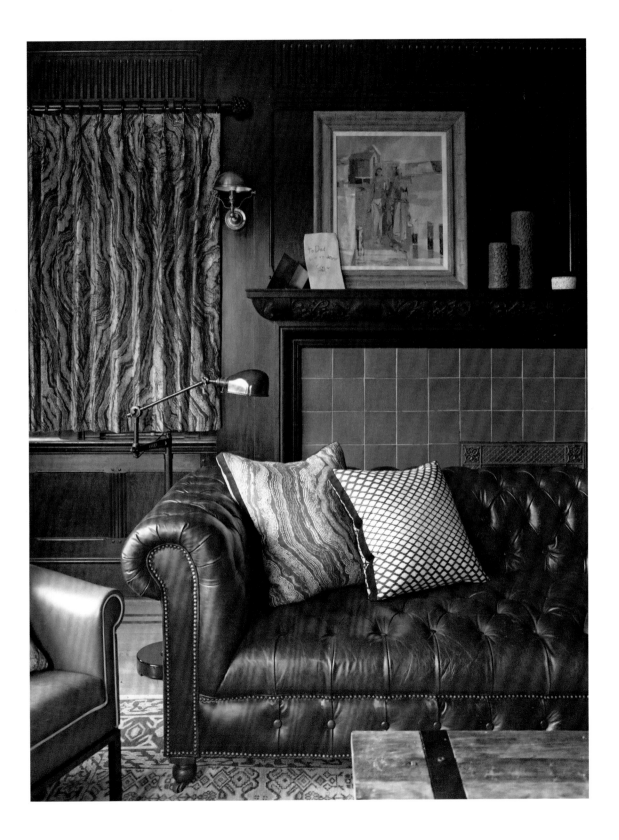

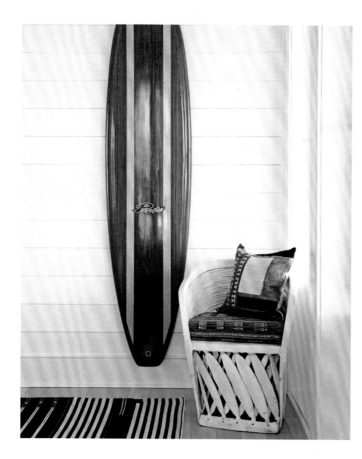

MAKE IT
*YOUR
OWN*

Build the mood with color and then refine it with patterns that have a distinct point of view.

Classic, neutral furniture works as a backdrop in most rooms, and pattern focuses the mood in keeping with your personal aesthetic.

Pick patterns that speak to activities and interests that make you feel good.

Enhance the mood with one statement piece.

This space is completely different, but it's perfect for Jenny Keenan's New York City clients' beach retreat in Sullivan's Island, South Carolina. Their home in New York is serene and muted to contrast with the city, so here they wanted to play with color and accentuate family fun.

Jenny relied on a neutral textural palette with pops of cerulean blue and electric yellow to achieve a seaside vibe. She chose patterns that have a loose coastal feeling to keep the mood easygoing in this second home. While color lays the groundwork for the mood, pattern creates specificity and emphasizes that this space is a beach home. Batik prints provide a breezy energy, and the texture in the artwork acts as an abstract pattern. Playful pieces encourage gathering—a seating area is centered on a striped table made from the same materials as a surfboard. The sporty, vibrant stripe contrasts with the more sophisticated linens and vintage batik prints, creating a mix that feels sophisticated metropolitan and fun coastal all at once.

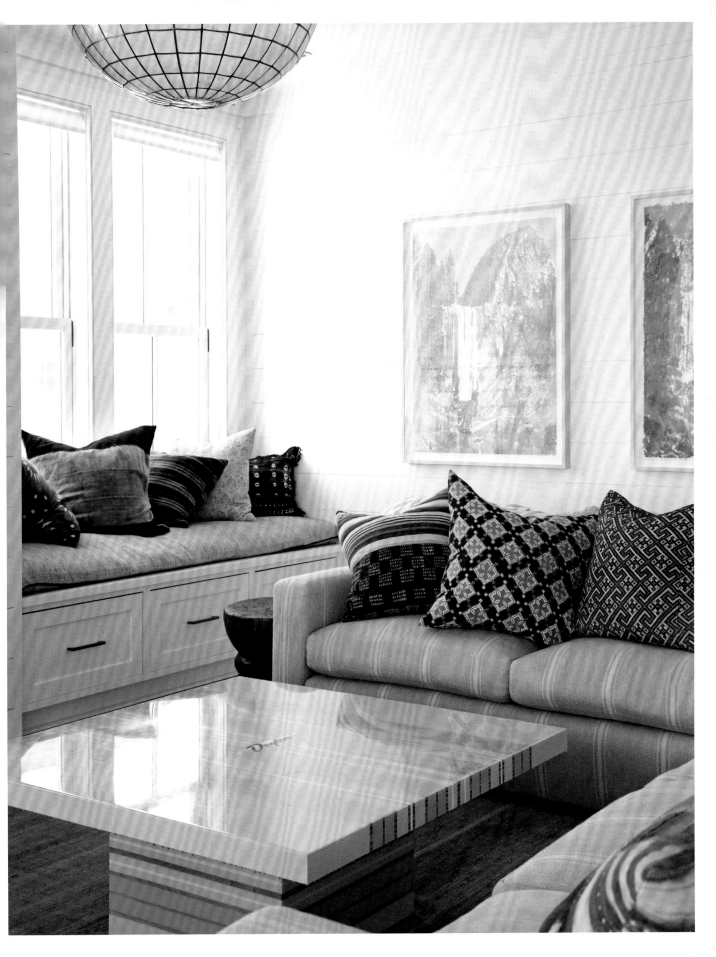

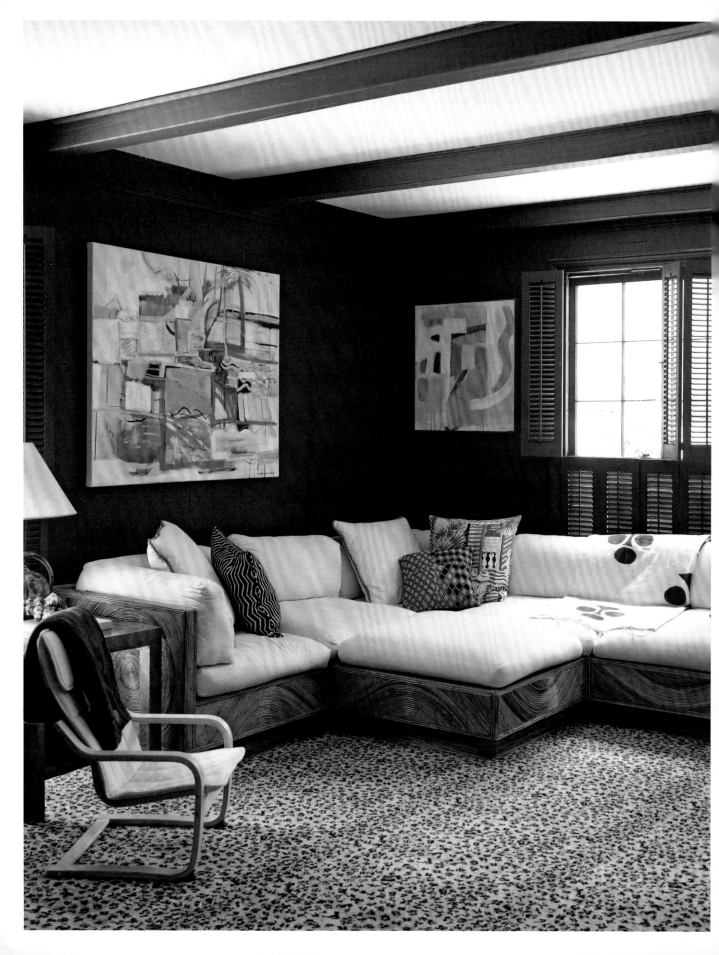

DISCUSS YOUR INTERESTS

A truly genuine person, Sally King Benedict is open and vibrant and has impeccable taste because she bravely displays her interests, gets particular with them, and structures them in the context of what's needed. While expression of interests is important, Sally knows that, for her family, it must also be married with comfort so that their house is a place they can truly live. With a young son, Sally believes keeping it comfy is important in all areas of the home but especially in their lounge-like living room. She does this with ease by delving into the specifics of what matters to her.

Danish modern, British colonial/West Indies plantation, safari style, Southwestern Americana, surfer style, and vintage campy all appeal to her, and she figures out how to make them work together. She loves bringing home the styles of places she wants to visit or memories from her childhood.

How can all these interests speak to one another? Here Sally has brought safari style to life with a textural leopard rug—it's a bit of luxury that references one of her dream vacations, but it's also soft and perfect for playtime. The L-shaped rattan sofa is comfy and practical but also speaks to Sally's surfer style. The conversation between the sofa and rug express different interests, but they have comfort and practicality in common. The sofa introduces an opportunity to add more personal elements and has been speckled with pillows in fabrics ranging from Kuba cloths to a vintage Collier Campbell print called Côte d'Azur. An African textile with a bold geometric print provides a larger-scale motif that draws us in. Dark walls accentuate her bright, cheerful paintings but keep the mood sophisticated in a way that white walls wouldn't.

MAKE IT
YOUR
OWN

Identify different periods and styles that intrigue you and pair them for a unique mix. Be sure the pieces can sustain a conversation with one another.

Choose interests that aesthetically feel more casual for pieces that should be more comfy, such as seating. Alternatively, choose more refined or lavish interests for decorative pieces.

Scatter different styles around the room through textiles and art; they're much easier to change.

"REBECCA AND I TRY TO DECORATE IN HARMONY AS MUCH AS POSSIBLE. WE HAVE A PACT TO 'SLOW DECORATE.' IT HAPPENS OVER TIME, COINCIDING WITH TRAVEL AND DISCOVERY."

— Wayne Pate

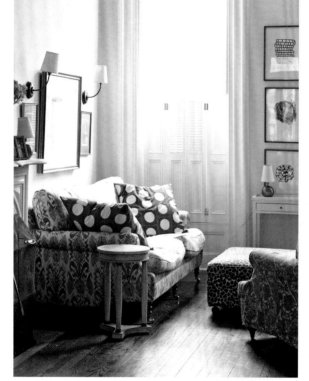

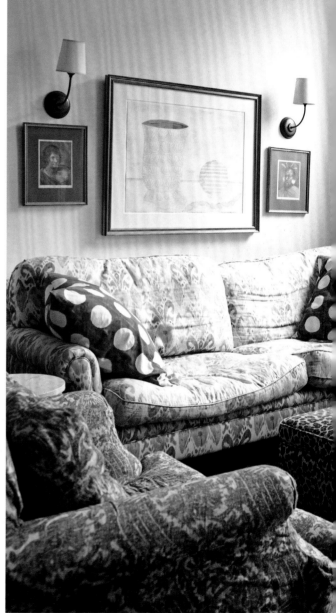

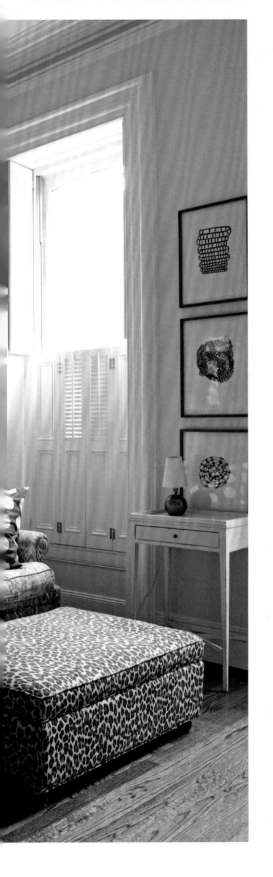

LET YOUR PATTERNS SPEAK

Creating dialogue between the physical pieces in your room also encourages conversation among people. Think of each pattern as a group of friends, since you're essentially creating a space meant for enjoying time with your guests and family. Each pattern should be unique, but all should relate, support one another, and work well together.

Wayne Pate and Rebecca Taylor are a creative couple with three kids living in Park Slope, Brooklyn. Wayne is an illustrator known for his graphic, whimsical drawing style; Rebecca is a well-known fashion designer admired for her feminine yet modern look. It's only natural that they would decorate in collaboration. They've created a home that's classic but still free and full of idiosyncrasies.

Their living room truly shows a conversation between the pieces, each with its own unique identity. Wayne and Rebecca have collected items over time and move them around to encourage the conversation and keep it fresh. The bones of the space are traditional, and so are many of the lighting fixtures, but the fabrics on the furniture soften the look and keep the balance casual and refined, just like the couple.

One sofa is covered in a beautiful ikat fabric; the sofa cushions have become worn and washed, and the pattern is faded. The fabric is even more beautiful because it's clearly been lived with and loved. Pillows with big dots on an indigo ground are layered on the sofa. The large-scale of the dot pattern emphasizes its playfulness but also means the pattern doesn't compete with the others in the room. In this same clustering of furniture, you'll see a blue batik-inspired fabric and a leopard print. The batik relates to the ikat in several ways: it has a built-in distressed look; it pulls from the same color palette; it is a no-print print; and they share roots in their history as patterns. The leopard print on the ottoman could feel unrelated, but it is printed on a natural linen fabric, which makes it feel more casual, putting it at ease with these more relaxed fabrics. Mixing casual pieces with dressy is a great way to achieve balance, much like you'd do with your wardrobe.

FAVORITE PATTERN

*Wayne's favorite pattern is a
French indigo flamme ikat from the
eighteenth or nineteenth century,
seen on the side table.*

9 MAI · 8 JUIN 1962

VIN

HOMMAGE A
MARCOUSSIS
GALERIE KRIEGEL
36 AVENUE MATIGNON · PARIS VIII

PARIS
ET SES ENVIR

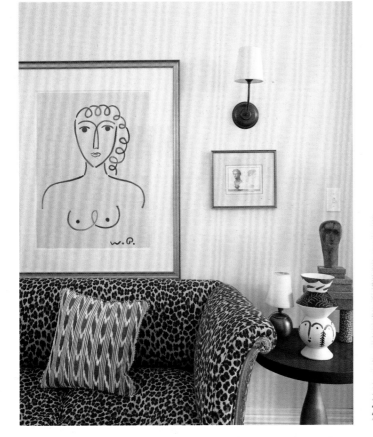

BREAK IT UP

Within this living room there are several seating areas. A leopard-print sofa, in the same fabric as the ottoman, is actually in the back of the room. Breaking up sets is a great way to tie the whole room together visually while keeping it from feeling too stuffy or perfect.

Relating unique patterns takes practice, but it comes down to a few things: a united color palette, a similar physical scale, and the more abstract balance of defining the mood through particular pairings.

Artwork is another place where conversation can take center stage. Displaying art shouldn't be static—use it to share your interests and curate the ever-changing dialogue between pieces that matter to you. Wayne is constantly moving around the artwork in their home. They have a large map of Paris hanging in the living room, but he had grown tired of looking at it so he decided to tape some other artwork over it. This approach to display—as a way of exploring visual relationships and discovering new things—is a great reminder not to treat items too preciously. You should live with them, interact with them, and enjoy them.

MAKE IT
YOUR
OWN

Think of patterns in a room as friends or family.

Use the same print in different places around the room.

Pick fabrics that get better with age, like linen.

Drape smaller textiles over surfaces to play without commitment.

Move your artwork around to explore different relationships.

LIVE YOUR STORY WITH PATTERN

Your living room is a place not just for conversation but also for activity and engagement—a place to live your story in real time. You can show where you've been and what's happening now by keeping your décor energetic.

Kate Loudoun-Shand is a creative director living in Brooklyn, New York, with her husband and three children. The family moved into their Bedford-Stuyvesant brownstone about two years ago, and while they did renovate, their home is still evolving as they get settled; one could argue that in a designer's home, nothing is ever truly done. While Kate's story begins with her childhood in the United Kingdom and design-career travels to India and the United States, it's also defined by her role as a mother. Motion is a constant with three young children, so this home is all about adaptability. Everything is in a state of flux, and design ideas are tested without the pressure of perfection.

Although the white couch may seem impractical with small children, it is soft, worn in, and ever changing. Nothing can be too precious with three kids jumping around—one of whom, perhaps making a design decision of her own, embellished the sofa with a ballpoint pen. Kate responded by laying down an extra textile on the cushion to cover the mark. The landscape of the cushions is constantly changing as the kids bring them onto the floor to play. Find a way to make it work by embracing the imperfections that will come.

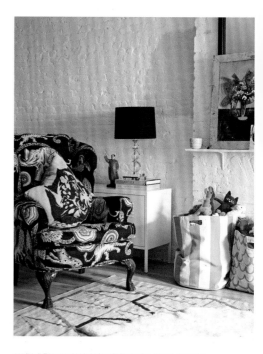

SPOTTING SPOTS

Pom-poms in the corner, hanging from the curtain rod, add a playful moment and are a nice complement to the long polka-dot pillow on the couch, as these shapes echo each other.

Kate has repurposed an old sheet as a curtain in her living room. Never discount using a fabric for something other than its original intention. A sheet can be a curtain, a woven Turkish towel can be a throw, a tablecloth can be put on a bed, and so on.

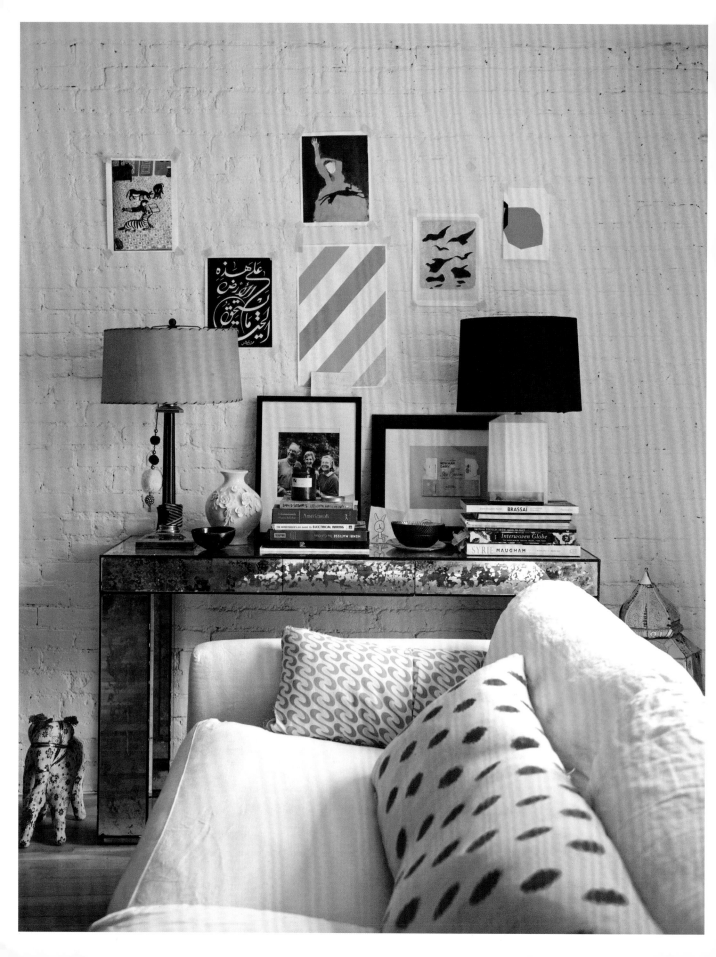

"HOW PATTERNS WORK TOGETHER IS KIND OF LIKE A FAMILY—WHO IS THE LOUDEST AND WANTS TO DROWN EVERYONE OUT, WHO IS THE GLUE THAT HOLDS IT ALL TOGETHER, WHO IS SUBTLE BUT VERY POWERFUL."

—Kate Loudoun-Shand

MAKE IT *YOUR OWN*

- Pair bold pattern with bold color instead of a matching set.

- Repurpose fabrics and objects for new needs.

- Create an informal inspiration board as artwork.

- Adorn your décor with unexpected personal accents.

- Let design choices happen naturally.

While a sofa is a larger piece that is less intimidating to buy in a solid, armchairs are an easier place to consider pattern. Kate chose a mismatched pair, a practical choice, as they can be moved around to suit the family's needs. While one is a bold, quirky pattern with elephants on it—a nod to her love of India—the other is a solid red. A bold pattern can hold its own against a bold color. In this case, if both chairs had been reupholstered in this unique patterned fabric, it wouldn't have felt as special. Chairs are often pulled into the living room from the connecting dining space as well. An extra multipurpose chair comes in handy, and can also be an opportunity for pattern. You can weave your own chair seat with the instructions on page 244.

Laser printouts are attached to the wall with masking tape as the family continues to settle in, but I love how these have become a fluid informal place to display inspiration. Temporarily hanging artwork, printouts, wrapping paper, fabrics, and other visually interesting objects is a great way to test out what you like.

You can easily change other décor elements, such as your lamp, by adding a little embellishment. One of Kate's children snapped a plastic bracelet around the base of a lamp, and Kate hung pom-poms from its switch. Taking an extra moment to adorn an object allows you not only to change the feeling with time but also to customize something more basic. Consider wrapping jewelry, ribbons, or tassels around a knob, lamp, or curtain rod for a quirky touch.

KEEP IT FLEXIBLE

A 12 x 16-inch (30.5 x 40.5cm) pillow is a great size for a chair as it's small enough for someone to sit with, whereas a large pillow may be too big when a guest uses the chair. If you have pillows that need to be moved when someone comes to visit, consider a cute storage basket nearby.

BALANCE YOUR STORY

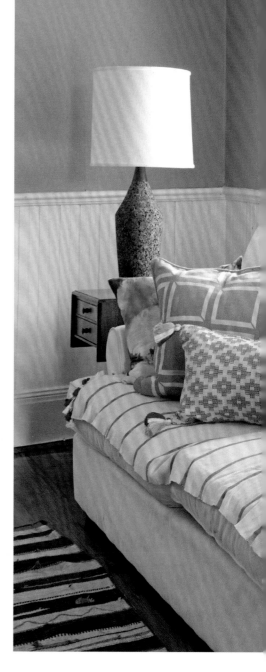

HOME /

CALM WARM HUES

The wall color of soft clay verging on mauve is a great example of how warm colors can be calm. Often we think of them as more exciting, but it really comes down to that subtle mix of hue, value, and intensity.

If making constant design decisions isn't your style, consider a more balanced approach. Harper Poe is the creative force behind Proud Mary, a line of ethically made home and apparel items with an ethnic, modern, and simple style. About ten years ago, Harper quit her job in New York City and went to South America with Habitat for Humanity. When she returned, she was so inspired by the people and textiles there that she decided to start her own line rooted in "pride not pity" for the artisans who make her items.

She and her partner Constantine rent a second-floor apartment on the peninsula of Charleston, South Carolina, and have made it a cozy and eclectic space. Wanderlust is in her heart, and her home is a visual diary of her collected travels. Harper has lived all over the world, but she grew up in the South, so her roots are there. She's been given many traditional family pieces and loves to mix colorful textiles, random folk art, and crafts to balance them out. In the living room sits a pink armchair with a small-scale feather print that belonged to her mother. Harper has thought of reupholstering it many times, as it's not something she would have chosen for herself. In another setting it could be all wrong, but combined with her blanket from Lesotho, it is part of a mix. Harper loves to share the story of the herder boys who make these blankets, gathering the wool and uniquely embroidering each one. She bought this one from a boy in the capital city of Maseru.

When Harper travels, she is not looking for souvenirs; instead she becomes invested in the place she visits. Knowing the story behind the pieces she brings home gives them weight and importance that are then translated into how she displays them.

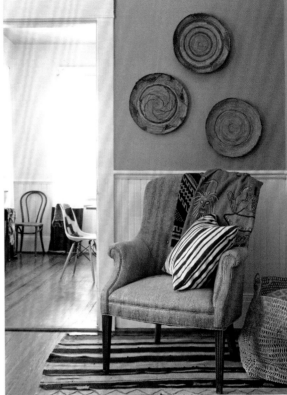

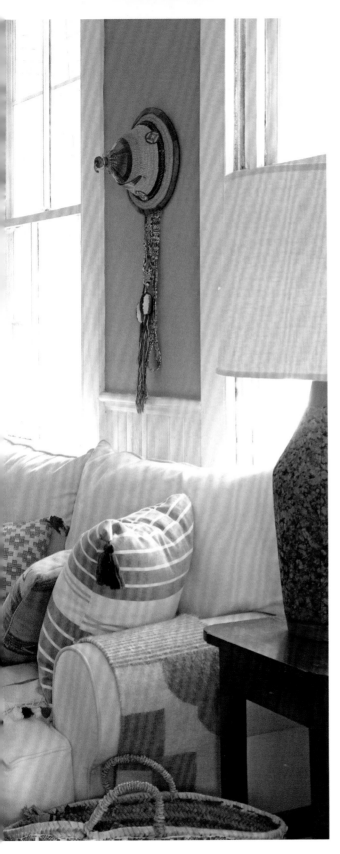

MAKE IT
YOUR
OWN

Every piece you truly love, even
if it's quirky, can somehow be used
in your home.

Look for a connection between
pieces that outwardly don't seem
to go together.

Search for one of-a-kind pieces.

Learn what makes a place unique.

Temper hand-me-downs with
patterns that speak to you.

STYLE IT | THE SOFA

et's take a moment to get specific and look at some
of the key pieces that will make your living room shine.
Generally every living room has a sofa. Most often it's a
solid color, making it a perfect focal point to start building
on your story through pattern, using pillows and throws.
Focusing on one piece is achievable and can give you other
ideas for the rest of the room.

TAKE IT FURTHER

*If you find a patterned fabric you're
crazy about, consider covering an
assortment of different-size pillows
in it for impact. It's a notch up from
a tonal textured-pattern look, but
more clean and modern than a
heavy pattern-mixing concept.*

PATTERN LIGHT

Think about pattern as adding texture and subtle tonal interest. Here the long, narrow pillow across the middle of the couch makes an unexpected layout, which breaks up the quiet monochrome. Think about proportions as a form of pattern, too. A round bolster works in the same way.

TWO 22 X 22-INCH (56 X 56CM) PILLOWS WITH ONE LONGER OR UNIQUE PILLOW IN THE MIDDLE

TWO 24 X 24-INCH (61 X 61CM) PILLOWS WITH ONE 16 X 20-INCH (40.5 X 51CM) PILLOW AND ONE 18 X 18-INCH (45.5 X 45.5CM) PILLOW IN FRONT

TWO 24 X 24-INCH (61 X 61CM) PILLOWS WITH TWO 18 X 18-INCH (45.5 X 45.5CM) PILLOWS IN FRONT

TWO 24 X 24-INCH (61 X 61CM) PILLOWS WITH TWO 16 X 20-INCH (40.5 X 51CM) PILLOWS IN FRONT

TWO 22 X 22-INCH (56 X 56CM) PILLOWS WITH TWO 16 X 16-INCH (40.5 X 40.5CM) PILLOWS IN FRONT

ONE 24 X 24-INCH (61 X 61CM) PILLOW PAIRED WITH ONE 16 X 16-INCH (40.5 X 40.5CM) PILLOW ON ONE SIDE OF THE COUCH AND ONE LARGER 20 X 20-INCH (51 X 51CM) PILLOW ON THE OTHER SIDE

PILLOW PROPORTIONS

Decorative pillows and throws are a great way to add pattern and change the feeling of a room without much investment of time and finances. First consider the size of your couch. A standard sofa is typically 6 to 8 feet (1.8 to 2.4m) long, which is what we're working with in these looks. Three to six pillows is generally a good number; more than that isn't practical. With the couch I'm styling, there are no back cushions, so we went with five pillows to make it comfier. If you have an extended or L-shaped couch, you'll have more room to play with and can use more than six pillows, depending on the size of the sofa.

Pairs of pillows give a more traditional look, whereas an odd number feels a bit more modern. Oversize cushions around 24 to 26 inches (61 to 66cm) square seem more casual; I love using them as floor cushions in a pinch! A few larger pillows look cleaner and more impactful than a bigger assortment of smaller pillows. If your couch is deeper, you can go with larger pillows; if it's longer you can have more pillows, as you'll be seating more people. I suggest testing out some different pillow sizes to see what works. Consider bringing your standard and Euro sham pillows from the bedroom into the living room just to see what they look like before buying anything.

PATTERN MEDIUM

To build on this patterning, let's look at mixing patterns with a refined neutral palette elevated by the addition of a few varying shades of blue verging on green. All of the pillows here are different, but they maintain a unifying thread of color, which ties this look together. The patterns include small and graphic, vintage indigo, loose paint splatters, modern floral, and a classic stripe. Thematically, there's a reference to a soft coastal scene, but that's coming primarily from the color palette. By limiting color, you really can mix just about anything you want and it will look pretty fantastic. Remember to mix up the scale and types of patterns.

PATTERN HEAVY

For a full-on pattern-mix version, we're expanding the color palette and playing up the use of a throw. I've covered the back of the sofa with a vintage kantha quilt, and the seat of the sofa with a Moroccan rug. The kantha quilt becomes the basis for the color palette; the rest of the pieces take cues from its multicolored scheme, pulling out the gray, soft blue, and faded coral. The triangle pattern is the next step. The large scale contrasts nicely against the intricate print on the kantha quilt and provides a visual break, allowing smaller scale patterns to be layered in front without competing. The ikat and embroidered pillows complement each other and read similarly from a distance, but up close, each has its own personality.

STYLE IT — THE SOFA

THROW STYLE

Go bold by carefully tucking or draping a throw or larger textile on your couch. Throws can be used in a variety of ways, not only draped along the side of your couch (FIG. 1). *Cover the bottom sofa cushions and tuck in the fabric for a tailored patterned seat* (FIG. 2). *Alternatively, try draping the throw along the top of the sofa* (FIG. 3), *or consider placing it across the center of the couch from the top back down to the bottom of the seat* (FIG. 4). *This is a great way to get the look of an upholstered patterned piece without the commitment or expense. To achieve this look, keep the size and style of your sofa in mind. A tailored sofa will be easiest to style as you can tuck the throw cleanly; a heavier-weight throw will stay in place best.*

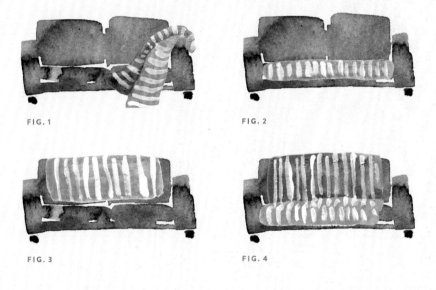

FIG. 1

FIG. 2

FIG. 3

FIG. 4

KNOW YOUR STUFF(ING)

Typically, pillow or cushion inserts should to be 2 inches (5cm) bigger than the cover size for a full look. When switching covers, be sure to measure the insert; don't just read the tag for the size. The fill makes a big difference with comfort, and it can be very subjective. Personally, I think down-feather blends are the most luxurious, but there are many other options on the market. Some hypoallergenic choices include fiberfill, recycled fiberfill, buckwheat, horsehair, and wool. Kapok has been seen more often recently as a natural option online, but it's highly flammable. Do your research and try to get your hands on the fill in person and test it first.

Rugs can pull together the living room. They define and shape it in a variety of ways. They can create separate areas within one space (see page 96 [Sway Studio living room]) or illuminate a path through a space (see page 89 [Jenny Keenan hallway]). Large rugs help unite a room by visually bringing together all of the elements, whereas using smaller rugs can divide or define a space (see page 101 [Wendy Wurtzburger Bentley living room]). Rugs, like artwork, can be the centerpiece of a room. They are also an investment; this is the place to look for something that you just can't stop thinking about.

COLOR AND SCALE IN RUGS

Color is also important to consider when choosing a pattern, especially one that will cover a large area like the floor. Lighter-colored rugs will open up the space, but they can be harder to keep clean. Darker rugs will feel cozy and rich. A mid tone is always a good option, as it's better for hiding dirt. Overall small- to medium-size patterns will also help hide dirt, pet hair, and stains, and thus can be more practical than solids.

Consider how much of your rug is going to be covered by furniture. If not much will show, consider a simpler pattern. If you have a good amount of area, a more intricate or large-scale pattern makes sense. Be sure to vary the scales of your accessories to play against the pattern size you use on the rug.

Your rug can be the basis for the room's color scheme. Pull out colors to use on your walls, accessories, and furniture to help everything feel cohesive. Focus on the subtle neutrals for the majority of colors in the room, then pick up on the accents with the accessories like pillows and lamps.

DESIGNER TIP

When it comes to picking the right size rug, take this advice from interior designer Caitlin Flemming: "Measure your space and sofa. My rule is that the rug should be at least a few inches larger than the sofa on both ends. But, if you fall in love with one that is too small, don't fret, you can always layer it. Also, it's important to be consistent: you either want all of your furniture on the rug or all of it off the rug. Pick one and stick with it!"

I've pulled together eight rug-layering looks from Studio Four NYC. My rule of thumb is to let your bottom rug be basic so the accent rug on top can have full impact.

HOME /

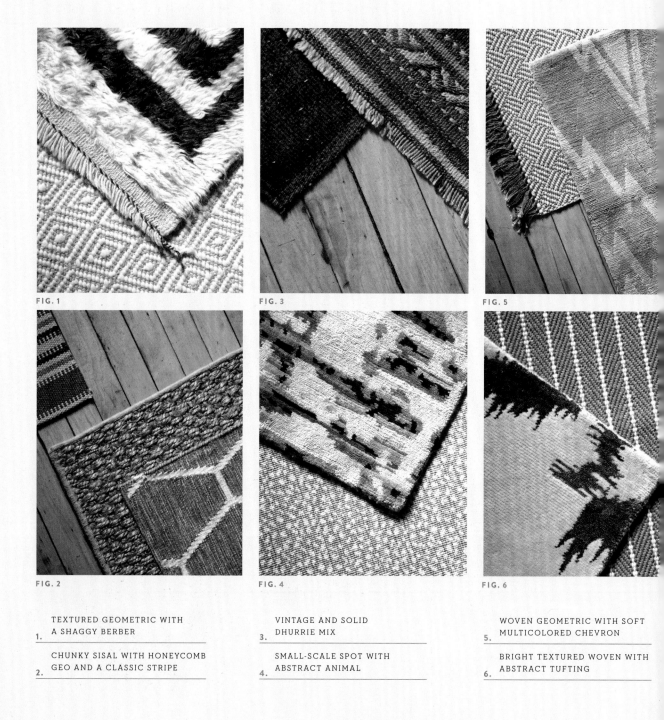

FIG. 1

FIG. 3

FIG. 5

FIG. 2

FIG. 4

FIG. 6

1. TEXTURED GEOMETRIC WITH A SHAGGY BERBER

2. CHUNKY SISAL WITH HONEYCOMB GEO AND A CLASSIC STRIPE

3. VINTAGE AND SOLID DHURRIE MIX

4. SMALL-SCALE SPOT WITH ABSTRACT ANIMAL

5. WOVEN GEOMETRIC WITH SOFT MULTICOLORED CHEVRON

6. BRIGHT TEXTURED WOVEN WITH ABSTRACT TUFTING

RUG MIXING AND LAYERING

When using multiple rugs, you want each to have its own personality, but they should all relate, much like when you play with pillow mixing (see page 124). Layering rugs is a great way to add different patterns and colors to make your floor really interesting. It's an eclectic look, but it can be made more traditional. For example, an Oriental rug on top of a sisal rug is a very classic combo. It's also a great way to save a little, as sisal rugs are less expensive than hand-knotted vintage finds. If you want something more relaxed, consider layering a flat-weave dhurrie under a cowhide rug. Test out different combinations and placements.

Try using two smaller rugs and layer them slightly offset so that they just overlap each other. This is a great way to get the look of a larger rug but allow for more contrast and customization. It can make one rug you've had for a while look new and give you flexibility to change things up. Here you'll just need to tap in to your pattern-mixing skills by choosing ones that sit together but don't compete.

If you have wall-to-wall carpet, you can still layer accent rugs in certain areas to define purpose, like a separate smaller seating area. Flat-weave rugs are nice for layering as they have a different texture than the tufted or looped construction you'll usually see in wall-to-wall carpet.

131

/ THE LIVING ROOM

7. STRIPE ON STRIPE

8. TINY CONTRASTING GEO WITH TONAL-PATTERNED DHURRIE

DINING
SPACES

COOKING AND dining as a family was an important part of my childhood and definitely shaped who I am today. A child of restaurateurs, as I grew older and worked as a food runner I realized what an artist my father was. Plating the food was a form of composition—the color, placement, and patterning created an appetizing art spread, ready to be eaten.

In the house, our nightly dinners had cloth napkins, heirloom silverware, and delicious home-cooked meals. Special occasions called for china, hand-painted with violets and gold, lace tablecloths, and embroidered napkins. My parents' restaurant is open most holidays, so Thanksgiving dinners happened late at night, with an assortment of friends and staff members joining our table. One year we made a big buffet and ate in the restaurant, rewarming the apple pie by the fire. No matter the occasion, my mom would always insist on matching placemats and napkins. Now in my own home, I can appreciate the significance of these little choices in making the mealtime special. When she brought out china, she wasn't just decorating the table, but she was also speaking to her heritage with these family pieces. While some people no longer opt for china, I love the romance of it. When my husband and I picked ours, I realized it symbolizes the significance of starting a life together and welcoming others to your home with your own aesthetic identity.

Ultimately the heart of any home is the dining spaces. It's embedded with daily memories, love, and joy. Whether it's an eat-in kitchen or a formal dining room, this is the place where we gather to celebrate the everyday as well as the special events. Community, sharing, and enjoyment are hallmarks here, too, so look to create a versatile environment that invites these gatherings. Setting the table gives you flexibility and opportunity to try new things and change the mood. The room's bigger picture should be versatile enough to accommodate all manner of events. Think of it as the place setting that holds your meal. Let loose a bit, as you'll constantly be changing it up.

SHOW YOUR HISTORY

Your personal history is perhaps most easily displayed in the dining room, as there are plenty of opportunities for it to be represented. Family heirlooms can be used for everyday meals or displayed on shelves or on the walls. While speaking to your heritage is a natural choice, you can also express your more personal history and that of food as well.

You may remember Nick and Rachel Cope's open-plan apartment from their contrasted living room (see page 104). Once again, they have chosen to use pattern to carve out the dining space, this time in a more abstract way that speaks to their history as a couple. Early in their relationship, their mutual interest in design and interiors, and respect for how each had decorated their respective apartments, was something that made them closer. Today all the rooms in their home are filled with eclectic objects that carry interesting stories and personal memories and give a sense of their shared view of the world. Mixing more functional plates and glasses with artwork, books, curiosities, and various collections makes this feel more personal. Having a few favorites out, or rotating what's on display, is a way to keep your kitchen looking fresh. The patterning of these objects is a great backdrop for any occasion. They often use simple striped linens for daily meals, keeping the overall feeling calm.

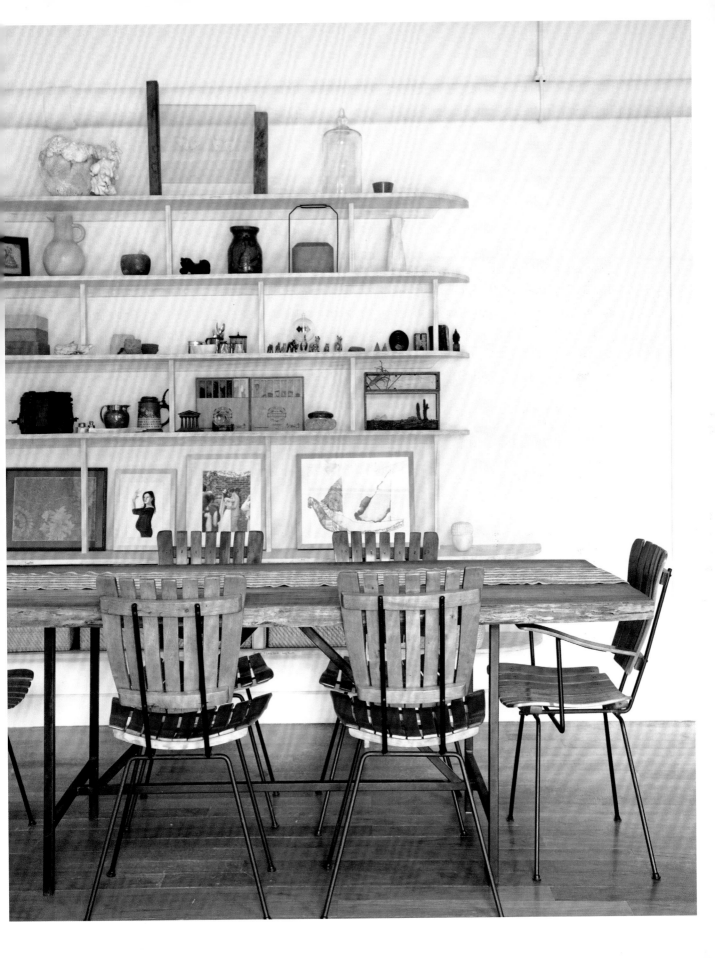

In addition to this more table-centered dining area, Nick and Rachel also have a breakfast bar in their kitchen. The patterning below the counter is a modular system of flat wooden tiles that can be slid into place, created by a friend and local designer, and it underscores their involvement in the Brooklyn design community. The medium-scale pattern has enough weight to become a focal point, but it doesn't compete with the other visuals in the open floor plan. Since the space is central and visible from other rooms, the kitchen uses pattern to relate with the rest of the house. The wood is stained in a soft green, blue, and black, but the wood grain comes through slightly to soften the geometric design. Pattern here provides personality that relates with their living space.

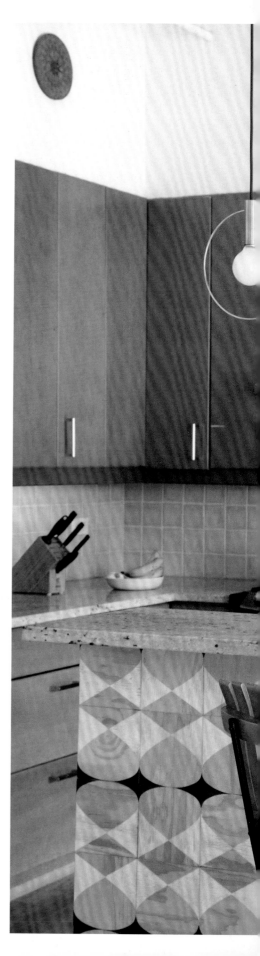

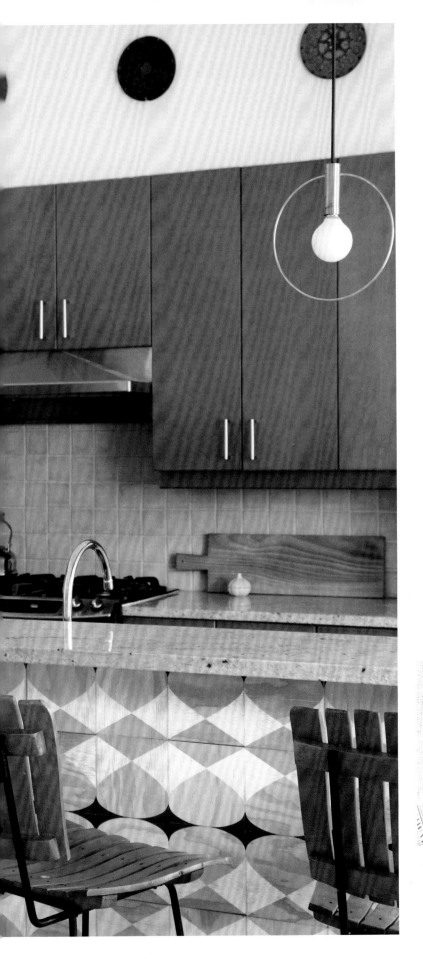

THE DETAILS

In the kitchen, line your cabinets and drawers with patterned paper, change the knobs on your cabinet, or bring in artwork. Take cues from other rooms in your home to make your space more personal.

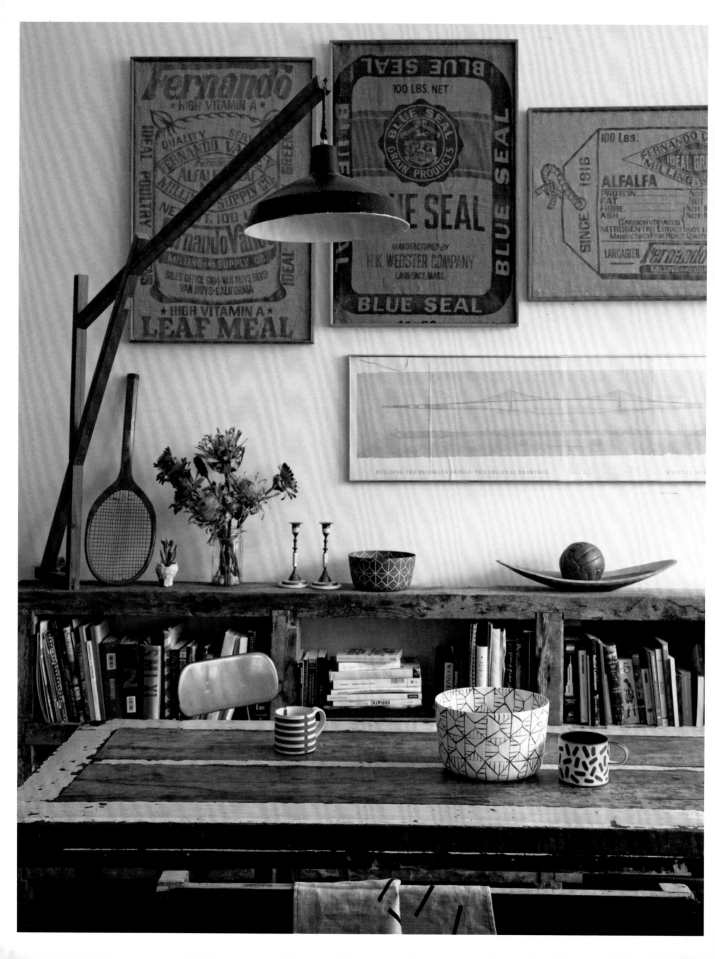

Gathering around a table reinforces the importance of family. Getting together to eat is a tradition with thousands of years behind it. It is the best way to celebrate both the everyday moments and our loved ones.

Huy Bui is an entrepreneur, designer, and artist working in New York City. Before studying architecture at Parsons School of Design, Huy worked in finance for six years. Now he is the founder of Plant-in City, a design company that merges architecture with the adaptability of plant life. Huy also cofounded An Choi, a Vietnamese eatery in New York's Lower East Side, with his brother. Celebrating with food is part of his life.

Huy's Brooklyn studio apartment is filled with curiosities and items that hold meaning for him. The center of the dining space is a table made from a repurposed twentieth-century door that was used at An Choi before its bar was built. The table has seen countless birthdays and family meals, and bringing it home is Huy's reminder of all of its previous lives, making the memories present and meaningful.

Huy has kept the bones of his dining area neutral, as it's a studio apartment and everything is open. Huy patterned his walls with framed burlap bags, a great example of how text can act as a pattern and bring a story into a space. He found these bags at the Brimfield Antique Show in Massachusetts; their history dates back to early nineteenth century, when they were the primary way of storing food. Although referencing food history can quickly become cheesy, take a cue from this space, where it's executed with sophistication. Instead of a big tomato painting, you may want to display a homemade tomato sauce recipe handwritten by your grandmother, or perhaps you'll find a creative way to turn labels from canned tomatoes into art or even repurpose the jars themselves.

MAKE IT
YOUR
OWN

Use open shelving or a credenza to display objects of meaning. They can be plates and dishes—or they don't need to relate to dining at all.

Pattern can be expressed in the arrangement of objects.

Let collections and small groupings shine by keeping the backdrop soft.

Look to bring pieces with history into your space. A table created from a vintage door layered with paint is so much more personal and exciting than something picked up at a big box store.

DISPLAY YOUR ARTISTRY

Michelle Armas's bright personality is on display in her dining area. Entertaining is part of her nature, and she keeps the space colorful and adaptable to make people comfortable. The foundation of this space, a wood table and woven leather chairs, could be paired with anything. By hanging her paintings over the paneling in an untraditional way, the energy of the room is buoyant and vivacious, encouraging feasting, laughter, and conversation. You can break rules when hanging artwork; just get it up and enjoy it—you can always move it later.

While Michelle creates a lighthearted space through art, Sally King Benedict uses artwork to create a darker environment meant for lingering at the table.

Weight and breeziness are balanced in Sally's paintings, and she has created a dining space that visualizes that balance as well. This small table near the front of the home is a cozy spot where she, her husband, and their toddler son often eat their meals. It's a spot that they want to be able to enjoy with their son, but also unwind together after a long day.

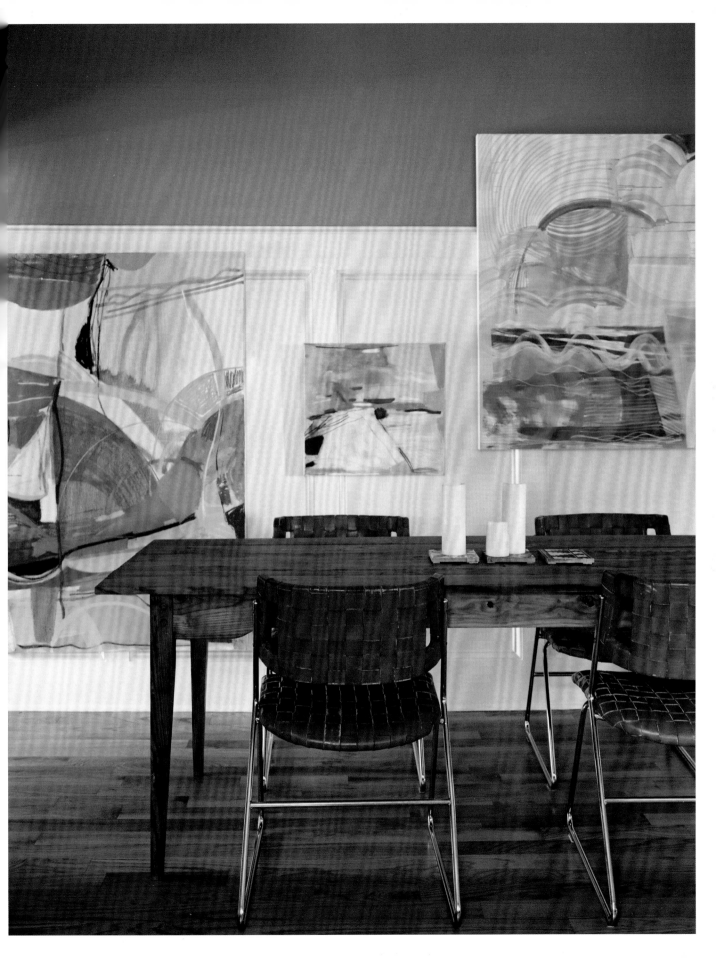

"COMPOSITION BEGINS WITH THE FUNDAMENTALS OF HARMONY. IF YOU HAVE A GRASP ON THAT, YOU CAN MAKE ANY STYLE LOOK GOOD."

—Sally King Benedict

The blues and greens in this dining room painting are cool and deep, almost as if you could fall into them, but hints of sienna and yellow feel earthy and grounding. This painting is a great example of how color can have different associative meanings. In this concentrated area, these colors oppose one another by referencing water and land, liquid and solid. When balancing elements in a room, consider the visual impact of a color and how its associations can lend weight and depth to an area. White areas add luminosity and accentuate the contrast between depth and grounding forces. Sally's painting draws you in and sets the thoughtful mood of the entire dining area.

This same balance comes through in three-dimensional patterning throughout the furniture. The Kuba-cloth pillows on the two leather chairs form an abstract pattern that is a basis for the composition. The pattern picks up on the negative space created by the legs of the chairs against the black walls as well as the warm sienna tones of the wood and leather chairs. By keeping the color palette tight, the eye is able to easily make these connections between a traditional idea of pattern and abstract execution. Alongside the dramatic spot of rich colors, Sally keeps the room from becoming too moody by adding some lighter elements, like the white lampshade, straw basket, and potted mini palm.

MAKE IT *YOUR OWN*

Make artwork the focus, and go big and colorful.

Artwork can also provide clues for how to compose the room.

If you don't have large-scale artwork, consider painting the walls a bold color, using wallpaper, or even painting an abstract mural by stamping or stenciling an easily repeated shape onto the wall.

A printed fabric can tie together an abstract patterning concept, such as the arrangement of your dining room chairs.

ELEVATE EVERYDAY

Creating balance within a dining space is all about making one that can serve the everyday as well as the special occasion.

The eat-in kitchen at Wayne Pate and Rebecca Taylor's Brooklyn brownstone is meant to be friendly and comfortable so they can enjoy time there with their three children and their Havanese dog. A large, worn wood table anchors the room and shows small indications of the fun that has been had here: meals, painting, and craft time alike!

The patterning in this space is thoughtful and calming, creating a cozy vibe that elevates it beyond the typical eat-in kitchen. Bringing an armchair into the space helps make the room feel more relaxed and encourages people to get comfortable. Seat cushions on chairs around the table are another great way to bring in warmth. The pattern around the room draws you in and begs you to stay, but it is very practical, too. The tiled floor in white, blue-gray, and black is much more easily cleaned than a rug, and it also hides dirt and crumbs better than a solid. If tiling your floor isn't an option, consider a flat-weave or indoor/outdoor-style rug, which is much easier to clean than a tufted rug. Even patterned seat cushions are a more practical choice than solids for the same reasons. These are beautiful and livable solutions for a busy, creative family!

Another way to elevate a casual or utilitarian space is with artwork. We've discussed how it can define the mood of a space, but it also can be important in balancing. The art on the wall is something Wayne recently painted and taped up over a previously framed piece. With its large scale and bright colors, it becomes a focal point, while the other smaller patterns in the room become supporting elements. The bright blues and greens play off the existing palette but pop because they are a more intense expression of color.

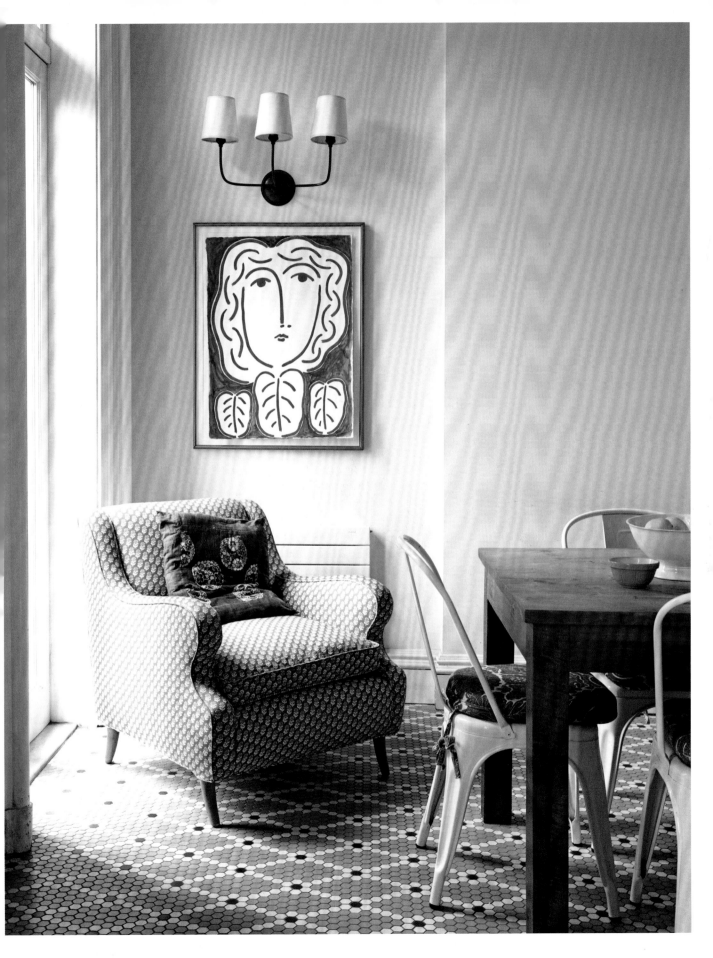

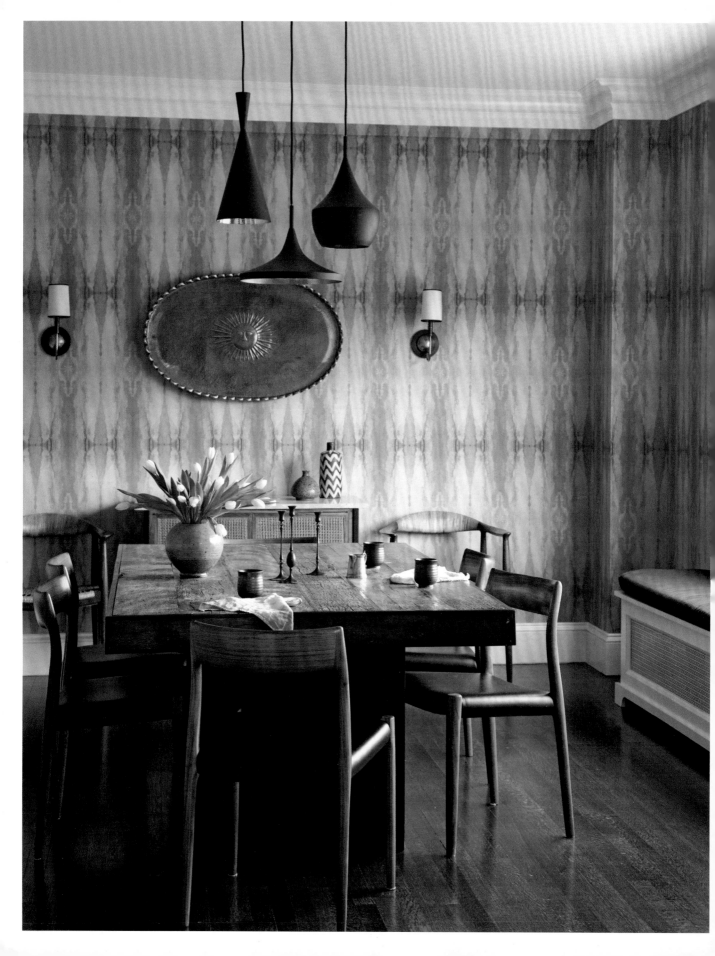

Elsewhere in Brooklyn, we visit a family that uses a more formal dining space every day. Kiki Dennis designed this dining room so that it would have flexibility to vacillate between an elegant dinner party and everyday use. This room's river view was the inspiration. Kiki wanted to emphasize this serene sense of place and started by bringing in wallpaper. The subtle reflected repeat of the pattern mimics the movements of water—color alone couldn't achieve the same effect on this space. A large soothing visual element like this can both unify an elegant area and give a relaxed vibe, allowing it to transform as needed for any occasion. This goes back to creating your foundation. The walls and large surfaces of a room create a backdrop for everything else you put in it. Using pattern on a surface like this unifies it by telling your eye to view this as one space. In this room, it's a pattern that feels sophisticated because of the way it repeats and the intricate details, but it's also relaxed because of the color and references to water. It's a flexible pattern that can tilt either way based on what's paired with it. If you choose a formal pattern with more traditional roots, such as an ornate paisley, you can make it seem more informal by bringing in casual furniture that feels more fun. Remember when you choose to go with contrasting styles, however, there needs to be one thread that ties them together, and color is an easy route to go. Your backdrop unites the space, and accessories can either harmonize or contrast to create balance.

Kiki hung a large brass platter that belonged to the homeowner's father to create a focal point in the room. This platter makes the room more elegant, but it's offset by a rustic table. Like the pattern on the wallpaper, the furniture is a mix of casual and refined.

Across the country in San Francisco, we visited another dining space built for adaptability. Sway Studio created this breakfast nook—the perfect spot to enjoy a cup of coffee on a foggy, gray morning. While its main purpose is a casual place for solo meals and quieter moments, it has the sophistication needed for entertaining, too. This small space doesn't have room for too much display, so patterning brings in the personal touches and defines the mood. Carefully chosen accessories, lighting, and furniture create three-dimensional patterns, while the simple black-and-white textiles on the blinds and in the frame create a sense of sophisticated, clean calm. The patterns are geometric coordinate prints that can go with anything, and they are a great layer that complements any table linens or other patterning brought in with accessories when setting the table for a party. This room feels perfect as is for quiet moments, but it can also handle a bold tablecloth for a special occasion. The mood can be refined or altered just with accessories. The triangular motif on the chairs plays off the rug pattern, and the brown flat weave gives warmth to this neutral palette. The neutral base is then given a feminine touch of soft pink.

MAKE IT
YOUR
OWN

Bring cozy furniture into a casual, utilitarian space to encourage lounging, or alternatively, mix more casual pieces into a formal space.

Choose a large-scale pattern to set the tone of a room and use it as a backdrop to build on.

Use pattern for practicality, covering areas that may get dirty quickly and making them feel more refined all at the same time.

Look for interesting shapes to create three-dimensional patterning with your lighting, accessories, and furniture.

When setting the table for an occasion, change the mood or refine it with the use of accessories.

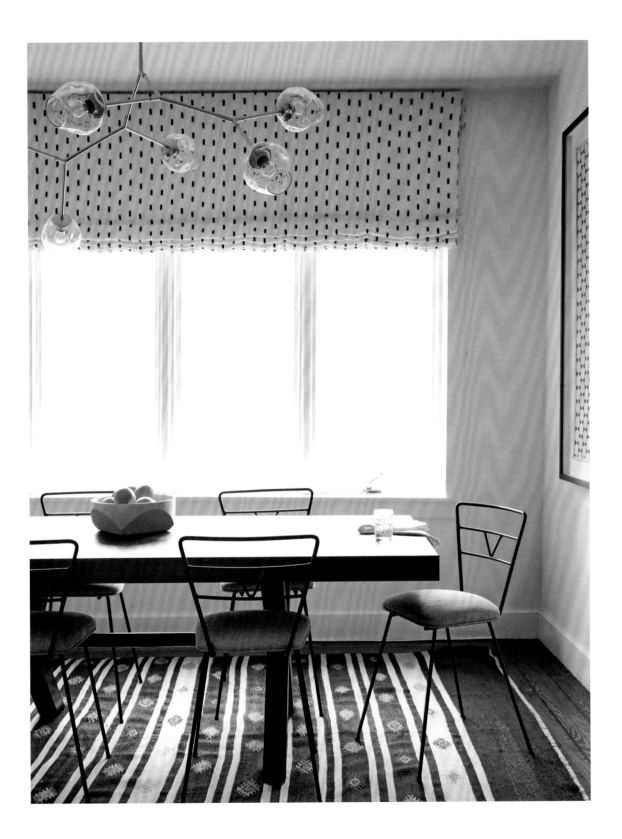

INDOORS AND OUTDOORS

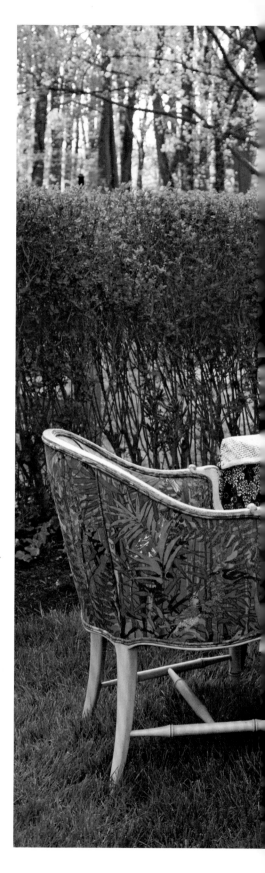

Dining is often an activity enjoyed outdoors. Dining is inherently about bringing the outdoors in with the fresh food we eat, so it makes sense to also bring the indoors out.

Wendy Wurtzburger Bentley and her husband Chris love to entertain. While they've raised two boys who have left home, they still have four loving dogs roaming the property and are always hosting friends and family. They've filled their home, both indoors and out, with spots to gather for drinks, meals, and conversation. Avid collectors, the couple has built up a huge assortment of dishes, bowls, mugs, and glasses. Layering these in new ways is always on their agenda.

"HAPPINESS IS THE NEW ENERGY CREATED BY MIXING THINGS WE LOVE: ART, OBJECTS, PRINTS, NATURE, COLLECTIONS!"

— Wendy Wurtzburger Bentley

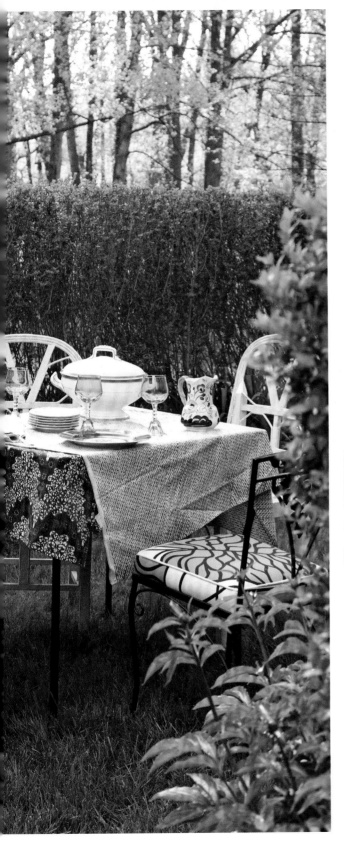

Nature is always finding its way into the house. In their dining room, a vine grows through the wall and pops out of a cabinet they use to store dishes. It's easy to see why it's one of Wendy's favorite things. But the couple also loves to bring their indoor pieces outdoors for an element of the unexpected. A hedged alcove in their garden is a perfect spot for setting up an intimate dinner party during warmer months. You can use your backyard, patio, or deck; if you don't have your own personal outdoor space, consider bringing folding furniture and textiles to a park for an elevated picnic. Explore patterns that reference nature to keep the feeling eclectic. Layer fabrics to create the right size tablecloth, and mix china and casual melamine pieces together.

Harper Poe also loves to collect and bring nature inside. She's made it her career to connect with people from all over the world and from different walks of life, and her space reflects that. Her space shows off her love of travel and an easygoing, no-fuss vibe.

The blue hutch, a family piece, has been paired with mementos from her travels. Her collection is built on objects found over time that make her happy. The antlers are from her years in New York, found at a thrift store in Brooklyn; the basket was picked up in Guatemala; the tassels are from a market in a sacred valley of Peru; the camel, with a traditional Guatemalan ikat fabric, is from Chichicastenango market; the llama comes from Lima; the wooden frog was a gift from a friend in Bali; and the framed textile is a collage from Charleston artist Karin Olah. Each piece expresses her global citizenship.

This room has an outdoor-patio vibe; plants become sculptural pattern within the space. Bring the outdoors in. Create an indoor garden and reference spaces that have an urban garden feeling. Consider how tiles, plants, and textiles can create a sense of place even when used sparingly. A palm or cactus can add liveliness and movement.

Let nature be a part of your meals, from where you're seated and the food you're eating to flowers on the table and china patterns that reference it.

Bring indoor furniture outdoors for a dinner party—it's unexpected and fun.

Surround your dining space with plants and let their unique shapes act as pattern in a more minimal environment.

Mix textiles to create a tablecloth if you don't have the right size, and layer them over chairs and display them on the walls.

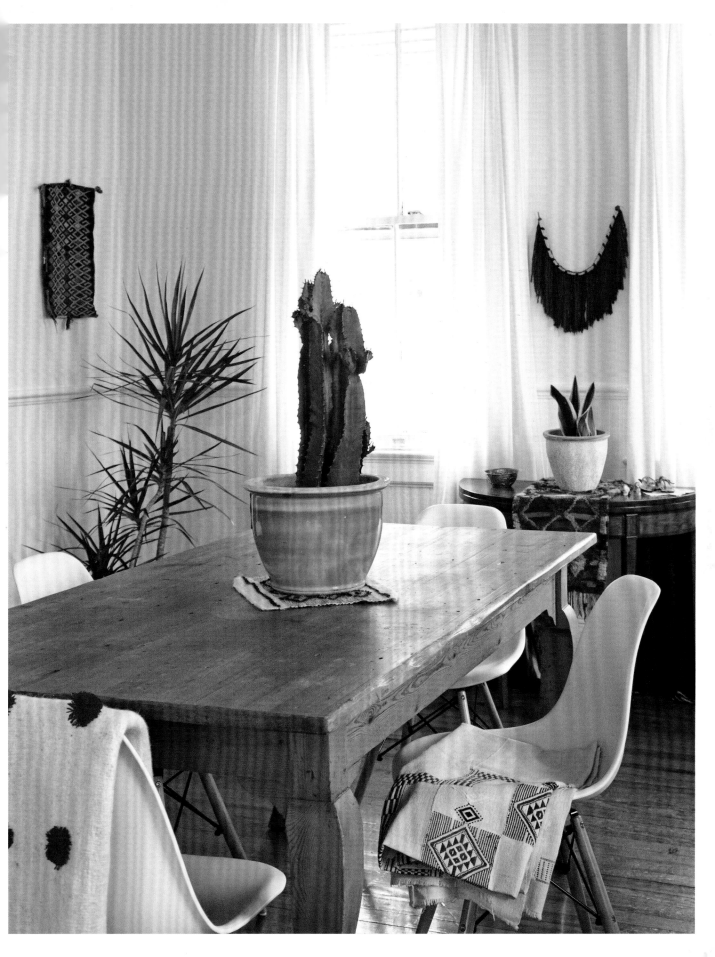

Setting the table is the easiest way to change a space to mark occasions, from everyday dinners to fall feasts and buffet brunches. No matter what space you have, and how you've built the foundation, the plates and pieces you bring to the table will shape the story and lead and encourage celebration.

EVERYDAY DINNER

Life gets so busy that making time to sit down for dinner on a regular basis can get lost. Since the dinner table is a great place to catch up with your family and loved ones, it needs to evoke a mood that is casual, classic, and simple to keep the focus on the company. You don't need any extra fuss after a long day. The styled looks within the next few pages aren't necessarily a traditional table setting, so you can interpret this concept in many ways. A color palette of soft neutrals with subtle purple-grays, creamy whites, natural linen, canvas, and deep blacks grounds everything. The black tone is used solely in the textiles that are soft and washed, which keeps it from feeling too slick. If you'd like to use black ceramics, think about matte finishes or rich glazes on earthenware or terra-cotta. Keep the linens simple and partner two or three patterns that coordinate, along with a striped or textured woven placemat. If you have multiple linen options that are in the same color family, you can switch them out on different nights, depending on what is clean, or mix them. Use your everyday plates, glassware, and silverware. Add tonal patterned salad plates or bowls.

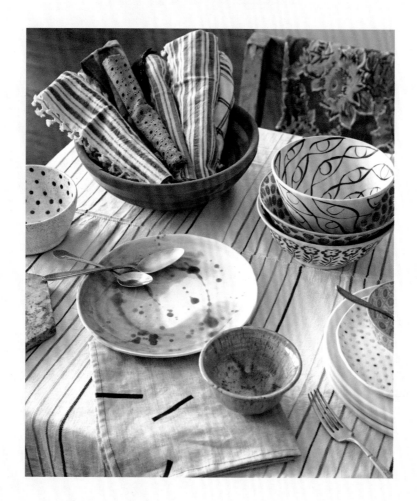

BRUNCH BUFFET

A casual brunch is my favorite meal to host, since you can keep things easy by letting guests serve themselves. Here the aim is to create an environment that is rich, playful, and cheerful, using a multicolored palette as a base. Use patterned napkins to roll up silverware and make it easy for your guests to grab everything they need at once. Mix and match all of your different napkins for a fun and festive look.

Try to have a color from one napkin present in another pattern you're mixing to unite them, as I've done here with the pink and blue. Your serving pieces can be an assortment of what you have on hand. Consider wooden bowls, handmade ceramics, and oven-to-table casserole dishes. This eclectic assortment will look great when paired with patterned side plates and assorted mugs.

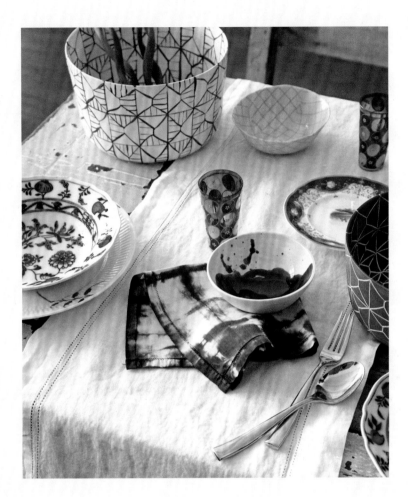

FALL FEAST

When you want to up the sophistication factor for a festive fall feast or another special occasion, consider limiting your color palette and mixing patterns. I'm a big fan of setting the table with your china frequently; why else have it? To keep it from feeling overworked, however, temper it with some more casual pieces and modern patterns. Elegant but easeful, vintage china plays nicely with hand-thrown stoneware and porcelain. To keep this blue-and-white palette from feeling too traditional, I've added accents of ruby, which feel unexpected. Alongside the classic porcelain is a mix of pieces from contemporary ceramicists. These bowls have more geometric and loose painterly designs, helping to modernize the whole look. Lastly, the linens are shibori-dyed (see page 253), which give the whole setting a subtle bohemian feel.

WHERE TO PATTERN

Knowing what to keep solid and where to put pattern doesn't need to be complicated. As you've seen on the last few pages, your table linens are also a very easy way to add pattern and change the look. Since you change them so frequently, it's an obvious choice, but when it comes to your dishes think practically: keep your dinner plates white, as you'll use them every day and they should coordinate with everything—not to mention it makes food look nicer, and chips will be less visible. Patterned pieces are your accessories. Salad or dessert plates, mugs, and bowls are great places to really go for it. Often you can find unique sets in which each piece has a variation on a common theme, or you can build your own set by keeping within a color palette. Start with just a few pieces to get an idea of what you really like before committing. Other items to consider include your serving pieces and decorative accessories such as pitchers, candles and candle holders, oven-to-table dishes, and vases.

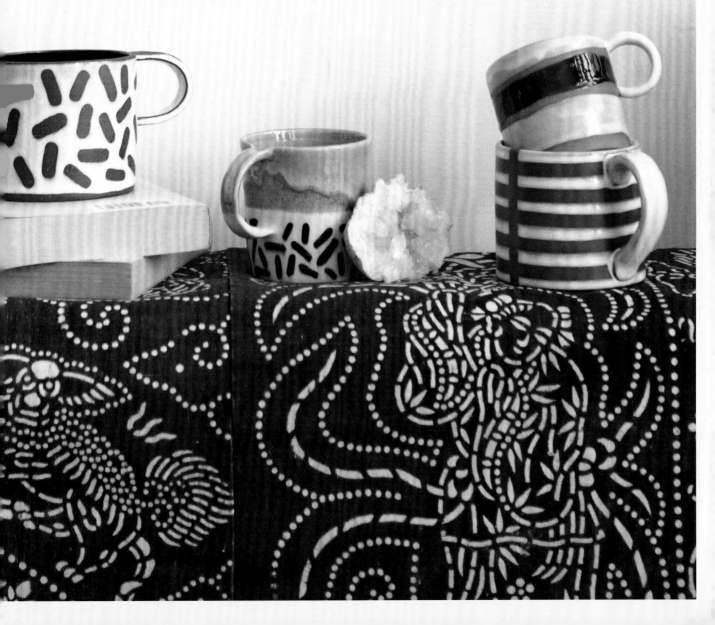

HAVE A CUP

Mugs are the perfect place to express the personalities of your family. Don't worry about matching sets here! Mix casual coffee mugs with more elegant teacups if that suits. Go for unique pieces and build a patterned collection as varied as your interests and those you live with.

SPACES
TO THINK

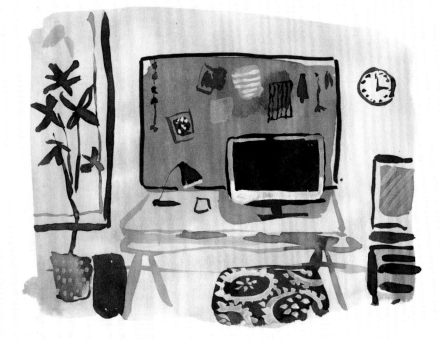

WHILE SOME areas of the home are clearly defined with rooms devoted to them, others must be carved out. Your needs are unique, and so, too, are the spaces within your home. One place that isn't predefined is an area to think and dream. Whether it's a library, a reading nook, an art studio, or a home office, having a space set up for working, reading, and thinking is important. We'll look at a range of solutions, as this sort of area can take on so many different aspects and shapes, and it evolves as your needs change.

There aren't always obvious rules or setups, so you'll have to make your own depending on what you need most of all. You must know yourself. Think about what makes you productive, what type of environment you get your best ideas in, how you like to work, and what encourages you to do so.

Not that long ago I ran my business out of our two-bedroom apartment, using the second bedroom as my office. Business grew, and for a while it took over, which made my setup feel more like living at work than working at home. I was dyeing fabrics in the bathtub, storing one hundred pillow inserts in the bedroom, and processing shipments out of the living room. It wasn't the best situation. Today I have a separate studio space, but I still do need thinking space at home, too. My husband now uses the second bedroom as his office, and my area is a corner of the couch next to our coffee table where I like to curl up and read, break out my paints and sketch, and even wrote this book. Sometimes it's easier for me to work on certain things out of the studio space because it gives me a fresh perspective and fewer visual distractions.

No matter the size of your home, you can find a spot. Perhaps it's a space that already exists, but you can find new energy there by defining it. Look around your home for the opportunities. It may be that there are space constraints and you need an area that's adaptable and can be tucked away when not in use, or you may be lucky enough to have an entire room. Whatever it is, find that spot and define it. Pattern is a key tool in such spaces, and here it should be about your inspiration, dreams, and desires. This is a place to try some whimsy, go for the unexpected, and surround yourself with whatever excites you most!

YOUR OWN LIBRARY

A library feels luxurious and even romantic. If you don't have one, the idea is still perfect inspiration for a thinking space. We'll look at three homes that play on the idea of a library. All are set up for work as well as inspiration.

Brian Paquette created a home office and library for his client that is both masculine and serious, but with a fanciful wink. The birch-tree wallpaper provides an Old World vibe with just a hint of whimsy that is perfect for a room meant to inspire. It also gives height to the room, drawing the eye up toward the ceiling. Bringing in a pattern that speaks to storytelling and imagination is a fun way to balance out a more serious space. If you want to mix it in without skewing too young, include elements such as a sturdy leather chair, geometric pillow, and traditional tufted rug to ground the space. Neutral colors and hints of blue and muted coral verging on clay maintain the sophistication.

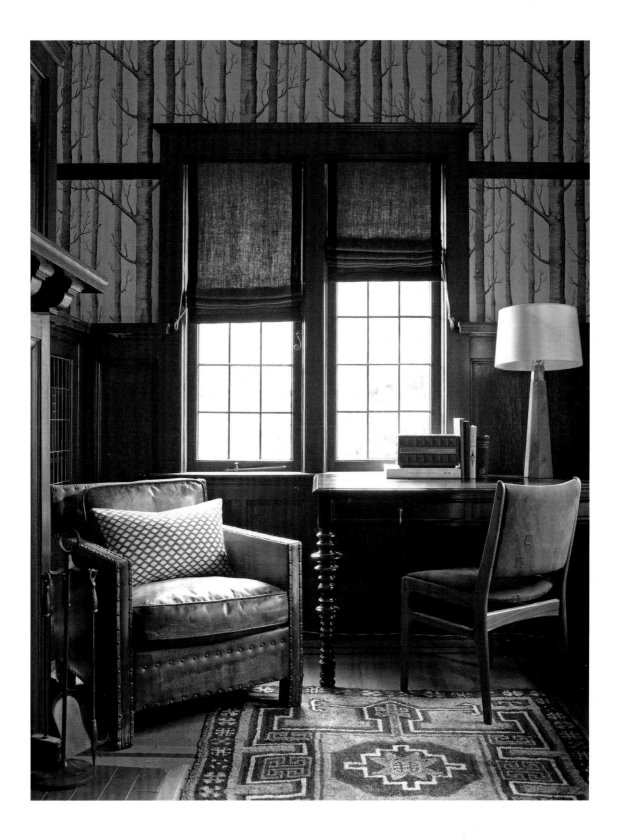

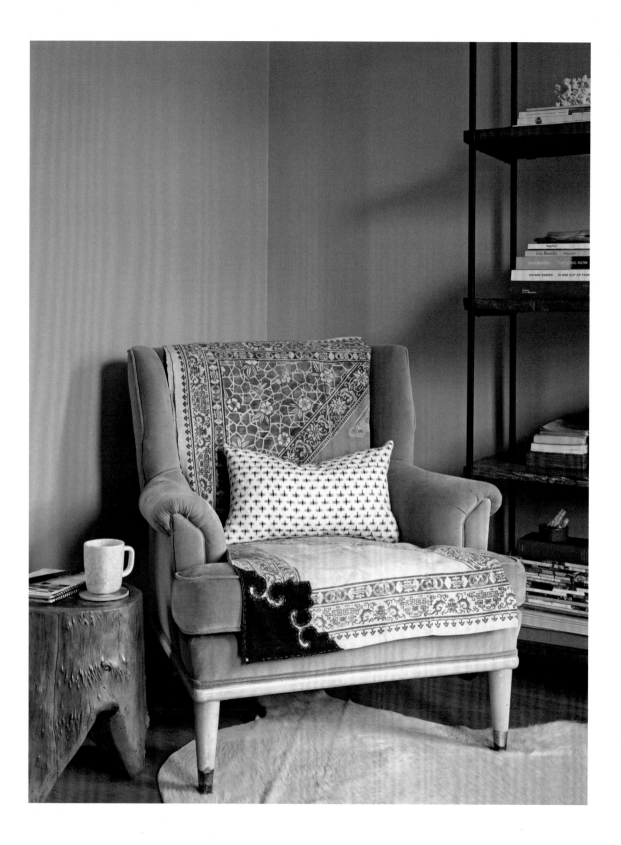

While we all don't have the space for a true library of our own, a small reading nook is an easy alternative. Everyone needs a space to curl up with a book, and an upholstered chair is the perfect place to start. Designate this area as your thinking space and surround it with the things you need. In photographer Emily Johnston's apartment, bookshelves create a mini library, thereby defining a nook. The solid chair becomes the focal point by bringing in pattern with a draped textile.

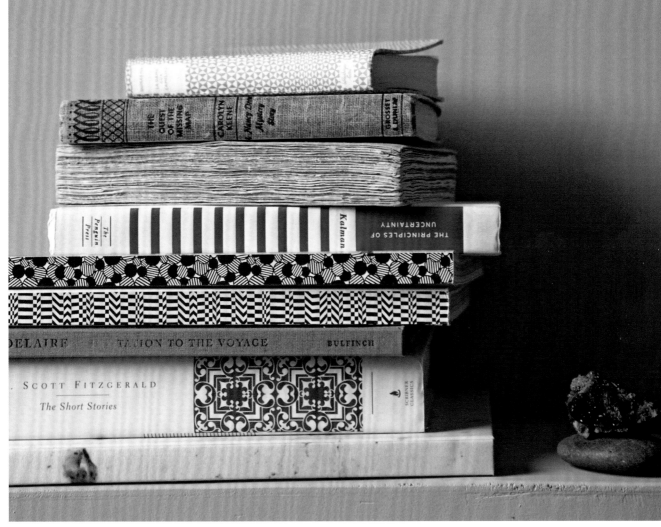

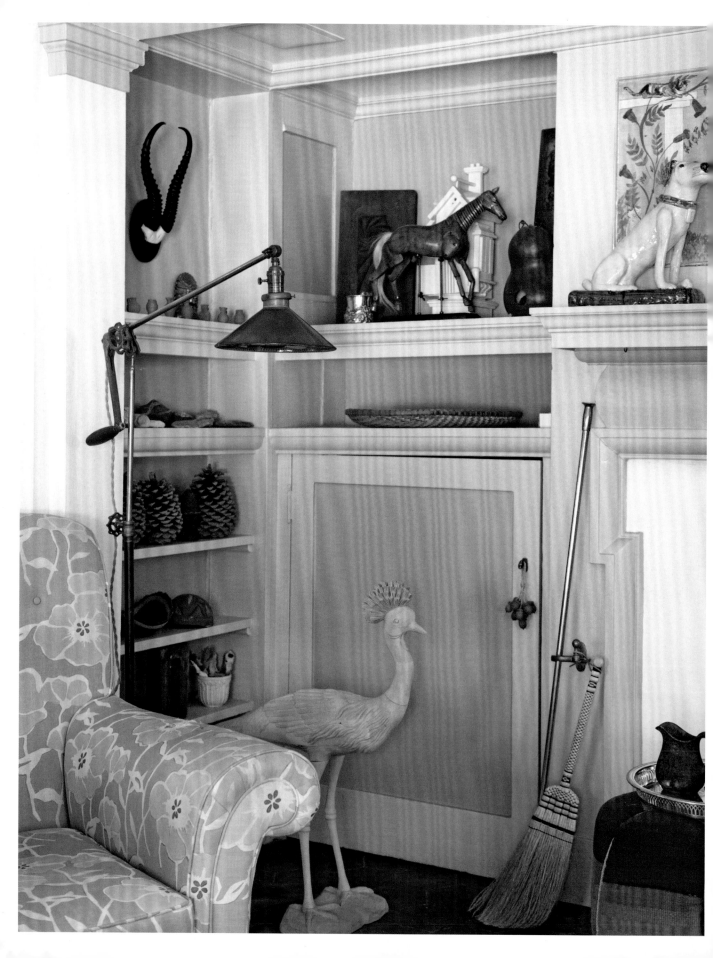

Wendy Wurtzburger Bentley and her husband Chris have a winding home filled with extra rooms and spots for thinking, but they love a good reading nook, too. On the main floor there's a quiet spot in a room they call their nature room. The couple is always finding ways to bring the outdoors in, as it is a constant source of inspiration as well as a calming influence. This theme connects perfectly with the needs for a thinking space. Just three pieces—an armchair, a striped pouf, and a metal lamp—make this spot functional, but it's pattern that best ties in the purpose of reflection. The floral pattern speaks to the outdoors, and despite the large scale, the neutral coloring makes it feel livable. The subdued ochre hue is a bit quirky when paired with the minty green walls. Bright red from the pouf brings out the green tones in the ochre, and mint highlights the yellow in the chair's upholstery, giving the tone more complexity. Built-in shelves frame this space and provide a nice structure for display. While other areas of this home are filled with books, Wendy has filled this library of sorts with other objects that inspire her, including large pinecones and mini antique Mexican pots. If calm is key to your best thinking, take a cue from this space and place objects in a streamlined structured pattern versus a more organic or haphazard arrangement.

MAKE IT
YOUR
OWN

Your shelves don't need to be filled with books; display whatever inspires you most.

Keep the furnishings simple and go big with a pattern that speaks to your imagination. Balance this with more serious furniture pieces or historical architecture, if it exists.

Draping textiles is a great opportunity to change a look for your current mood, or to use a more special piece that may not stand up to constant use. I encourage you to go for pieces that really inspire you here.

Decorate around a design concept that moves you, such as nature, history, or even a specific location. Keep it loose and not too literal.

Display objects of curiosity on shelves, keeping them clean and calm.

CREATIVE SPACES

While libraries and reading spaces offer a calm place for thinking and quiet, pensive work, you may need a room for more creative activity and engagement.

Collaboration is a key part of how Wendy works, and she has structured her work space around that. A large worktable has two facing chairs to encourage conversation. Another key element of her process is to visualize what she's working on. Her office is filled with bits and bobs from her travels and day-to-day life, which she displays on a large board and scatters across the shelves and windowsills. Like me, Wendy creates boards for the individual projects she's cultivating, but she also has a large one to display current ideas, thoughts, and interests that are top of mind.

PIN IT UP

You can bring this inspiration-board concept into your home by using big foam-core sheets and covering them with muslin fabric, like I do in my studio. Simply staple the fabric on the back as you would when stretching a canvas or upholstering (see page 277) and hang it on the wall. If you want this to last, consider a thicker foam core, or even go with something heavy-duty like Homasote and paint it white. This is a great way to display what interests you.

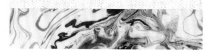

Wayne Pate's work space, on the lower level of his family brownstone, is simply a dream. Small, slatted shutters provide privacy when needed but also let light in and give view to the iron fencing outside. Woven chairs with an outdoor feeling are used instead of basic desk chairs and add to the textured base of the room. Your eyes can't stop exploring the area that's filled with beautiful books, magazines, lamps, objects, paint, and supplies. Collections are a big part of how Wayne inspires himself and generates work. While Wendy has an inspiration board, Wayne has an inspiration room!

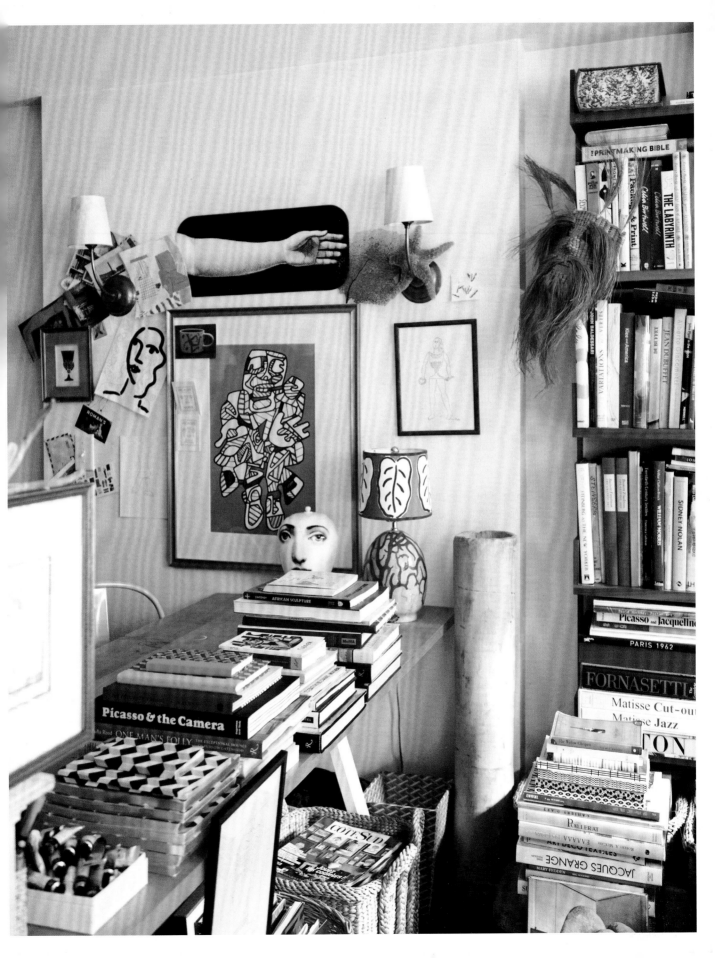

"PATTERN IS A TONIC FOR ME, IT INSPIRES, IT AIDS IN MY CONSTANT NEED FOR VISUAL STIMULATION AND THE COMFORT IT BRINGS ON A COLD, RAINY NIGHT."

— *Wayne Pate*

Everywhere you look there's another considered detail—from a marbled shade on the lamp, to the blue ikat textile hanging on the door, to the graphic Matisse print on the wall. Wayne fills his space with pieces that speak to him and has fun finding ways to display them: within the bookshelves, tucked and stuck on the wall, or placed on any empty surface he can find. Little objects, cards, artwork and notes, fabric balls made out of Japanese textiles, seashells, coral, turtle shells, ginger jars, small textiles, hats, and a woven mask are dotted around the room. Collecting things you love will lead you not only to discover things about yourself and inspire you to try new things but also to produce and create. Wayne's space isn't about creating a finished, decorated room, but rather about creating one that is truly engaging and meant to keep the wheels turning. Essentially it's a living, ever-changing three-dimensional inspiration board. While some people work best in a minimalist environment, a "more is more" space can be equally productive, depending on your personality.

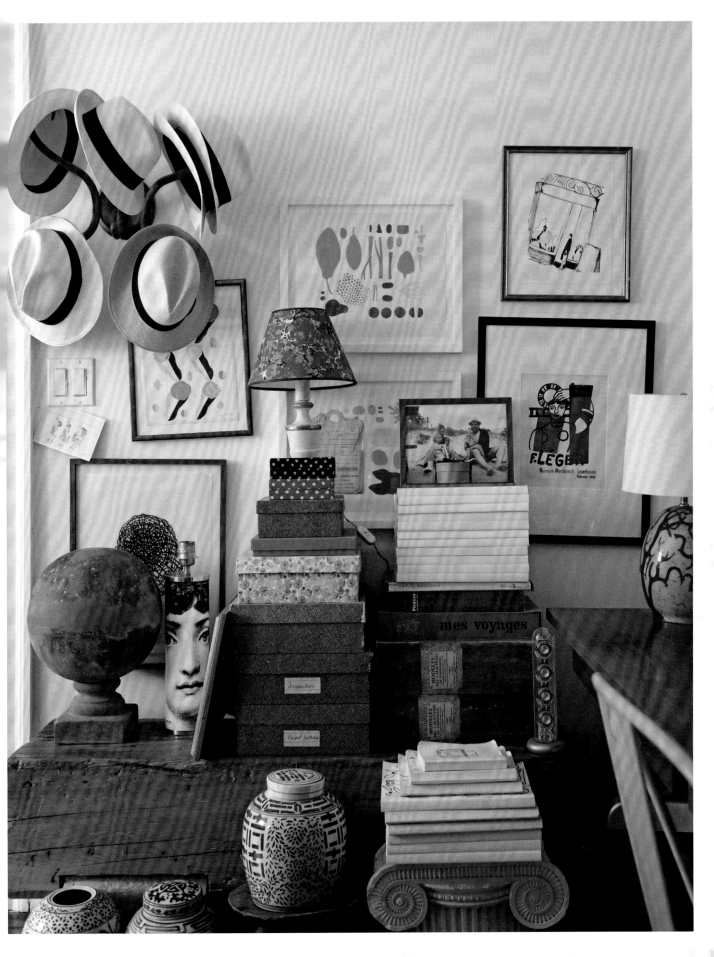

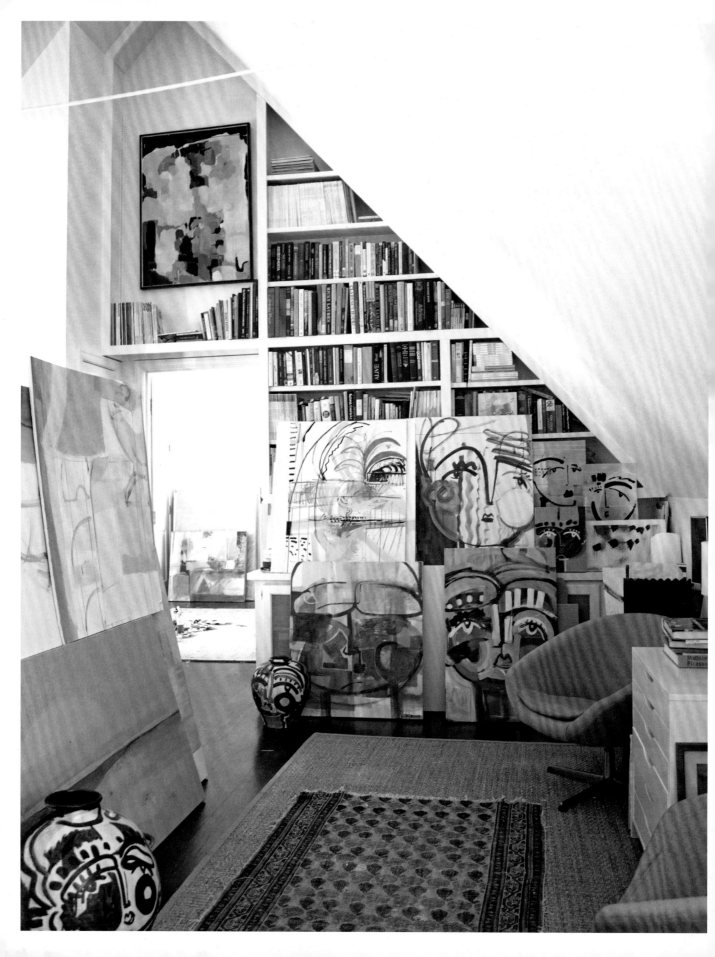

On the desk you can see that all of the supplies are contained in beautiful vessels—from painted ceramic jars to paper-covered boxes. In a work space, it's important to stay organized, and giving this level of attention to what holds your supplies makes a busy space more beautiful. Try covering old shoeboxes, cans, or jars in wallpaper, or even paint or decoupage (see page 242) designs onto them.

Making a mess can be an important part of the working process. Sally King Benedict has created a space where she can create openly with spontaneity. Her home studio is a lofted area that looks out over a living room. It has two rooms: one, a small area overlooking a living room filled with books, art, two rounded pink chairs for chatting, and a desk for computer work. The other is her creative space—her painting studio. In other homes, it might make sense for the more defined room to be the home office, but for Sally creativity takes priority. The desk and library are relegated to the hallway space, which works perfectly for Sally's needs. If you need a space for messy projects, consider what you could rearrange to accommodate that. Sally covers the wood floor in her painting room with a sisal rug that becomes a drop cloth of sorts (see above). In this setup, she can work freely and allow herself to be messy.

MAKE IT
*YOUR
OWN*

Search for beautiful boxes and vessels to store supplies, or create your own with paint or decoupage (see page 242).

Display your collections organically. Gather them together in ways you find pleasing and inspiring.

Repurpose rooms and spaces to fit *your* purposes.

Cozy up the space with rugs and chairs if you have room.

AN EVERYDAY RETREAT

While a working space makes sense for some people, you may need a place that's more about dreaming and less about working. I'm a firm believer that making time to unwind increases productivity and the ability to be creative.

The porches in and around Charleston, South Carolina, are one of the things that make the city so charming. Everyone can create a little vacation right outside their door. Apparel designer Lindsey Carter took this opportunity with her back porch. One of her favorite places is the Dunmore, a Harbour Island resort, which has a legendary pink-sand beach. It's idyllic, and of course a busy mom of two would want to bring a little of that home. Rattan furniture and big bold stripes are just a few of the cues Lindsey's pulled from there. She mixes things up by introducing a modern silhouetted floral in soft gray that references the outdoors but is fresh and relevant to her tastes. All she has to do is step outside and she's back on holiday.

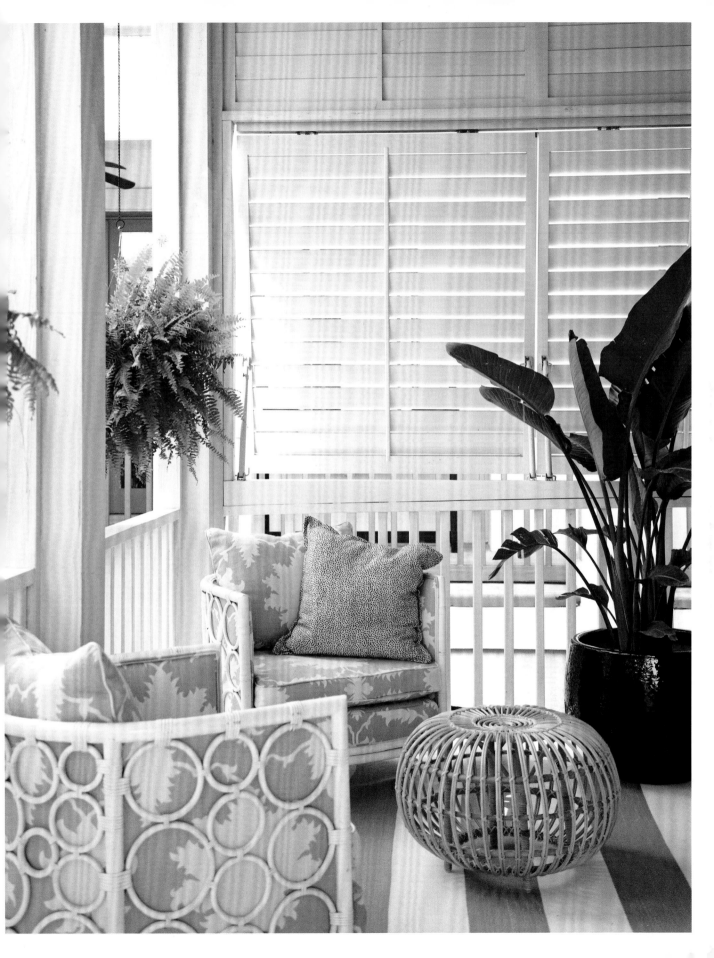

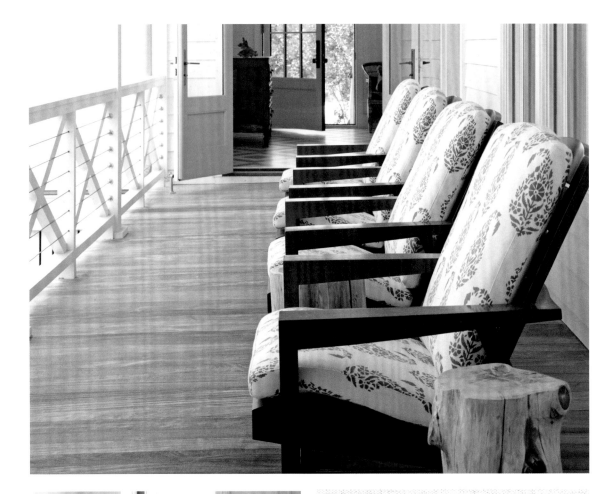

HANG OUT

If you don't have a porch, consider a hammock. I turned a small room off our bedroom that lacked purpose into my own little retreat. For me, a hammock is the epitome of outdoor relaxation, but there's no reason you can't bring this idea indoors. I love ones with striped fabric or crocheted edges, as they feel a bit more easeful and sophisticated indoors. Add a pillow or two, but don't overwhelm the space—you need to fit in it, too! For cooler months consider a comfy throw or sheepskin to make things extra cozy.

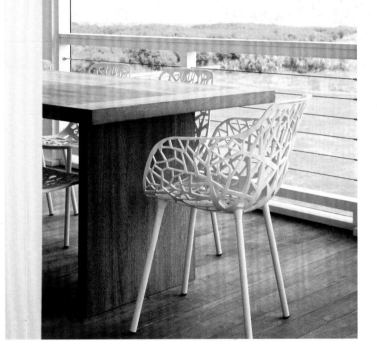

IF YOU'RE LUCKY ENOUGH TO HAVE OUTDOOR SEATING, LET NATURE
SHINE. IN THIS BEACH HOME, ENJOYING MEALS OUTSIDE IS A MUST—IT'S
ALL ABOUT THE SALTY AIR AND OCEAN BREEZE. WHILE THE WOODEN
TABLE IS SIMPLE, THE OUTDOOR CHAIRS HAVE PATTERNING THAT
REFERENCES TREES OR OTHER NATURAL FRACTALS. IT FEELS MODERN
AND APPROPRIATE FOR A HOME THAT'S ALL ABOUT RELAXATION.

The Sullivan's Island beach home Jenny Keenan designed also has a dreamy porch (see opposite, above). This house has a few different porches, actually, but the one on the side of the house is a bit removed from the main areas. It's a quiet landing, perfect for having your morning coffee or escaping to read a book. While it doesn't face the ocean, it nevertheless feels secluded opposite a row of palm trees. Here the railing and repetition of chairs form an architectural pattern. The paisley print on the chairs adds a feminine touch as well as personality to the space.

Relaxing and getting away from the day to day, even if it's at home, can recharge you. I get my best ideas when I'm just observing and watching. Make time to sit, without your electronic devices, and just look at your surroundings. You may be surprised about what new ideas come your way.

MAKE IT
YOUR OWN

Use outdoor space as a way to unwind.

Let favorite vacation spots inspire your design.

Orient directional patterns, like bold stripes, in a way that leads you into the space. It's a great way to subliminally draw you in.

Mix circular, organic, or floral patterns with strong horizontal and vertical patterns for contrast.

Enhance architectural details as your base.

JENNY KEENAN TOOK ADVANTAGE OF
AN ODD SPACE IN THE BEACH HOME SHE
DESIGNED, CREATING A THINKING SPOT
IN THE UPSTAIRS HALLWAY. TWO CHAIRS
AND A TABLE CAN MAKE FOR A PERFECT
SPOT TO DISCUSS IDEAS OR TO SIT SOLO
AND REFLECT.

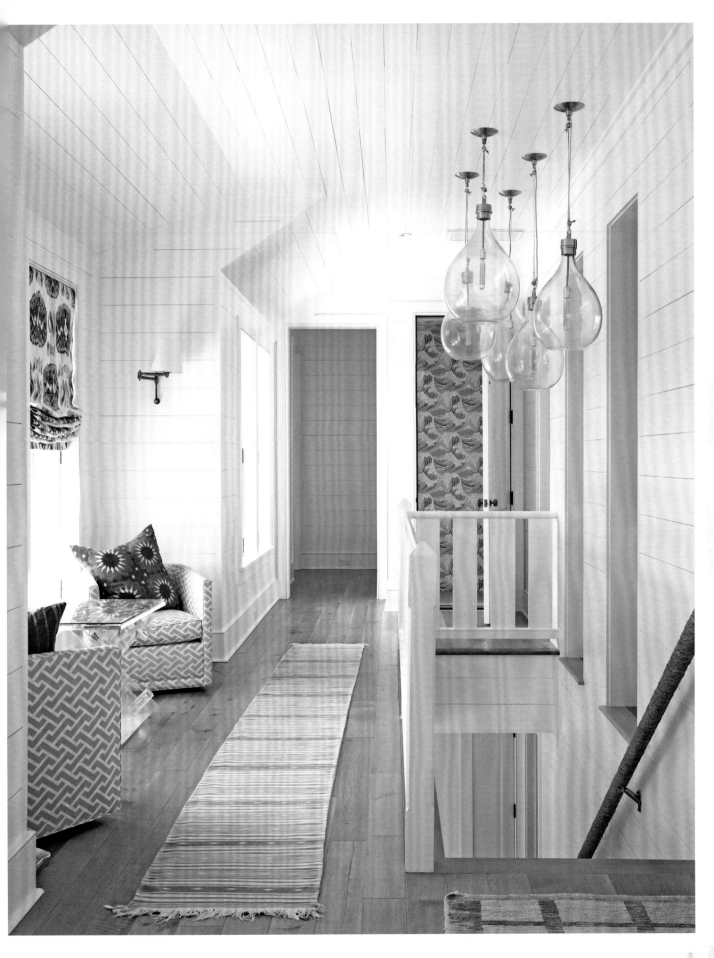

THE
BATHROOM

THE BATHROOM is often a neglected space when it comes to decorating, but as one of the most personal rooms in any house, it deserves attention. Approach the bathroom as you would any other room. View its weird fixtures and pieces that you can't move as design challenges rather than hindrances. Focus first on the foundation; if the flooring, tiles, and architectural details are something you have the ability to change or tweak, that should be the first step. Then bring in furniture and objects like you would in any other space. Try not to feel confined by the conventions of a typical store's bath department. My mom would find ways to decorate our main bathroom to make it feel like the rest of the house. She brought in a quirky hutch for storing towels, hung plants by the window, and placed antique jars, baskets, and other objects.

Bathrooms are typically smaller spaces you can decorate with impact without emptying your wallet. Just a few pieces can completely transform them. New York apartments notoriously leave a lot to be desired in this area, and the bathroom in our apartment was no exception. When we moved in we quickly realized that we would have to get creative in order to make it feel fresh and personal. Since my story is about coastal calm, I chose soft patterns. While there's no room for extra furniture, a woven basket on top of the toilet, a sheer patterned linen shower curtain, Turkish hand towels, and a striped bath mat are helpful additions. This space is a place to rejuvenate and renew. Make it one that speaks to that desire through the use of pattern.

EMBRACE A VISION

Think about unique places you've seen that use tile, glass, mirrors, porcelain, stone, marble, and other materials found in the bathroom and that exude a vibe you love. Your inspiration could be a visit to the spa that left you blissfully relaxed, an elegant hotel bathroom, a restaurant with an open kitchen, a subway stop with a mosaic, or even the simplicity of an outdoor shower in the summer. Consider researching historical sites, such as Turkish or Roman bathhouses.

Kate Dougherty and Ben Towill are newlyweds living in Charleston, South Carolina, by way of New York. Kate is an interior and set designer as well as a sought-after prop stylist; Ben is co-owner of several restaurants, including the Fat Radish, the Leadbelly, and the East Pole. After ten years in New York, they wanted a change. The couple bought their first home together in Charleston, a renovation project Kate was thrilled to tackle.

The mood for her bathroom came from a photo she found while researching for *Moonrise Kingdom*, a film directed by Wes Anderson and shot on the coasts of Rhode Island and Massachusetts. It was of a bathroom in a New England seaside cottage with an old porcelain sink and sailor paintings on a white shiplap wall. She loved the idea of creating a New England cottage in the South.

She focused on bringing her vision to life and worked tirelessly to let the materials of the space shine. Throughout the home, she stripped sixty years of lead paint off doors, took down pounds of drywall to expose brick, and sanded floors to the original heart pine. Elbow grease can go a long way, so consider if you can make small changes to your space that will make it gleam; a new coat of paint and a deep steam clean can make a difference. While Kate's bathroom isn't full of bold pattern, it is full of quiet pattern.

BRINGING CHARACTER TO A WHITE SPACE GIVES IT WARMTH. OLD WOODEN DOORS ARE ONE OF HER FAVORITE THINGS, AND SHE SUGGESTS SEARCHING YOUR LOCAL ARCHITECTURAL SALVAGE SHOP FOR SOME THAT HAVE CHARACTER.

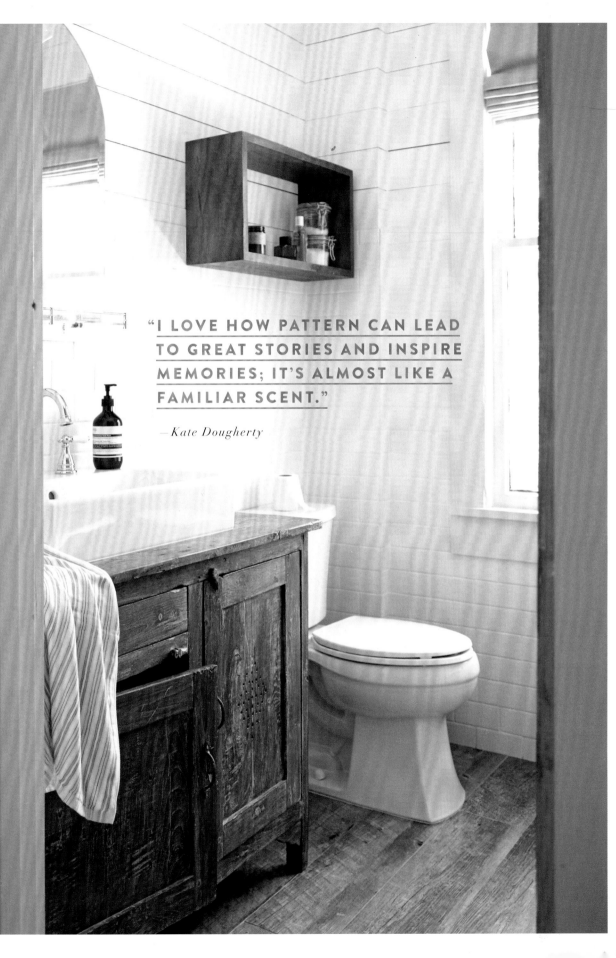

"I LOVE HOW PATTERN CAN LEAD
TO GREAT STORIES AND INSPIRE
MEMORIES; IT'S ALMOST LIKE A
FAMILIAR SCENT."

—*Kate Dougherty*

A BLANK SLATE

The reality is that most of us are starting with white or mostly neutral bathrooms. Almost all of them have imperfections or awkward moments, but they're a great place to start. White is clean, calm, and brightens up small spaces—it's a great foundation!

Chassity Evans focused her energies on building out her blank slate. Her fresh white master bathroom is a perfect example of a calming base. She and her husband also took on a renovation and paid attention to the details, choosing a herringbone pattern for the tiles on the floor and wooden shutters for their windows. Without any other elements, however, a white room lacks personality, and Chassity wanted her space to feel cheerful, too. Adding simple natural elements, such as the ladder and basket, helps warm up the space and maintain visual tempo.

Layering textiles was her next step. You can do a lot with them no matter how little space you have, so don't overlook them. A shower curtain mixed with bath towels, hand towels, a rug, and a bath mat can truly transform a space—and they don't need to match. A shower curtain is large; try a smaller-scale pattern or a simple stripe if you want a calm vibe, or really go for it with a bold statement pattern if that's more your style. Keeping your bath towels neutral is practical, but your hand towels are a place to experiment. Consider striped Turkish towels, vintage tea towels, and other easy-to-wash woven cotton or linen textiles instead of terry cloth. Look for patterns within a color palette, much like you would with napkins, and use them to change the space frequently.

MAKE IT
YOUR OWN

Consider the big picture first and set an overarching vision for the space.

Remember that a bathroom can be personal and homey even if it's simple. Start by paying attention to the finishes.

If you live in an old home, consider peeling back the layers to expose the history of the space.

Mix natural elements, such as linen and different wood textures, to warm up a space and keep white from feeling stark. You can even find tiles that look like wood.

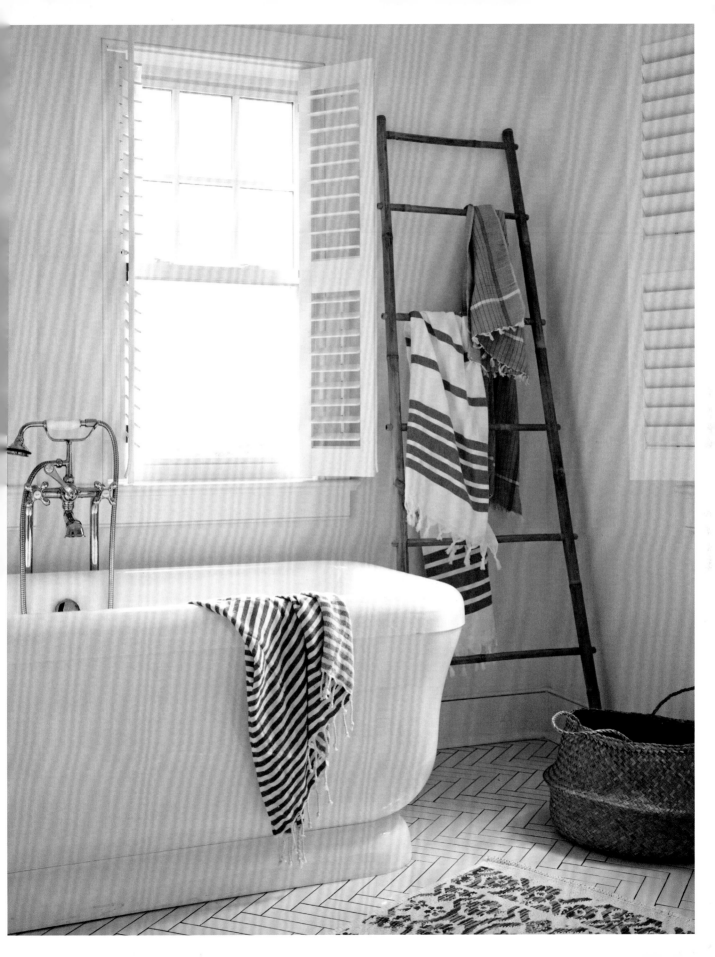

LOOK DOWN

Next look to the floor. If you don't have a beautiful floor, there are still lots of ways to use this surface to your advantage.

Stephanie Pesakoff, a pattern lover and Brooklyn-based illustration representative, warmed up her bathroom by placing a vintage rug on the floor. This makes the space feel more like the rest of the home. It's a great trick you can use, too! You can layer a bath mat on top when needed—consider one with a raised sculpted patterned versus a print to add texture. Or go bold with a pattern—allover-printed designs hide dinginess better. Another option to consider is a small indoor-outdoor rug.

While Stephanie chose a rug in rich hues, she still wanted her space to feel light and airy, so she kept the rest of the space simple with just a striped shower curtain. Notice that the stripes are on the bottom portion of the shower curtain, allowing for the white space to keep the overall feeling bright.

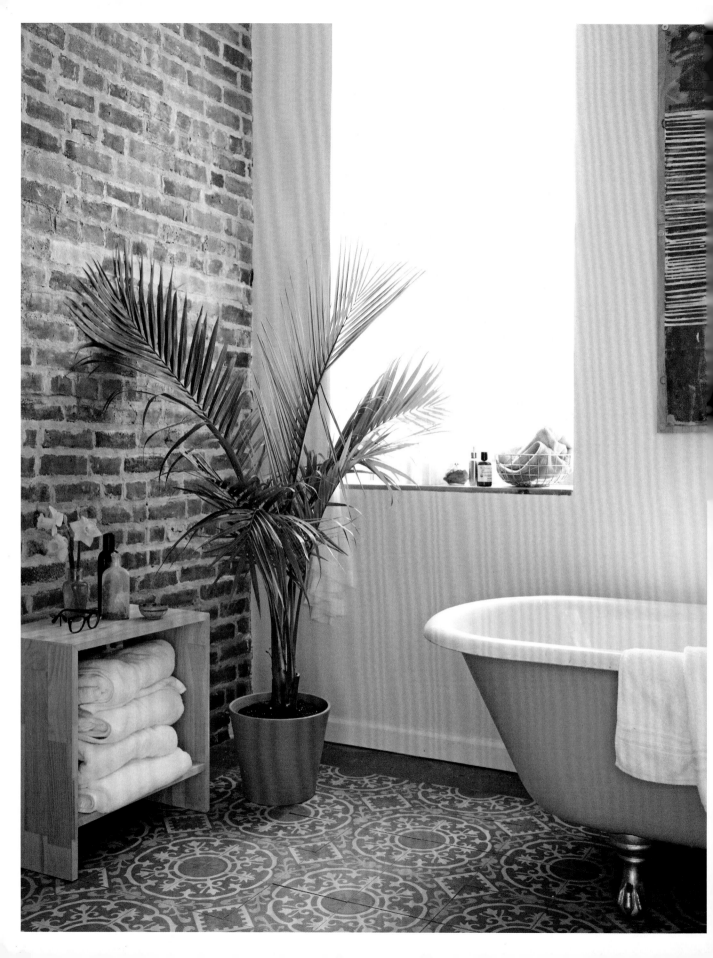

THE POWER OF TILE

Don't underestimate the power of tile. It's practical, but there are many options and a ton of ways to experiment. A larger-scale patterned tile can create a story and also looks great mixed with solids or even brick. A small novelty tile, or grouping, is a chance to get more personal. Tiles can transport you, so investigate what's typical to other cultures, too.

MAKE IT
YOUR
OWN

Use contrast to enhance the feeling of calm.

Take décor cues from bold patterns but use them in more subtle ways, such as a more subdued version of a pop color.

Create an unexpected pattern moment in an adjacent hallway, or on a door or a ceiling.

If wallpaper isn't an option for your space, adding a floor runner or even painting the walls a bright color may serve the same purpose.

IN THE DETAILS

The little details make a space personal. In addition to the pattern of your towels, shower curtain, and bath mat, consider hanging textiles instead of art as well. You won't need to worry about water damage or humidity, and they can make the space feel cozy.

Hard goods are also key in small spaces. One of my personal décor peeves is matching bathroom accessories—your soap dish, toothbrush holder, and cup—just because there are so many other options. Instead of a set, just look for beautiful vessels. Mix materials, finishes, and patterns. Consider a carved marble dish, a vintage brass cup, a Japanese tea mug, a vintage ceramic ramekin, an old candle jar with a great label, or even a small enamel pitcher with a sponged design. And your trash bin can be a natural basket, a big ceramic vase with a wide top, or a vintage metal bucket with a painted design from the flea market. Get creative!

MAKE IT
YOUR
OWN

White subway tiles are always classic and can be inexpensive.

Pay attention to texture within your white base and add patterning where possible.

Patterns are better mixed—don't buy matching sets.

Think outside the box when it comes to accessories, and repurpose vessels from other rooms.

Consider textiles beyond terry cloth towels.

FINDING A TRANSITION

Part of what makes a bathroom relaxing is also the context of what surrounds it, so consider how pattern can create a transition. Angie Hranowsky, whose work you may remember from the bold entryway on page 80, chose a similar tactic for the hallway leading to the master bath and bedroom, but this time she used graphic gold geometric wallpaper. The pattern is elegant, but the large scale makes it bold, too. Here the patterning isn't actually used within the bathroom, but it helps make that space feel more serene in contrast with its entrance. Patterning can set the stage, without even being used within the space itself.

The bathroom is neutral with gold accents, including a brass light fixture and grass-cloth wallpaper with a subtle gold sheen to it. These pick up the gold from the hallway wallpaper, but in a much more subtle way.

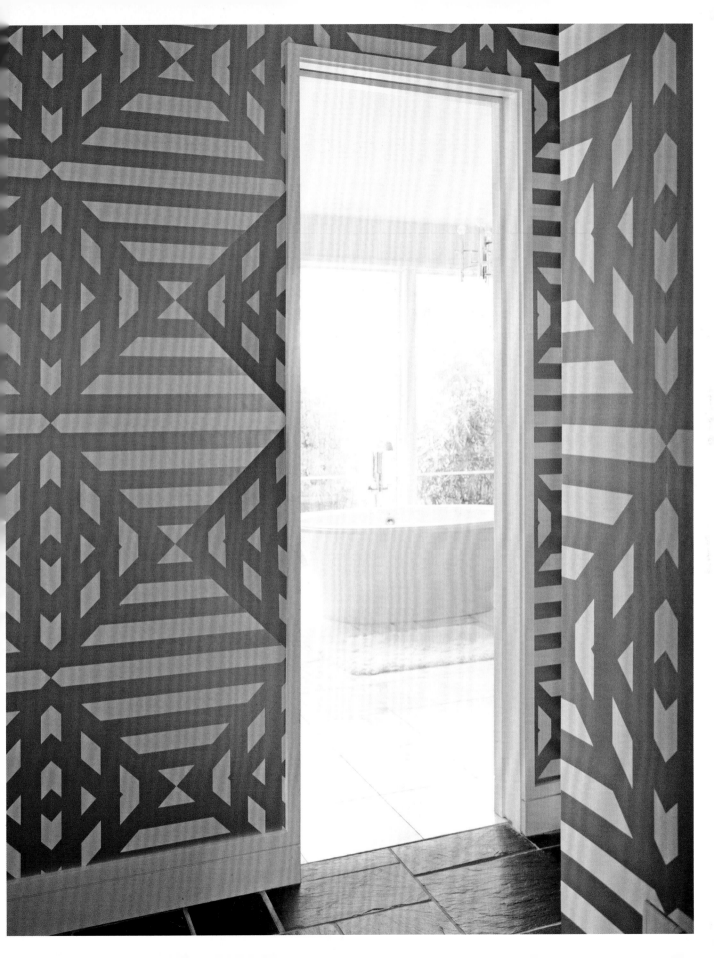

CONNECT WITH NATURE

Nature is a grounding force that we often rely on to refresh our souls. For some it's the woods, the mountains, or the desert; for me it's definitely the ocean. Bringing nature into the bathroom is a way to renew, which is ultimately what this space is all about.

This elegant modern bathroom by Kiki Dennis is all about natural textures. The teakwood and marble tiles provide subtle patterning and contrast within the space. The wood grain is elongated and almost becomes a soft painterly stripe, while the marble has the appearance of shimmering water but in a tonal gray palette. Kiki's textiles are simple and classic. While you may not be able to take on a renovation of this scope, you can still take lots of cues from this space. If marble is out of the budget, look for a pattern that has a similar feeling—something organic that has soft blurry lines or a design that abstractly references water.

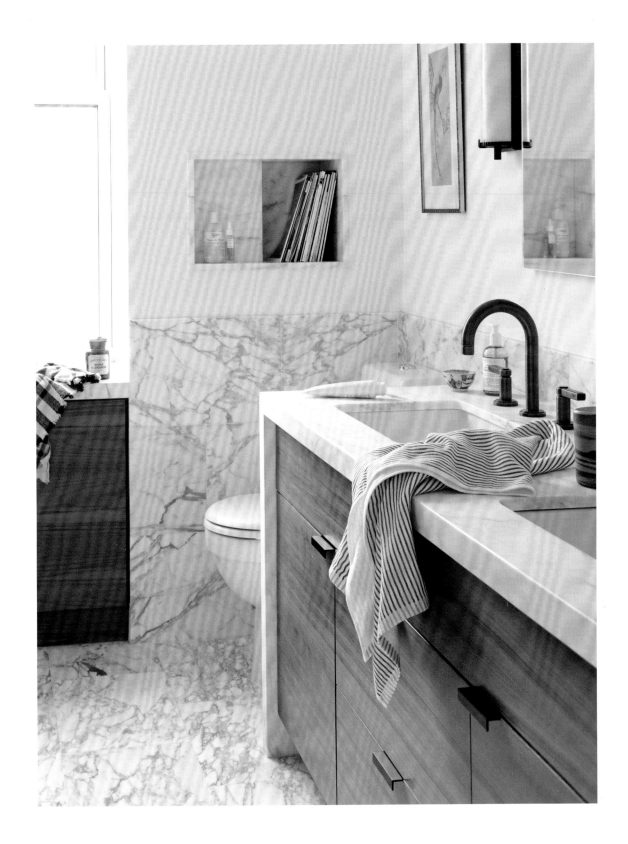

PLAYING WITH REFLECTION

Mirrors are a great way to emphasize pattern. The scale of the pattern in the reflection will be smaller, and it's a fun way to play with distortion and scale mixing.

PLANT LIFE

I'm a big fan of plants in the bathroom. No window or very little light? My friends at the Sill, a delivery-based plant store, recommend the snake plant, Sansevieria trifasciata, and the ZZ plant, Zamioculcas zamiifolia, as both can tolerate poor or artificial light. They don't recommend keeping them in a closed closet, but they can survive (though maybe not thrive) in extremely low-light levels.

MAKE IT
YOUR OWN

Pick textures that speak to natural places you love. Think of wood, stone, marble, and plants.

Contrast refined textures like marble with earthier ones like wood.

Keep textiles in classic patterns that don't distract from the overall natural theme.

Go bold in a small space.

While you may want to go neutral with a master bathroom space, a powder room is the perfect place to go bold since you don't spend too much time there. And it's easy to make a big statement in a small space.

Renée Shortell, one of the founders of the print studio Anona, lives in Philadelphia in an old home with many floors, along with her husband, daughter, and two dogs. Their top-floor powder room has character, with an unusual triangular window that adds graphic lines as well as a perfect spot for a plant, but they also wanted an impactful update that brought in nature. The bold, swirling blue marble pattern gives instant punch but also refreshes.

BEDROOM

WHILE SOME people's favorite room is the kitchen, mine may be the bedroom. I love to get in bed early and curl up with a good book—and I love to sleep! A serene and peaceful bedroom is extremely important to me, and it helps me decompress from the busy day. The bedroom is your most private space, a place to rest, rejuvenate, and find a bit of peace from the world, so here pattern should be personal and comforting.

Growing up, I remember the simple pleasure of changing the bedding with the weather. My mom would put on flannel sheets in the winter and pile on the blankets, since half of our old Cape home didn't have heat. In the summer we'd open all the windows and use crisp, breathable sheets and thin blankets. I remember when I got my own room my mom and I went shopping for bedding. We found reversible Laura Ashley bedding on sale—one side had a floral print with a light ground and the other was the same print but with a dark green ground. We used the sheets to make matching curtains and even painted the floor to match the marine-green hue. It was such a special moment, and I still remember that bedding so well because it was something we picked out especially for me.

The most important element of the bedroom should be a place to recharge and rest. Of course, this means different things for different people, but pattern can help you create that mood. Think about the places and things that make you feel recharged. Dark and cozy or light and airy? A peaceful and serene space may be what lets you unwind, or conversely, a space filled with visual inspiration could provide you comfort. Investigate this on a personal level and make this place your retreat.

PART OF A WHOLE

Think of the rooms in your home as you do pieces of furniture within a seating arrangement: they are parts of a whole, but each has its own personality—just like the people they are designed for. Ideally you want some continuity among rooms so it doesn't feel like you've entered a different house when you move from one room to another, but they should still stand independent and maintain their own identities. Let's look at two bedrooms by Brian Paquette in the same house. Together they are a great example of how you can take similar spaces and furniture and make distinct but cohesive looks.

The first bedroom is softer in mood with pale blue-green walls. While both rooms have white wrought-iron bed frames, in this space the shape—with curved lines and subtle scroll details—is more romantic and dreamy. Small-scale prints build texture, and a plaid kantha quilt goes beyond basic with a unique color palette and small sewn patches. The fabric on the blinds furthers the dreamlike feeling, referencing stars glowing at night.

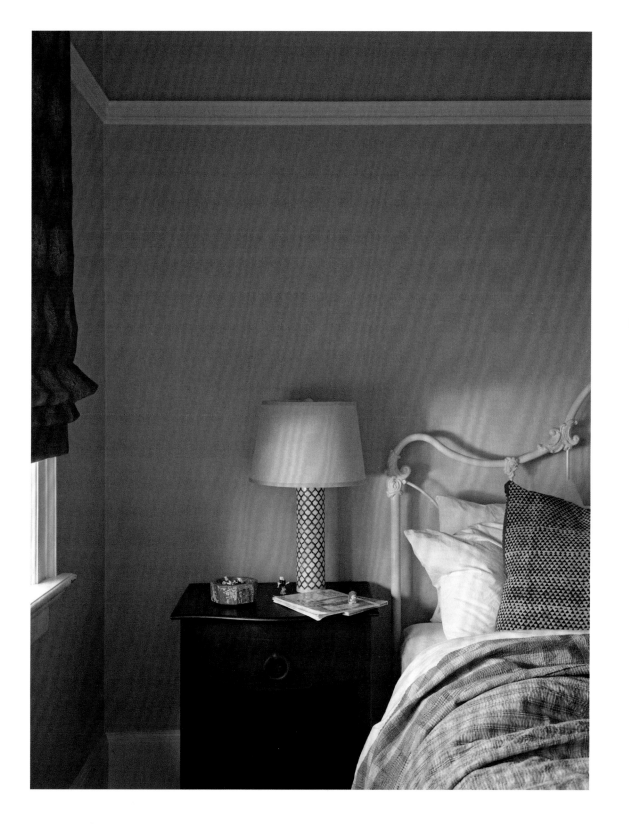

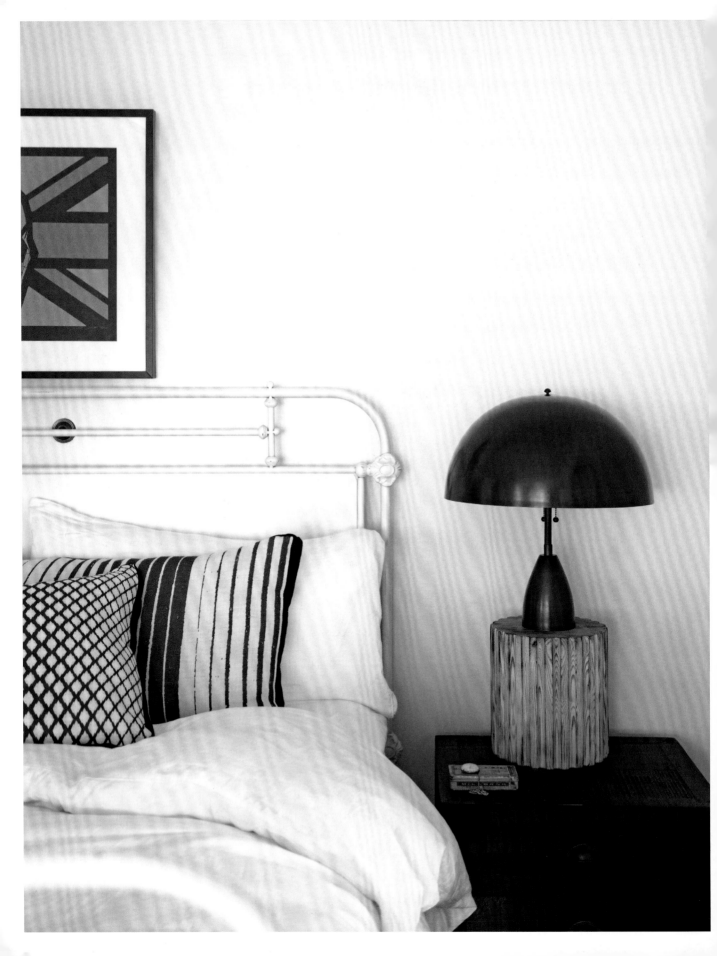

The second room relies on a crisp black-and-white palette and high-contrast elements to bring a graphic edge to a calm space. Here the setup is similar, with the light bed frame and dark side table, but the look is more structured and geometric. The palette and accessories build on this story. This room not only relates to the other bedroom but also other spaces within the home. Stripes are a common pattern in this home; they also appear in the living room, as seen on page 98. In the bedroom we explore this motif again as the stripes act as a directional map, leading your eye from one piece to the next. The ridging on the wood base of the lamp mimics the striped pillow. The black graphic shapes of the lamp play nicely with the diamond shapes on the pillow, emphasizing a secondary geometric theme. If a crisp, clean space makes you feel at ease but your overall taste is graphic, not subdued, consider how Brian has combined those needs here. Just a few accents can take a white bedroom and make it striking.

MAKE IT
*YOUR
OWN*

Decide on overarching décor values for your home, like crisp and clean, that all rooms should reflect no matter what.

Use color and accessories as tools to make individual rooms feel unique.

A little continuity can be as simple as reintroducing or reinterpreting elements used in other rooms.

Consider bigger items like furniture as a way to provide unity throughout the home by making sure they have an aesthetic connection on a broad level—think design period, materials, and color.

RECHARGE AND CALM

Newlyweds Kate Dougherty and Ben Towill embraced their new home in Charleston, South Carolina, by taking on a massive renovation. Their move from New York not only gave them a slower pace but also more space! Kate draws a lot of design inspiration from Santa Fe, a place where she experiences incredible energy, particularly visiting Georgia O'Keeffe's home there and viewing her landscape paintings.

She believes in tranquillity over statement-making and that working well with pattern means knowing when to use it and when to hold back. In this minimalist bedroom, Kate added patterns in a throw pillow and the tiles but held back on bigger items like the bedding, as large pieces aren't as easy to replace when you want a change. This bedroom is all about simplicity and hangs together because of the attention to detail in the materials. The bed frame has wicker detailing, which references the gridded patterning inside the fireplace, the surrounding tiles, and even the large grid motif on the pillow. The Moroccan rug and the wood floors have tonal striping.

In calmer spaces like the bedroom, focusing on the textural base becomes even more important. First consider the items you'll touch most frequently. Your bedding can be a mix of crisp, cool percale; slubby linens; and woven blankets. Your bedside nightstand can be a soft worn wood or have a marble top that's cool to the touch. When you step out of bed, perhaps you want your feet to hit a soft shaggy sheepskin, or a tufted antique rug. If you do consider yourself more of a minimalist, start with the foundation and the things you touch and use most within a room. Look first to these surfaces to build the pattern story. This way you can have less, but everything will still feel considered.

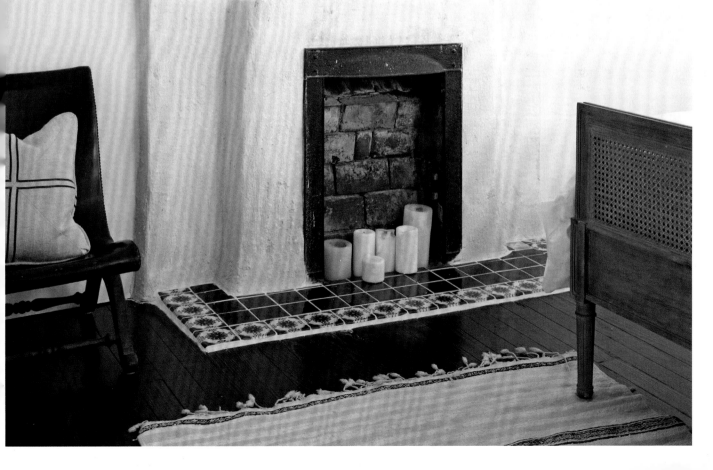

"I EVEN HAVE A TILE I FOUND IN SANTA FE THAT I MIXED IN WITH THE MOROCCAN TILES OF MY FIREPLACE FLOOR IN MY BEDROOM. THE TILE IS OF A PAINTING OF THE DESERT VISTA AND MAKES ME HAPPY EVERY MORNING WHEN I LOOK AT IT."

—*Kate Dougherty*

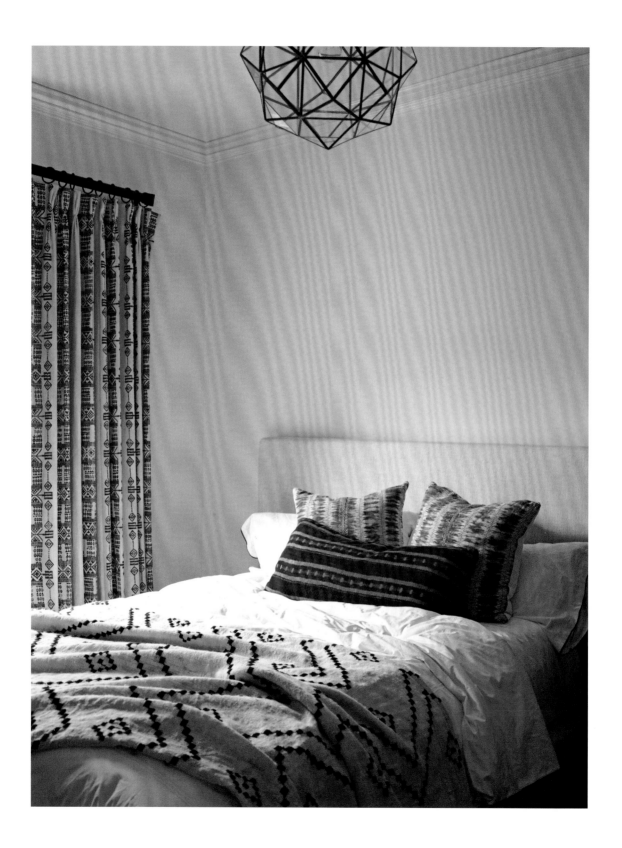

This extra bedroom, in a home by Sway Studio, is a space for guests to stay and, thus, a little less personal than other spaces within the same San Francisco home. This bedroom makes the most of a small space by keeping the overall feeling soft and light with an emphasis on neutral patterning. Remember how impactful repetition can be? The curtains provide a textural, tribal-inspired backdrop that's picked up again on a much larger scale with the throw at the end of the bed, as well as more abstractly in the lighting fixture. The key here is for the pattern to appear soft. Even geometrics can feel this way if they're woven or hand-painted, and if they're in the right color palette. Classic blues, ranging from bright cobalt to deep indigo, are added to the top of the bed as pillows. These cool-toned accent colors keep the room from feeling too dry or too neutral.

MAKE IT
*YOUR
OWN*

Make simplicity work by focusing on textural elements, such as stucco, wood grain, wicker, tile, and woven stripes.

Choose patterns that feel calm but still impactful—such as designs with bold motifs but neutral color palettes, soft painterly marks instead of sharp edges, and lots of white space.

Consider adding just *one* narrative element—an accent tile, pillow, or piece of art that has special meaning.

Contemplate how architectural elements, such as a fireplace, windows, or sconces, can act as pattern.

Blue, used in an otherwise neutral space, can soothe like a pool of fresh water even when used sparingly.

Consider a graphic lighting fixture that plays off of textile patterns.

BOLD AND COZY

While some people recharge through calm, others need more visual stimulation to feel comfort.

Huy Bui puts a new spin on the phrase "bachelor pad," as his studio apartment in Brooklyn is filled with plants and other beautiful treasures. Since the space is one large room, keeping the tone simple but impactful is important—and a balancing act!

The interest in this bedroom area comes from a vintage red-and-white quilt that hangs over the platform bed. Thanks to the low bed and the high ceilings, there's plenty of wall to use pattern as a tool to frame the space. It's personal and, despite being vintage, still modern and in Huy's taste. The simplicity of the design makes it graphic, but knowing it was hand-pieced with care makes it even more special. This quilt ties into the bedroom space through another red-and-white print on the pillowcases. While the pillowcase print is a leafy floral, referencing Huy's love of plants, the overall vibe still feels masculine because of the bold coloring and other graphic details.

If neutral spaces don't make your heart sing, consider how you can balance the need for recharging with bolder pieces. This space works design-wise because the bold red hues are harmonized with earthy details like the army-green blanket and terracotta pot, as well as wood and natural textures. The wood can hold its own against a strong hue like red. Cooler textures like marble, stone, or cement would contrast the red and make it seem even bolder, so it's important to think about what natural elements intrinsically go with certain colors. On a broad level, this goes back to color basics. Instead of choosing cool light-colored materials when you have a strong warm palette, choose warm mid-tone colors. The wood is warmed up when placed next to red, which brings out those tones. The subtle greens in this room, red's complementary color, also enhance the reds in the wood and in the terra-cotta, and the bright green of the plant pulls out the green in the blanket.

RED AND WHITE

These quilts have a long history in America and became popular in the late 1800s when "Turkey red" dye became widely available. Turkey red dye, made from the rubia plant, was originally very expensive, as the process to make it was labor intensive. During the Industrial Revolution, advances in synthetic dyes made this color available to the masses.

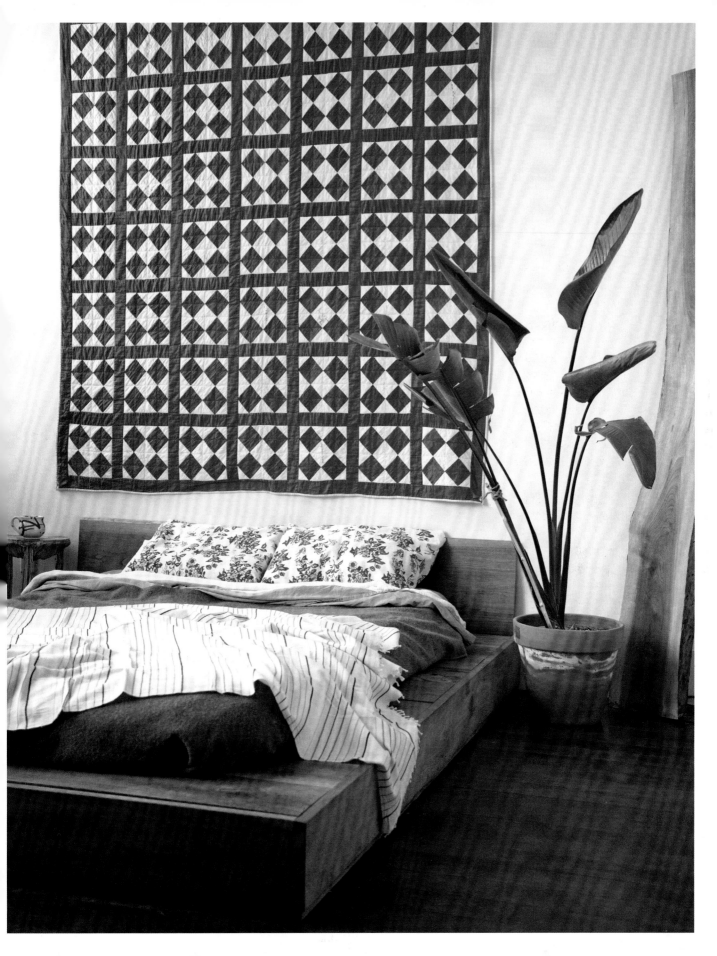

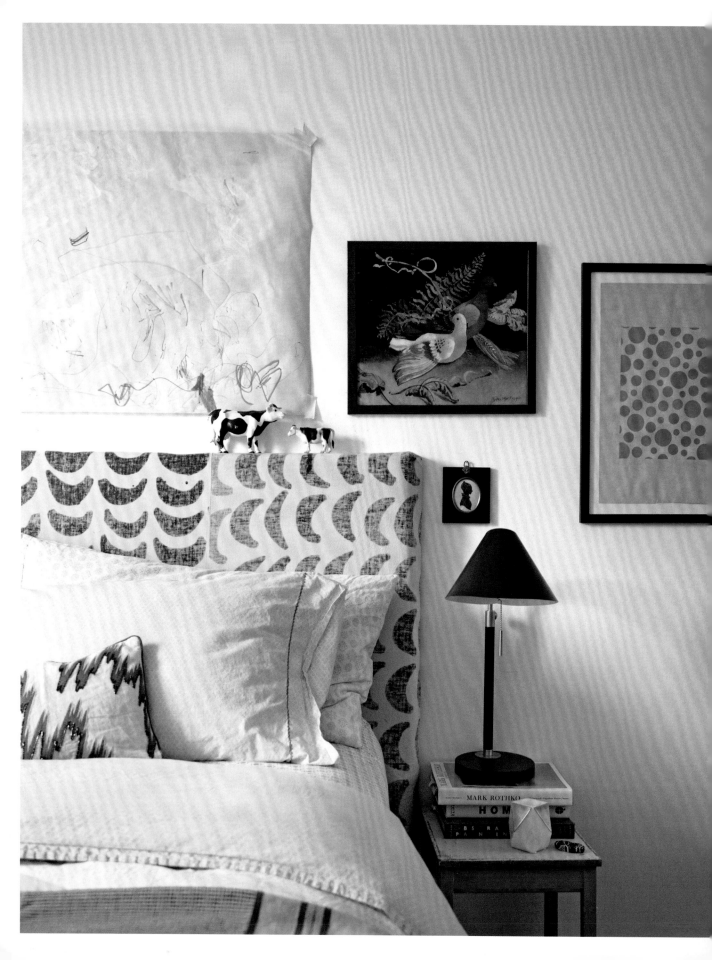

Kate Loudoun-Shand's master bedroom is warm and cheerful, a representation of the family that lives here. For Kate, a designer and creative director, it's important that her bedroom be a place to rest and reboot, so that she can wake every morning with fresh eyes. This room is her place to play and practice with design ideas. She brings home samples from work, mixing them in with old favorites. Seeing them in her personal space always shines a new light on design choices.

One of the most eye-catching pieces in the room is her headboard, made from fabric she printed herself. Here she's actually used the reverse side of the fabric to give it a softer look, as it's a high-contrast design. The right side of the headboard is oriented in a different direction, breaking up the repeat and adding character. Offsetting or changing a pattern by repiecing adds a subtle shift that allows you to play with proportions and customize a print. Above the bed hang two drawings made by the couple's middle child, Sophie. The transient nature of taping up artwork feels fresh and easeful; it's the mark of a true family home. The bedding is a mix of old and new. Kate combined an antique patchwork quilt with several different sheeting prints and a decorative pillow of her own design.

If a cozy and collected room speaks to you, remember that color can keep it from feeling chaotic. It's all about keeping to a more limited, but rich, color palette. Consider letting dark neutrals have the impact, followed by a primary mid tone, and then an assortment of paler hues. The larger dark areas, whether they are walls, furniture, or even accessories, will deepen the tone. The mid-value colors give a cozy feeling when used in larger amounts. Limiting your overall color palette keeps things calmer. Take a good look around the space every few months. You can always tuck away items, change artwork, or rotate favorites to keep your objects from overwhelming a space.

MAKE IT
YOUR
OWN

Larger pieces define the area and are also great for filling space and telling a story.

Remember the impact color can have on the feeling of a pattern—for example, keep the color of a feminine print vibrant if your overall style is extroverted.

Consider what natural elements go with your color palette and aesthetic sensibility.

Make your own bed skirt with heavyweight canvas by tucking pieces of fabric under the mattress on three sides. Embrace the raw edge, and don't hem the fabric.

Hang homemade artwork on the walls with masking tape and enjoy the impermanence.

Mix sheet patterns instead of going for a matching set.

Upholster your own headboard and consider the reverse side of the fabric, too. It's a pretty simple project, and you can easily change the fabric, so don't be afraid to try something bold (see page 270).

Evaluate what items make you happy and pare down if needed.

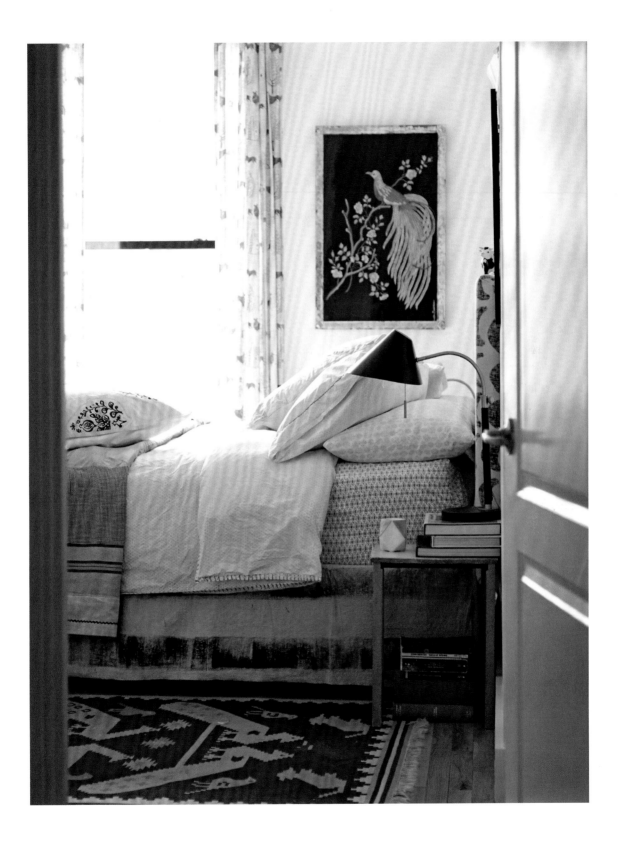

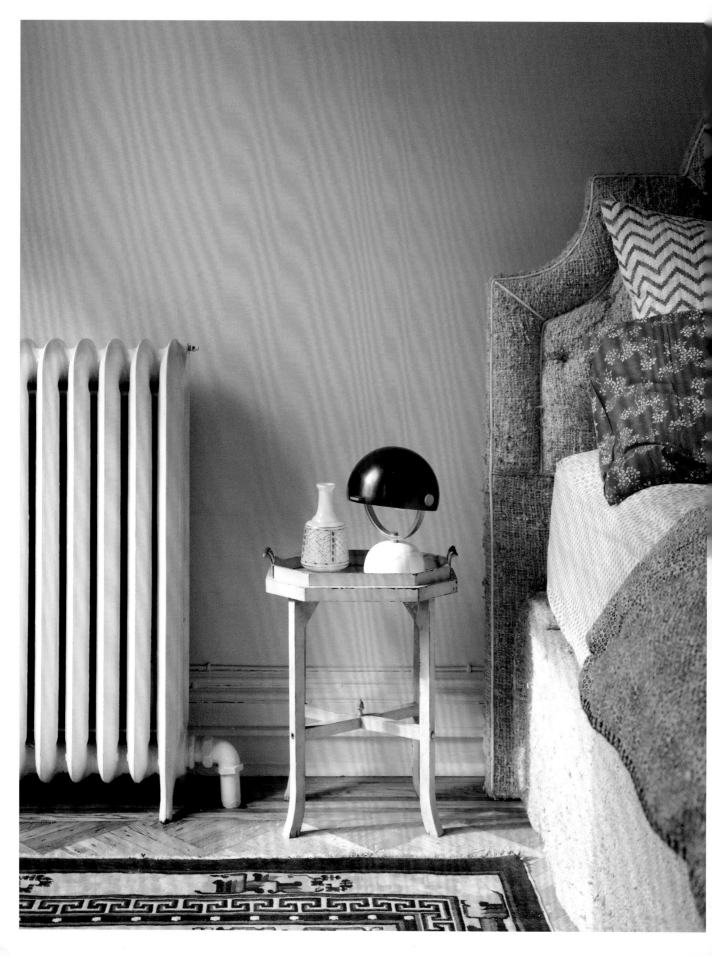

BEYOND THE BED

While the bed is the obvious focal point of the room, don't forget the surrounding area is also full of opportunities.

The nightstand is a great place to add little touches of pattern. You could consider a statement nightstand—using the furniture itself to bring in pattern with its inlays and construction. You can often find interesting pieces with more character at antique shops. You can also embellish a plainer side piece with a scarf or runner on top—as a bonus you get to use up extra fabric or pieces too small for anything else. I'm always falling in love with beautiful patterned ceramics; displaying them—as well as jewelry and other small trinkets—on the nightstand or a little shelf at the side of the bed is a nice way to enjoy them every day and a practical place to store them. If you only have a small space, try pattern on a lampshade (see page 272), or a small rug by the side of the bed—also a nice way to define the space and keep your feet warm!

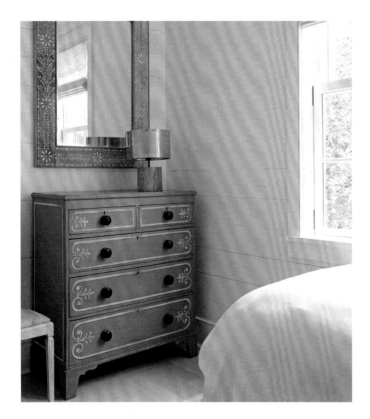

I f you like a white bed, the other elements in the room, such as a dresser, can become more important for bringing in visual interest. Jenny Keenan decorated a guest bedroom with a sage-green dresser, which has a scroll-leaf motif, and a wooden mirror with floral detailing. When the sun hits it, the mirror's mother-of-pearl glitters, which is accentuated by a tin shade. Oftentimes people choose solids for both the dresser and the mirror, but here you can see how unique patterned pieces can make a statement.

If you have a separate walk-in closet, treat it like a room, as Wendy Wurtzburger Bentley has done. A quirky parrot pattern, such as the one on the armchair, could be tough to mix in a room, but because of the muted coloring and painterly drawing style, it's quiet enough to play with other patterns. The color is perfect with the butter-yellow doors, and it's enriched with the multicolored rug. Wendy treats her closet like a room, which is a trick we can all borrow for a walk-in space. If you only have a small closet, consider adding a novelty knob or even hooks on the inside of the door. Wallpaper or a fresh coat of paint can also create interest and personalize the space.

MAKE IT
YOUR
OWN

With simple bedding, bring in pattern with other major pieces.

Texture and shine are soft ways to play with pattern and complement a white bed.

Treat your dressing area as a space of its own, getting personal with pattern.

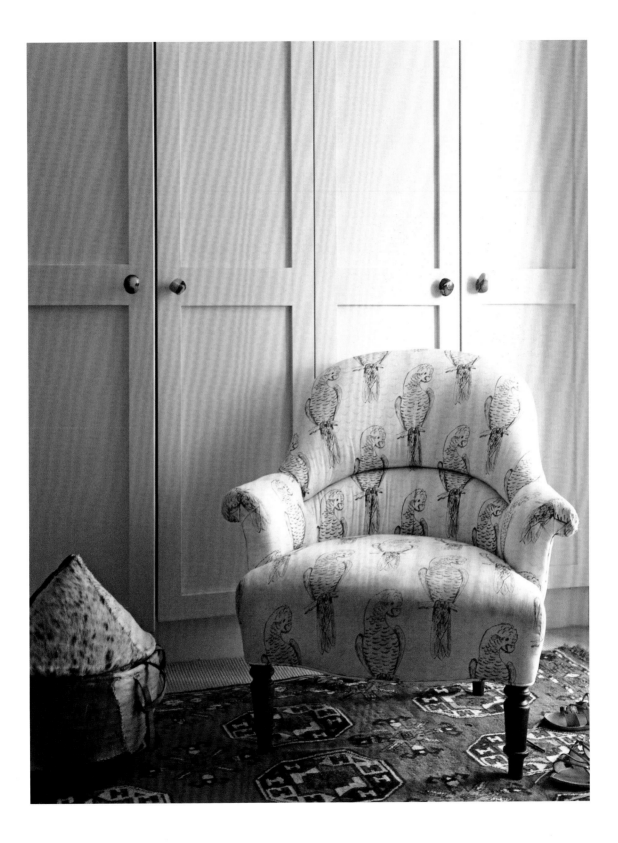

THE BALANCING ACT

When a room is meant solely for you, it's easier to make decisions, but the bedroom often balances a couple's shared needs, or reflects what another family member or guest may want.

Abstract painter Michelle Armas's bedroom feels almost velvety with its warm gray walls, shaggy Moroccan rug, and layered patterning. She balances her need for constant visual inspiration and pattern with those of her husband: comfort, practicality, and modern lines.

Michelle sees taking the needs of others into account when decorating as a way to show love. The modern bed is completely her husband's style. The headboard is the right height for sitting up in bed, but low enough that it still feels modern. The bedding is kept mostly neutral with a matelassé quilt, Moroccan wedding blanket, and a mix of prints on the pillowcases. These tonal and textural patterns also speak to her husband's need for peace and calm, but they are interesting enough for Michelle. The red suzani pillow may feel counterintuitive, but it gives this pale bed a pop that pulls out the creams, purples, and blue-greens, and speaks to Michelle's need for visual stimulation. Its patterning is bright and bold but doesn't feel out of place because it relates to the area across the room that is anchored by a velvet chair, framed artwork, and pillows by Josef Frank. She found a number of different ways to incorporate textural pattern, too, which helps to balance the bolder moments. She loves animal hair, woven straw, caning, leather, glass, and metal with bubbles and pleats, as seen on her side table. Their bedroom speaks to both of their wishes through pattern.

Sit down and talk with your partner about what recharges him or her. If you have opposite preferences, consider how compromise and balance can create an even better, more interesting space that tells your *shared* story.

THE PATTERNED OTTOMAN IS HEAVILY LAYERED WITH PIECES MICHELLE COLLECTED: A BASOTHO BLANKET FROM A SOUTHERN AFRICAN TRIBE, A STACK OF TEXTILES, AND A SHEEPSKIN.

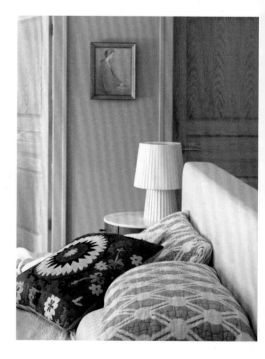

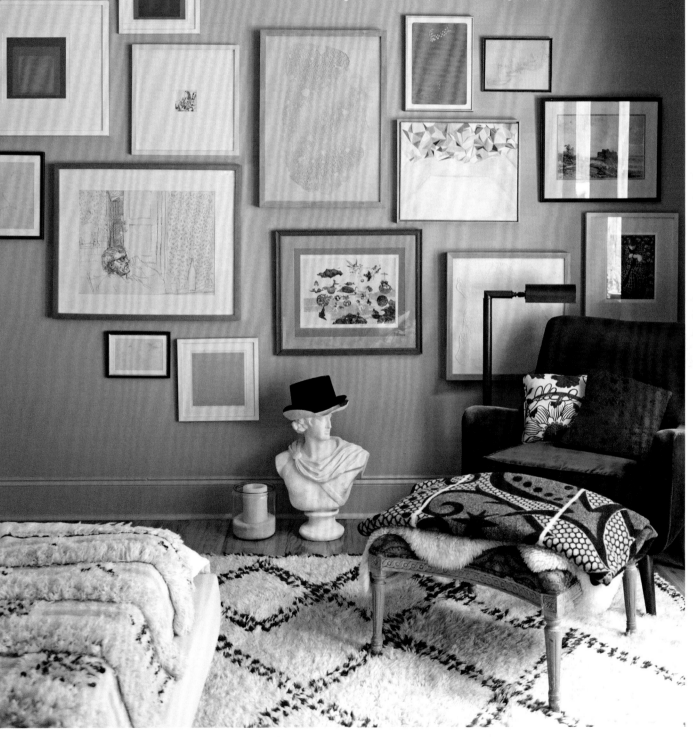

GENDER NEUTRAL

Finding common ground in bedding can be tricky. Mixing up your sheet sets and various patterns within your linens allows a couple's different tastes to be expressed. In my home I can easily slide in a set of purple pillowcases if the rest of the bed is more gender neutral. If your partner loves classic but you prefer bohemian, incorporate them both in smaller ways. Mix clean plaids, or use a tailored duvet with Indian block prints. A style with more than one design element is always more interesting anyway.

COLOR MIX

The yellow in the painting pops up again in the embroidered floral motifs on the tiny red suzani pillow that's paired with two larger pink cushions.

Considering the needs of others comes into play with other rooms in the home as well, but it's especially true in sleeping areas. A guest room can have your aesthetic preferences, but it should also address the care and welcoming feeling you want to extend.

Sally King Benedict is known for her paintings of faces. Powerful with bold sweeping marks and distinct colors, they have a magnetic spirit, and for Sally they represent a home guardian that protects us. Sally hung one of her simpler pieces in her extra bedroom, representing her hospitable heart and giving protection to her guests. It perfectly sets the intention of the room and its visual tone. The bold black marks in the painting are accentuated by the room's simple black-and-white color foundation. The dresser is graphic, and the knobs and drawers assume a subtle dash patterning. The *bògòlanfini* blanket covering the headboard relates to the graphic language of the drawers and knobs visually. This fabric (also known as mud cloth) has special meaning within the Malian culture, and each one has a specific story known only within that community; again, Sally highlights the concept of personal and special meaning within an object. The room is rooted in hospitality but still feels like Sally.

Try patterns that abstractly speak to protection or love. Mandalas are spiritual symbols in Indian culture that represent the universe and being part of a whole. Native American dream catchers are meant to protect you from negative dreams by filtering out the bad dreams and only allowing the good ones to pass through. Objects and patterns can hold more than just beauty—they can tell a story and our intentions, so consider the deeper meaning behind them, even if it is one you have created yourself. And as seen here, they can be a great starting point for decorating a room.

MAKE IT
*YOUR
OWN*

Balance people's joint needs by picking your pattern moments.

Focus on textures to bring in luxury on the items you use most.

Objects, art, and patterns can have embedded meaning, too. Find ones that resonate with your heart and display them with importance.

Keep guest room palettes graphic and simple and then add pop with pillows and accessories that you can change as desired.

Push yourself to combine colors that you might not think of off the bat.

PLAY AND REST

Children's bedrooms are another great source of inspiration for all ages. They are a place to have fun and are often created with the notion that they will evolve and change with the child (but, of course, that's how all rooms should be designed).

Keeping a connection to other rooms in your home—but with a more playful spirit—allows your story to evolve. Sally King Benedict's son, River, has a little dresser vignette in his room that works for all ages. The dresser's handles speak to the "surfer spirit" Sally wants to encourage in her son. Most of the accessories in this room can transition with him as he grows, and just a few playful pieces, including a small chair and mini plaid pillow, identify it as a child's room. You can achieve a similar look by pairing vintage elements with playful abstract shapes.

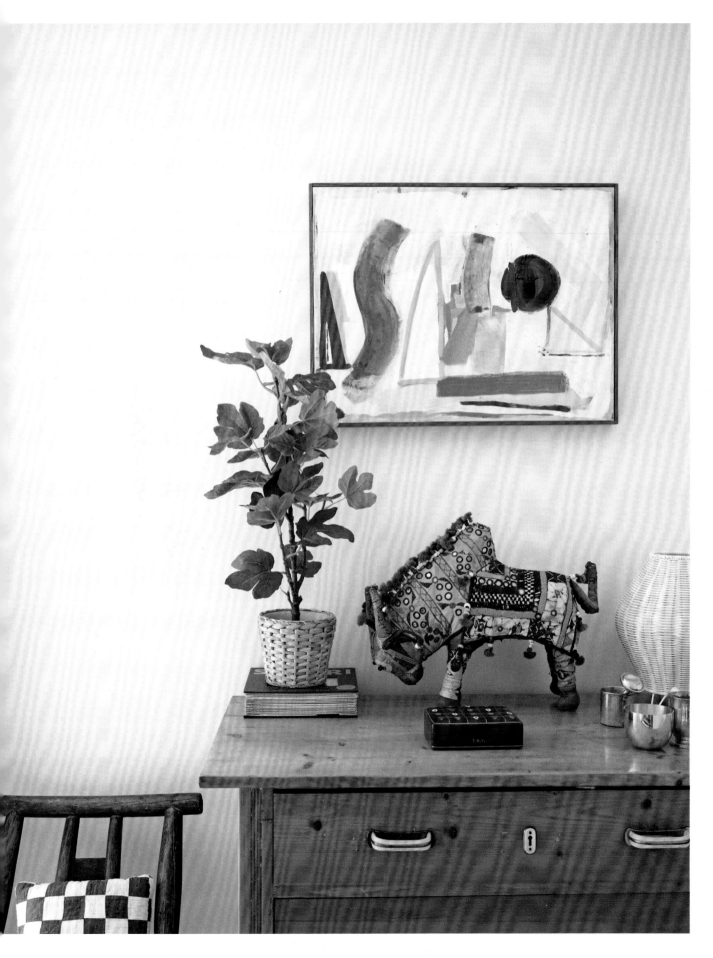

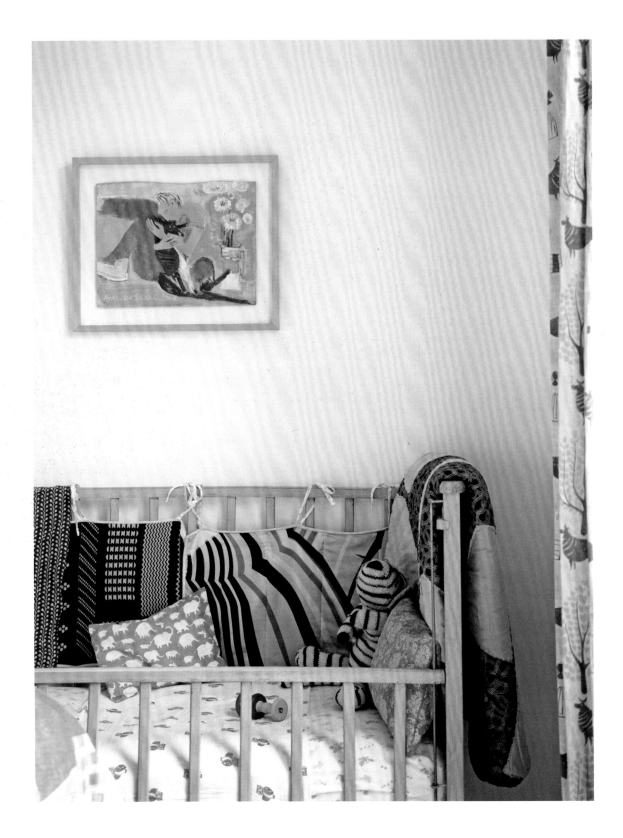

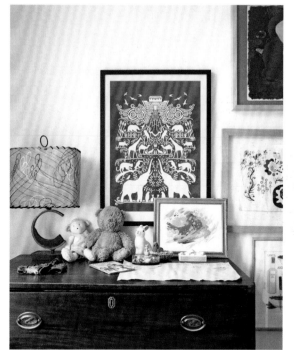

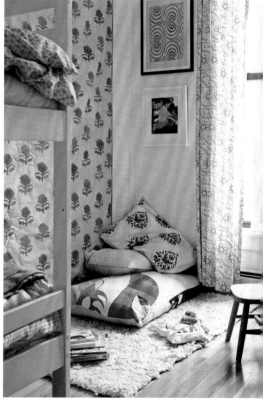

Kate Loudoun-Shand tucked a pea-green crib in the corner of a bedroom for her youngest child. Baby décor doesn't have to be soft, sweet colors—the palette can be just as complex as in any other space. The silk bumpers are made of fabrics from Kate's days studying textiles at the Royal College of Art in London. I especially love the little elephant print, where the line work is so faint that the silhouettes become abstract shapes, and thus a bit more sophisticated. The orange owls on the sheets are a cheeky complement. This room is a great example of how picking patterns you truly love can work. The common thread is that they resonate with the person who picked them out.

The rooms for the two older kids are a mash-up of prints, artwork, and toys. In one corner of the room, a pink Indian-inspired floral quilt hangs on the white brick wall, defining the little nook as perfect for playing. On the other side, the swirly patterning on the vintage lampshade complements the movements in the graphic Noah's Ark artwork to the right. While this is clearly a kid's space, most of the patterns could be used in an adult room. It's the mix that makes this room playful.

In the bedroom of Lindsey Carter and her husband Wes's twins, scale plays a huge role. Lindsey worked with Haskell Harris, decorator and *Garden & Gun* editor, to make the space come alive. Haskell took cues from Lindsey's clothing line to bring in interior print options, but she also wanted to balance them with Wes's more traditional side. They chose green as a gender-neutral color. The bold kelly green gingham floor makes a statement and really show the impact of going big with a pattern—but notice how the large scale keeps it livable and modern. Since gingham is such a traditional pattern, it could easily go saccharine in a nursery, but blowing it up and doing it in this summery, happy color really set a sophisticated tone. You could translate this idea into your home—for example, in a dining or kitchen space—just by using a more neutral color, as we saw in the beach house entryway by Jenny Keenan (see page 88). The vintage beds complement the floors and highlight Wes's taste. The soft, scalloped headboard and black-and-wood combination are elegant and help elevate the space overall. Artwork, pillows, and rockers in a green-leaf pattern tie it all together playfully without sacrificing sophistication.

MAKE IT *YOUR OWN*

Choose furniture pieces sophisticated enough to grow with children.

Use texture to make the surface cozy, and use art and accessories to make the space playful.

Pick interesting colors and combinations that go beyond traditional blue and pink.

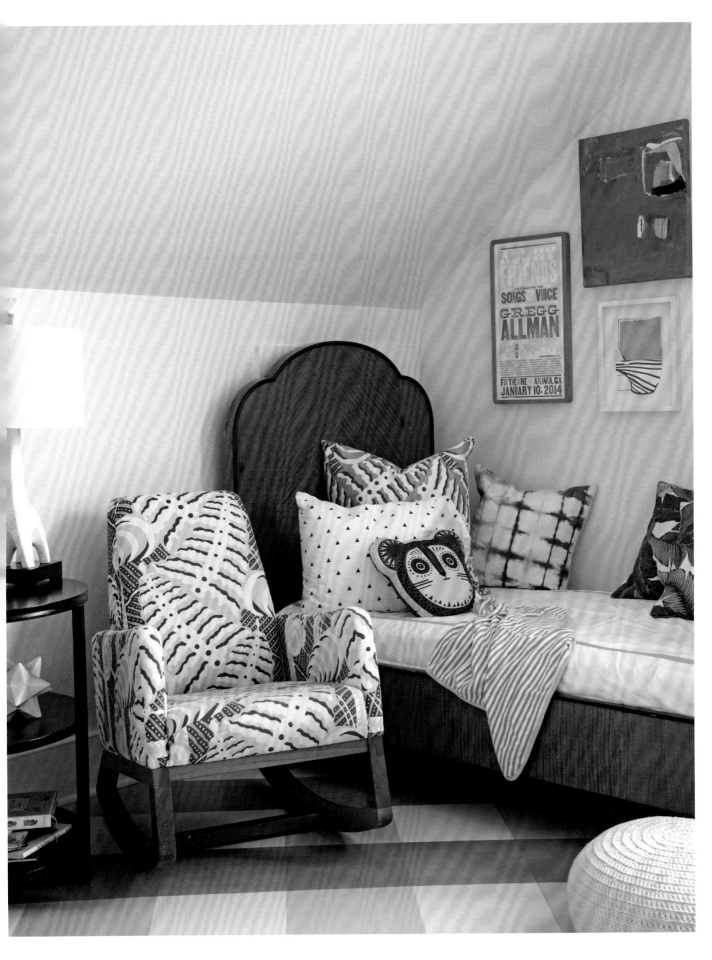

PLAYTIME

Fashioning a more playful space can be a great way to let loose and explore your creativity. Try out combinations that push your usual boundaries. Maybe this experience will spill back into the other areas of your home, too.

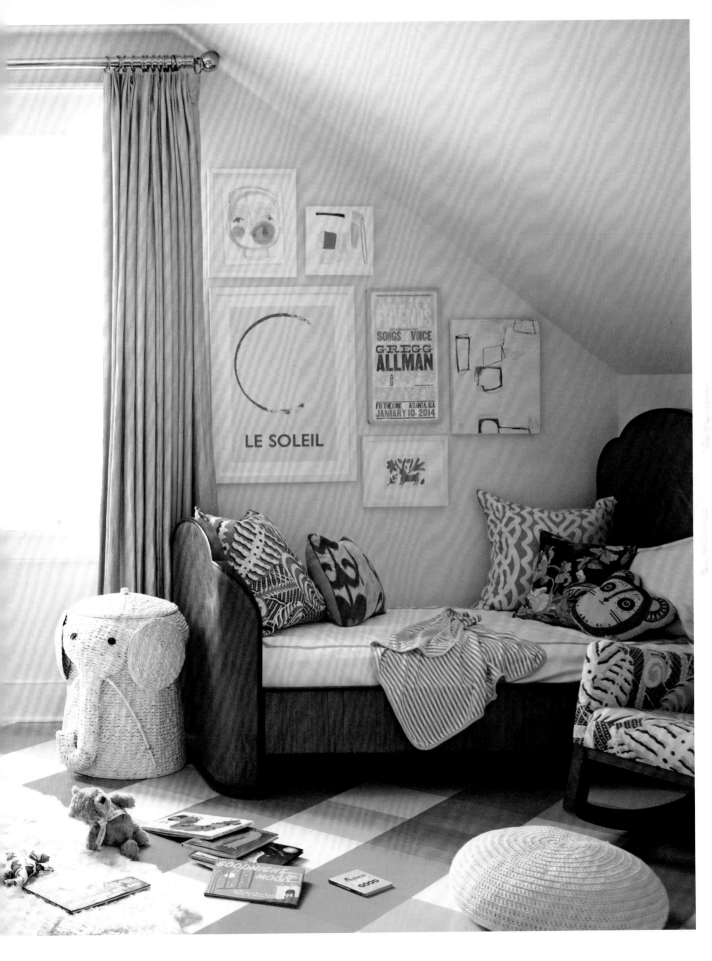

STYLE IT THE BED

The easiest way to change your bedroom is through the bedding. Start in your linen closet. When fully stocked, it's easy to create many looks that take you through all moods and seasons. Let's be honest: sometimes the matching pillowcases aren't clean, or you need to swap out your top sheet, or you spill your morning coffee on the duvet. If all your linens work together, your job will be much easier. You'll also find that your linens will last longer if you have more to rotate, and your bed will show an interesting mix. My personal feeling is that the bed should always be slightly unmade, not too perfect, as you've seen in this chapter. Embrace the imperfections and wrinkles; otherwise you'll always be dissatisfied (unless you really love spending your mornings perfecting your bed-making skills).

BREAKING UP BEDDING SETS AND
MIXING YOUR PATTERNS IS ONE
OF THE EASIEST WAYS TO CREATE
A CUSTOM LOOK. SINCE THE
PATTERNS ARE TYPICALLY SUCH
A SMALL SCALE, THEY READ AS
TEXTURE FROM A DISTANCE.

THE WHITE UPGRADE

Every once in a while in our linen rotation, I end up with an almost all-white bed, which feels luxurious, light, and clean. It's the kind of bed that makes you want to sleep in and enjoy the sun streaming through the windows. White is the default when you want that peaceful, serene vibe, but there are more options to consider. Add pattern in a quieter way. Keep the color palette soft and tonal, with a mix of white, taupe, sand, and tones verging on blush.

Texture is key. Some interest comes through the subtle finishing of the fabric—like pairing textured linen-and-crocheted Euro shams with a sateen pillowcase. Try mixing a sheeting fabric, like percale or even flannel, with a hand-knit pillow, fuzzy throw, or other textures such as eyelet, chunky woven linen, or natural canvas. It helps to have one piece that has a few tonal whites within it as well.

If you already own a set of white sheets, make sure the patterns you bring are white based, not ivory. The ground on the sheets with the small-scale print is very similar to the white in the quilt. Mixing white and ivory or cream on the bed can be very tricky, but it can be done; off-white pieces can look dirty or old next to optic white. To show you how to achieve this look, I styled graphic pillowcases and a quilt in tan and cream, which works because the pattern is all over and each color is equally balanced, allowing the print to read like a solid pale tan. It's visually clear that I'm not trying to match everything, which makes the combination work.

If you're working pattern into your bed for the first time, start with your sheets. Stripes or ditsy prints are great additions to any white bed. When making your bed, the printed side of the flat sheet is placed pattern side down; when you fold over the top of the sheet, there's a peek of pattern. It's less overwhelming, as most of your bed is under a coverlet or duvet. In this way, the sheets are an unexpected accent, and they can help you to get used to a large surface covered in pattern. Even before that, just use the pillowcases to live with the pattern for a little while before committing to a full set. If you're still unsure of trying allover printed sheets, consider solids with an embroidered or woven header detail.

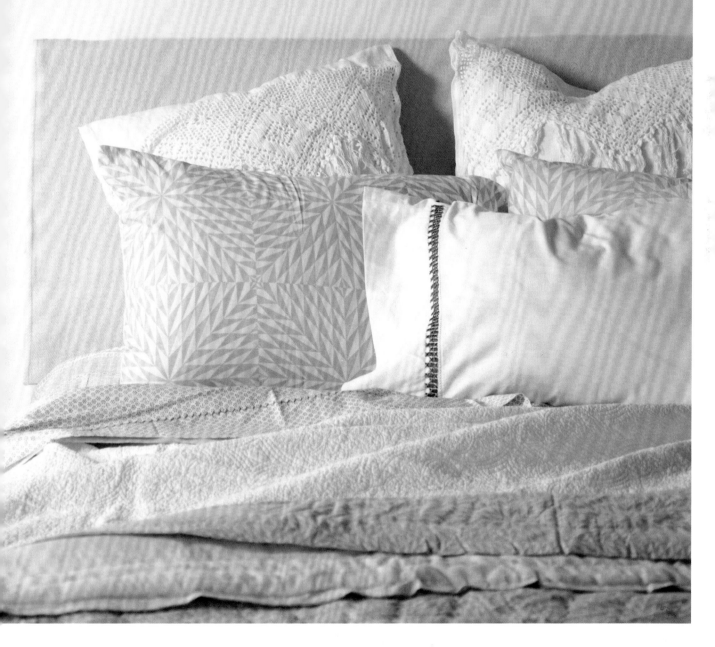

LAYER CHANGE

Here the headboard is covered with a textured throw, which is a great way to change the look of your bed without reupholstering. Try it when you want to change things up seasonally or if you're bored with your room. While we've used a solid here, you can also test a pattern without the commitment. You can use a throw as we've done here, a unique textile, or even a rug.

CALM AND COOL

This next look takes things up a notch on the pattern scale, but it remains ethereal with a watercolor-inspired print paired with tiny Indian block prints. Here the color palette and relatively small scale of all the patterns keep the bed feeling soft. The patterns almost blend together like a coastal landscape where sea and sky merge. The Euro shams layer into this blue-gray-lilac story and add a nice abstract horizontal stripe. The quilt at the end of the bed is full of pattern mixing and interesting patchwork moments that make it a true work of art. The decorative pillow ties together the whole color palette, bringing in cleaner shades of purple and blue.

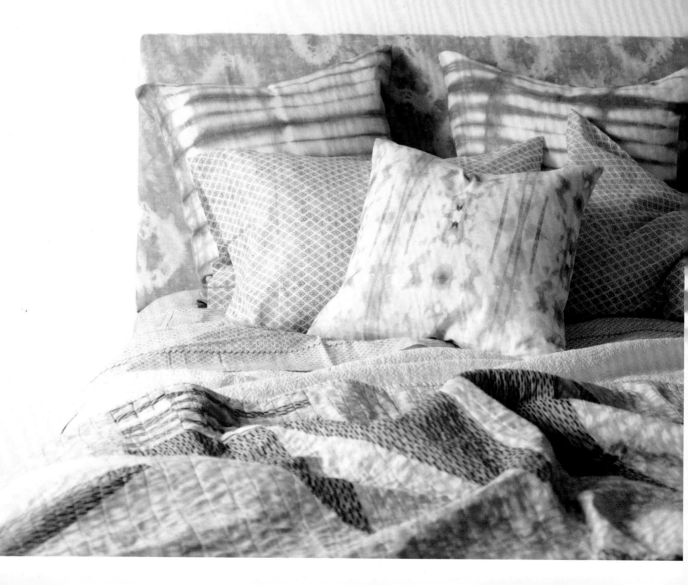

PILLOWCASES AND SHAMS

A standard sham is a decorative covering for a pillow and usually has a flange or trim of some kind with an envelope closure on the reverse. A standard pillowcase differs in that it has an opening at one end. A regular standard sham measures 20 x 26 inches (51 x 66cm), whereas a king-size sham measures 20 x 36 inches (51 x 91cm). A Euro sham uses the same concept but is square at 26 x 26 inches (66 x 66cm); it usually sits at the back of the bed. Euro shams are a great place to start adding pattern to the bed as a secondary visual element, as opposed to a duvet or even a standard sham in the front of your pillow stack. Or consider adding one long headboard pillow.

Sham

Flange

Pillowcase

Header

COTTON COUNTS

We spend one-third of our lives in bed, so to me, buying the best bedding I can makes sense—that means fabric quality. Pay attention to thread count, fiber, and weave. Thread count refers to the number of vertical and horizontal threads per square inch in a woven fabric. It is an indication of quality; a higher count means a softer hand. The fiber from which the fabric is woven is equally important, if not more so. Longer fibers make for the best hand feel. Cotton is the go-to fiber in sheeting: it is breathable, durable, and soft. Egyptian cotton is considered the finest, as it has the longest fiber length. If you don't want to splurge, look for pima cotton, which is the next best. Read the labels carefully, as marketing and packaging terms can be confusing. Whenever you can, go organic, as pesticides are often used on cotton. After that, it's time to consider the weave. Percale cotton, known for its crisp feel, is very common. It is considered a plain weave, meaning that the warp and weft threads cross over each other one at a time. If you're looking for a softer feeling, consider the silkier finish of a sateen weave. Linen and flannel are good choices, too, respectively breathable and cool, or cozy and warm. Steer clear of any synthetic fabrics or blends like polyester—they don't breathe!

BOLD AND LIVABLE

Here I've gone for full-on pattern, but it's still easy and livable. The color palette is pulled from the vintage kantha quilt. I've used a lot of the same pieces from the other styled looks, including the Indian block-print sheets and pillowcases in purple and clay, to show you other ways they can be used. The white coverlet is mostly hidden by the quilt, but it provides an extra layer of warmth. You can always show more of it to soften the color story. The large shibori headboard pillow adds impact with its rich color and larger-scale painterly grid pattern. The second yellow pillowcase is an odd match to the purple block-print one, but it brings a bit of quirk and character. For one final pop, I've added a decorative pillow in a tangerine color that pulls out the rust hue in the kantha quilt; its clean graphic pattern is the boldest one on the bed. The small-scale prints on the sheets read as textures from here, and the petals on the headboard support the potato-print pillow.

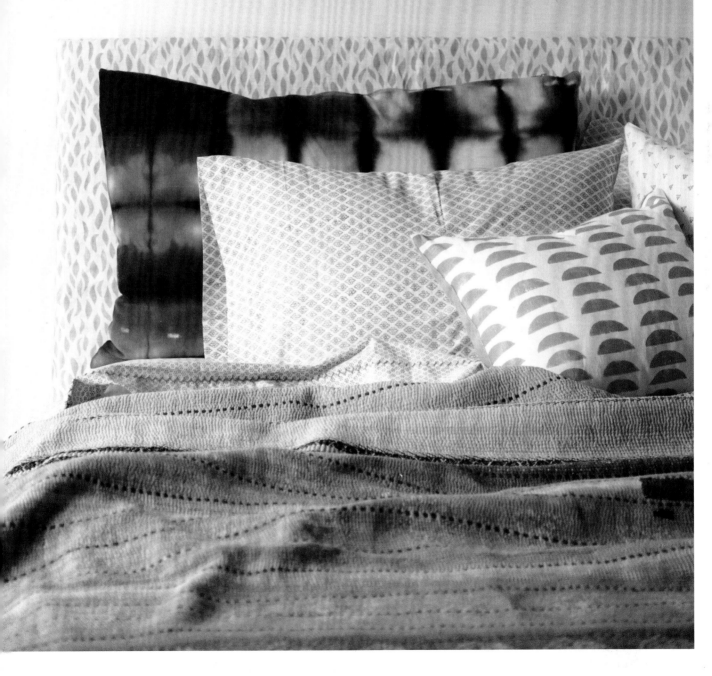

LAYERING FOR THE SEASONS

As the seasons and perhaps your moods change, you'll want to layer things differently. In the warmer months, you can probably get away with just sheets, a coverlet, and a lightweight throw. You may prefer to switch out the down insert in your duvet for a lighter-weight silk insert that still provides some weight and fluff but will feel cooler. Colder months are a perfect time to really go for it and layer all your pieces. Figure out if you prefer having a blanket on top of your sheets and between your duvet, or just layering a quilt on top of it all for extra warmth; you can keep it folded at the bottom of the bed during the day.

PART THREE

PROJECTS

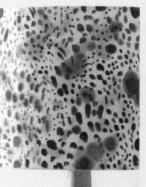

DECOUPAGE-PATTERNED GLASS TRAYS

Decoupage is a simple technique that can be used to create many different looks with very little effort. Technically anything can be decoupaged, but I recommend glass, as you can adhere the images to the reverse of the object for a smoother finish on top. These small glass trays and paperweights are the perfect accents for an entryway, office space, or even bedside table—not to mention they make great gifts! Note: You can download the artwork shown in our project at www.rebeccaatwood.com/book-decoupage.

SKILL LEVEL: Easy

SUPPLIES:

- Laser-printed artwork (make a few extra copies so you have more to work with)
- Scissors
- Mod Podge
- Foam brushes
- Glass tray, plate, paperweight, or any other item you want to decoupage
- Small plastic squeegee or firm cardboard for smoothing paper to glass
- X-Acto knife
- Paintbrushes for applying paint (optional)
- Black, gold, or silver paint for back/bottom of glass piece (optional)
- Felt for back/bottom of glass piece (optional)
- Glue for applying felt (optional)
- Apron or old clothes
- Rubber gloves

STEP 1: Prep the Artwork

Print out your artwork and decide how you want to use it. It can be applied as one big sheet or cut into stripes, dots, and so on. Have fun and experiment! Cut your artwork as desired, leaving a little extra to hang over the edge of the item and trim later.

STEP 2: Apply the Artwork

Apply Mod Podge to the front of your artwork with a foam brush and stick it to the back or bottom of the glass, adjusting the position of the artwork as needed. Smooth out the paper using a squeegee or a piece of cardboard, pressing out the air bubbles and extra Mod Podge by moving it from the middle to the edge. If you mess up, simply remove the paper, wash off the glass surface, and try again.

STEP 3: Seal the Artwork

Apply Mod Podge on the back of the paper attached to the glass. Allow it to dry. Repeat several more times until hardened.

STEP 4: Trim the Edges

Trim the extra paper around the edges using an X-Acto knife.

STEP 5: Finish (optional)

For a more finished look, paint the bottom or back of the decoupaged glass a solid black, gold, or silver, or glue on a piece of felt backing.

CHAIR WITH DIP-DYED WOVEN SEAT

It's easy to find chairs without seats at yard sales and flea markets. For this project, we've modified a traditional Shaker-style seat-weaving technique that my great-uncle Ed told me about. The weaving here is done with a dip-dyed twill tape, but you could use striped twill tape, leather straps, or even fabric scraps stitched together into a long piece. You could use one material for the lengthwise warp and another for the crosswise weft (see page 258, Woven Wall Hanging), creating endless design possibilities. This project is easiest to do with two people.

SKILL LEVEL: Medium

PROJECTS /

SUPPLIES:

FOR THE HAND-DYED TWILL TAPE (OPTIONAL)

- *Twill tape*
- *Pot for scouring*
- *Measuring cups and spoons*
- *Soda ash (if using fiber-reactive dye)*
- *Synthrapol (pH-balanced soap)*
- *Dye in your choice of color (I used fiber-reactive Pro Chemical MX 628 Black)*
- *Small recyclable plastic container for mixing dye*
- *Shallow plastic tray (1" [2.5cm] deep) or dish for soaking and dyeing tape*
- *Salt (if using all-purpose dye)*
- *Vinegar (if using all-purpose dye)*
- *Rit Color Stay Dye Fixative (if using all-purpose dye)*
- *Kitchen timer*
- *Drying rack*
- *Iron*
- *Apron or old clothes*
- *Rubber gloves*

FOR THE CHAIR

- *Chair without a seat*
- *Twill tape or some other material that can be woven*
- *Tacks*
- *Hammer*
- *1" (2.5cm) foam, cut to the size of the inside of seat area.*

PART 1: MAKE THE DYED TWILL TAPE (OPTIONAL)

STEP 1: Scour the Twill Tape
See page 274.

STEP 2: Dye the Twill Tape
See page 275 for general dyeing instructions.

Roll the fabric up into a nice clean roll and then soak in water. Try to keep the bundle together and nice and even so it can sit in the dye.

Pour the dye into a shallow tray, filling it about a quarter to halfway. Place the twill tape bundle in it. Allow it to soak for about 60 minutes.

Rinse the twill tape, then unroll it, hang it on a rack, and wait for it to dry. You may want to iron the twill tape once it is dry.

PART 2: WEAVE THE CHAIR SEAT

STEP 1: Weave the Warp

FIGS. 1–4

To begin, tack the twill tape to the underside of the chair along the left-hand back edge. Hammer the tacks into place; depending on the width of your tape you may need to use two tacks. Pull the twill tape up, around the back, and toward the front of the seat, then wrap it over and under the front bar and toward the back of the seat. Wind it back and forth, working from left to right. Pull the tape as tightly as you can. Avoid overlapping one row with another, but also avoid gaps.

When you are about halfway finished winding the warp, insert the foam between the top and bottom layers of twill tape. The foam allows for comfort when sitting and also helps join the two layers of twill tape to support your weight when the chair is used.

Continue pulling the warp back and forth, pulling as tightly as you can across the foam. When you've

project continues ■ ■ ■

FIG. 1

FIG. 2

FIG. 3

FIG. 4

FIG. 5

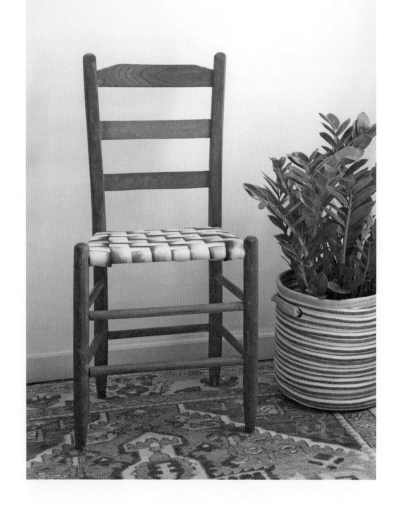

finished the last row, on the bottom of the chair, tack the twill tape to the side railing on the underside of the chair near the back. Once tacked, make any adjustments to the position of the warp so that everything lies flat and there are no overlaps or gaps.

STEP 2: Weave the Weft

FIG. 5

Next you will weave the other way—crosswise—creating a checkerboard pattern. Tack the twill tape as described above to the underside of the chair along a side rail. Then turn the chair upside down and begin, on the underside, to weave under and over the twill-tape framework you created previously. When you get to the end of the first row, bring the tape over to the top of the chair and continue on that side.

After you've completed the first row on the top of the chair, the tape will wrap around the side, go to the underside of the chair, and continue to weave the weft. The size of the twill tape and chair seat might not be perfectly proportional, so you may want to fold the twill tape in half or weave a row that doesn't go all the way to the back face of the chair.

Tack the loose ends on the underside of the chair when finished.

SPLATTER-PAINTED SISAL RUG

A classic sisal or jute rug can go in any room, work indoors and out, and is a great layering piece. Inspired by the rug in Sally King Benedict's studio (see page 175), adding paint to this neutral is a great way to give it personality.

SKILL LEVEL: Easy

SUPPLIES:

- 2 or 3 colors of water-based acrylic or latex paint
- Plastic container for diluting paint (optional)
- Sisal rug
- Spoons and spray bottles for splattering paint
- Big paintbrushes (I recommend a 4" [10cm] brush)
- Stencils (optional)
- Apron or old clothes

STEP 1: Choose and Prepare the Paint

Choose paint colors that complement one another and the scheme for your room. Black and white are a classic combination that can't go wrong. Dilute the paint if needed; latex paint is a good consistency, but acrylic paints are generally thicker and will need to be mixed with water to dilute them.

STEP 2: Paint and Splatter

Begin by splattering the paint onto the rug by dipping a spoon into the paint and flicking it across the surface. Try using a spray bottle, too—just mix your paint with water or use a liquid paint like latex house paint. Use a large paintbrush and paint abstract marks onto the rug's surface. If you'd prefer a more traditional pattern, consider using stencils.

STEP 3: Finish

Allow the paint to dry and enjoy!

POTATO-PRINT FLOOR CUSHIONS

Potato printing is one of my favorite ways to literally make a mark. The results vary, but they're interesting, and the irregularity makes them beautiful. Test the print on a piece of scrap fabric while you get the hang of it. Here we use a classic color combination of natural linen and black to create a fabric you can use for floor cushions.

SKILL LEVEL: Medium

SUPPLIES:

- *Natural linen for cushion's front*
- *Fabric of your choice for cushion's back side*
- *Iron*
- *Scissors*
- *24" (61cm) ruler*
- *Newsprint, newspaper, or kraft paper*
- *Potatoes, any shape or type you like*
- *Serrated knife*
- *Black fabric paint*
- *Iron*
- *Straight pins*
- *Sewing machine or hand-sewing needle*
- *Thread*
- *Pillow insert (see Know Your Stuff[ing], page 127)*
- *Apron or old clothes*

STEP 1: Prepare the Fabric

If you want your pillows to be washable, wash and dry the fabric prior to cutting to allow for any shrinkage. Iron the fabrics. Cut the front fabric to the size of the pillows you want to make, adding 1" (2.5cm) for seam allowances. Cut the fabric for the back; note that the size is different as the back is actually two pieces that create an envelope closure. Essentially you are cutting two pieces that are each approximately 5" (12.5cm) smaller than the front piece of fabric, as they will be folded and overlap each other when sewn.

STEP 2: Print the Fabric

FIG. 1

Lay out the newsprint and place the front fabric on top, right side up. Cut a potato in half with the serrated knife and cover the cut side in black fabric paint. Press firmly onto the fabric and lift up. Repeat this across the entire fabric as desired. Set aside and allow the paint to dry.

FIG. 2

FIG. 1

STEP 3: Sew the Pillows
FIGS. 2, 3

Iron back a ½" (13mm) seam
allowance at edge 1 and edge 4.
Then fold back and iron at fold A
and fold B of bottoms edges.
Topstitch all of the folds just to
secure them. Pin and sew together
edge 2 and edge 3. Iron all stitched
lines so they are flat. Pin and sew
together edge 5 and edge 6. Flip
inside out and iron.

STEP 4: Finish
Insert a pillow form and enjoy!

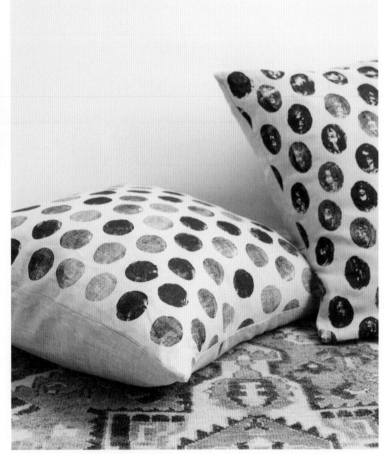

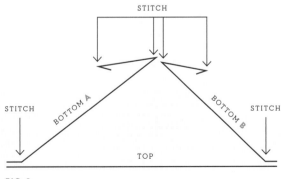

STITCH

STITCH STITCH

BOTTOM A BOTTOM B

TOP

FIG. 3

EMBROIDERED PLACEMATS

There are lots of great and inexpensive plain-woven placemats out there that you can customize with a bit of embroidery. The woven structure of the placemat provides a basic grid that's easy to stitch on, but drawing the framework will help you stay on track. You can do a simple linear border with X shapes or zigzags, or create a more intricate layout as shown here.

SUPPLIES:

- Plain-woven placemats
- Erasable fabric pen or tailor's chalk
- Embroidery needle
- Embroidery floss
- Scissors

STEP 1: Prep for the Embroidery
Lightly draw the embroidery design of your choice onto the placemat with an erasable fabric pen or chalk.

STEP 2: Embroider
FIG. 1
Thread the needle with a doubled length of embroidery thread and knot the ends. Pull the needle and thread through the placemat from the wrong side so that the knot is now against the back. Insert the needle from the right side to form a diagonal line. Then repeat this step, but in the reverse direction, to form an X. Carry on until you've completed your design.

STEP 3: Finish
Knot the thread when your design is finished. Snip any excess thread.

FIG. 1

PROJECTS /

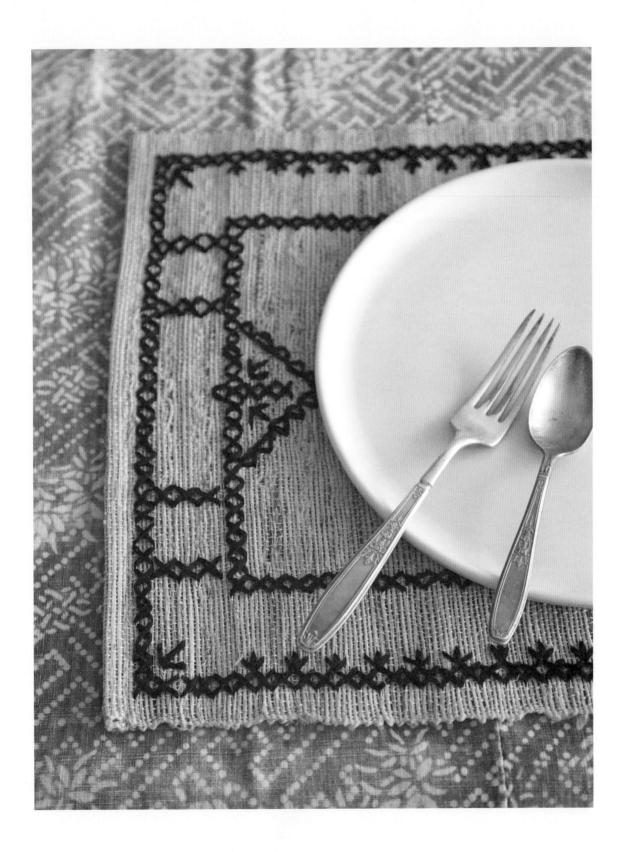

OVERDYED NAPKINS

Over time I seem to have ended up with an odd assortment of mismatched napkins and dish towels, and many have stains on them. Instead of getting rid of them, I give them new life by overdyeing them. If they have patterning, choose a color that is dark enough to cover it; the patterning will show through subtly, but the new overall color will help tie everything together. You can also use this technique for other mismatched items in your life, such as pillowcases, old socks, and T-shirts.

SKILL LEVEL: Easy

SUPPLIES:

- Old napkins in cotton or linen
- Pot or washing machine for scouring
- Measuring cups and spoons
- Soda ash (if using fiber-reactive dye)
- Synthrapol (pH-balanced soap)
- Dye in your choice of color
- Medium- to large-size recyclable plastic or glass container for mixing dye
- Large, flat plastic or glass containers, similar to dishpan or larger pot, for soaking and dyeing fabric
- Salt (if using all-purpose dye)
- Vinegar (if using all-purpose dye)
- Rit Color Stay Dye Fixative (if using all-purpose dye)
- Kitchen timer
- Drying rack
- Apron or old clothes
- Rubber gloves

STEP 1: Scour the Napkins
See page 274.

STEP 2: Dye the Napkins
See page 275.

SHIBORI-DYED NAPKINS

I love the idea of updating vintage linens with shibori for a modern look. I have a collection of old linens, but if you don't, they're affordable and easy to find on eBay and at flea markets. If they have slight stains, not to worry—this is a great way to hide them.

SKILL LEVEL: Easy

SUPPLIES:

- Vintage napkins in cotton or linen
- Pot or washing machine for scouring
- Measuring cups and spoons
- Soda ash (if using fiber-reactive dye)
- Synthrapol (pH-balanced soap)
- Dye in your choice of color
- Medium- to large-size plastic or glass container for mixing dye
- Rubber bands
- Large, flat plastic or glass container, similar to dishpan or larger pot, for soaking and dyeing napkins
- Salt (if using all-purpose dye)
- Vinegar (if using all-purpose dye)
- Rit Color Stay Dye Fixative (if using all-purpose dye)
- Kitchen timer
- Drying rack
- Apron or old clothes
- Rubber gloves

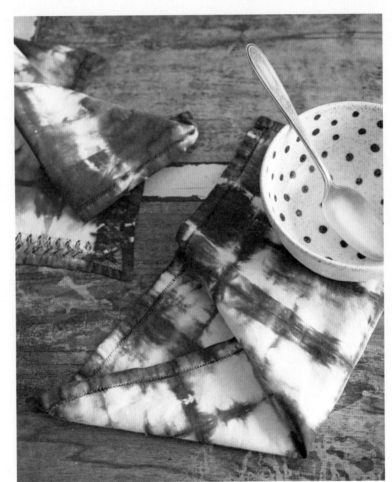

project continues ▪ ▪ ▪

FIG. 1

FIG. 2

FIG. 3

FIG. 4

FIG. 5

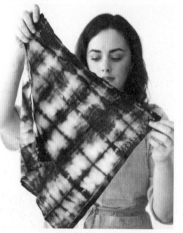

STEP 1: Scour the Napkins
See page 274.

STEP 2: Fold the Napkins
FIGS. 1–5
There are various ways to do this
but we will use a simple fold and
rubber bands. Feel free to get
creative!

Fold the fabric in half lengthwise,
and again twice more or until you
have the desired width. The width
of your fabric will change the scale
of the pattern you achieve. I chose
a very small fold because my
napkins are pretty small. A smaller
fold width will result in a smaller-
scale pattern.

Once you have a long folded
length of fabric, begin to accordion-
fold it into a rectangular shape until
you run out of fabric. Be sure to
fold evenly.

Once you have your folded
bundle, wrap it a few times with
rubber bands around the center
of the bundle. The tighter the
rubber bands, the less dye will
get underneath.

Repeat with more napkins.

Put your folded fabric bundles
in a bowl of water large enough
to soak them all for approximately
10 minutes. This step allows the
dye to be absorbed evenly.

STEP 3: Dye the Napkins
See page 275.

SIMPLE REUPHOLSTERED SEATING

It's easy to find pieces in need of a little love at a yard sale or flea market. Benches and chair seats are places you can tackle without any expertise. Update them with fabric that better suits your personality!

SKILL LEVEL: Medium

SUPPLIES:

- *Bench or chair*
- *Batting*
- *Staple gun and staples*
- *Fabric*
- *Scissors*

STEP 1: Prep the Bench for Upholstering
See instructions on page 277.

STEP 2: Add the Batting
See instructions on page 277.

STEP 3: Stretch the Fabric
See instructions on page 277.

STEP 4: Finish
See instructions on page 277.

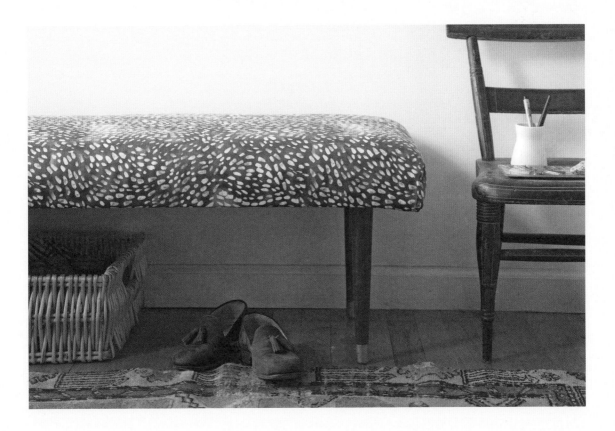

PAINTED-STRIPE REVERSIBLE THROW

A reversible throw is a great piece that can be used many ways. Throw it on the end of a bed, use it on a picnic, bring it to the beach, or cozy up with it on the couch with a good book. By using different fabrics on each side, you'll be able to easily change the look, too.

SKILL LEVEL: Medium

SUPPLIES:

- *Plain white linen for the throw's front*
- *Cotton or linen fabric for the throw's back side*
- *Brown packing tape, width of your choosing (I used 2" [5cm])*
- *Plastic drop cloth or newspaper*
- *Fabric paint or dye*
- *Container for mixing the paint*
- *Wide paintbrush*
- *Straight pins*
- *Sewing machine (optional)*
- *Hand-sewing needle*
- *Thread*
- *Scissors*
- *Iron*
- *Embroidery floss*
- *Apron or old clothes*

STEP 1: Tape Off Your Stripes

Lay your fabric on a drop cloth or newspaper. Carefully place the tape, on the front of your fabric, in the position and direction you want your stripes to go. Press it down on your fabric and make sure it attaches securely. The areas you cover will be white, and the areas showing will be painted.

STEP 2: Paint the Stripes

FIG. 1

Mix the paint to the color of your choosing, and then dilute with water. Fabric paint can give a very stiff hand feel if you don't dilute it, so err on the side of more water. Paint the stripes on the fabric with a wide brush, moving quickly to give a slightly irregular and painterly feeling. Don't worry about bleeding—it's part of the painterly look.

STEP 3: Wash the Fabric

FIG. 2

After your fabric has dried, remove the tape and rinse it. Wash your striped fabric, as well as the fabric you'll be using for the back, in the washing machine, to prevent any shrinkage later. Washing the fabric after applying paint also gives a softer hand feel and removes any excess residue.

STEP 4: Pin the Panels

Position the fabric printed side to printed side, so that the outside is the wrong side of the fabric. Pin all four edges.

STEP 5: Sew the Panels Together

Stitch all the way around the edges with ½" (13cm) seam allowances, leaving approximately a 10" (25.5cm) opening on one side. Cut away the seam allowance at the corners and turn the fabric inside out. Then lay it flat and press with the iron. Close the opening with hand stitching.

STEP 6: Stitch the Panels

FIG. 3

Pin along the lines where you intend to quilt. With a sewing machine or by hand, begin stitching at the center of the throw and work your way out. We chose diagonal lines as that worked nicely with the patterning, but you could do a grid or stripes. If you are stitching by hand, you may choose to simply tack the throw in several places with a stitch or a knot to keep the layers together. If you choose this route, I recommend using a thicker thread like embroidery floss.

STEP 7: Finish

Wash and dry your throw in the washing machine one more time for a soft finish.

FIG. 1

FIG. 2

FIG. 3

WOVEN WALL HANGING

Weavings and other wall hangings are a great alternative to artwork and give a cozy feel to any room. Here you'll learn the basics of weaving on a small hand loom as well as how to make tassels so you can customize your weaving further. I've asked Soraya Shah of Studio Four NYC to lend her expertise. The basic terms you need to know are warp and weft. Your warp is the thread that makes up the length of the fabric, and your weft is the thread that weaves crosswise through the warp to create the fabric.

SKILL LEVEL: Medium

PROJECTS /

SUPPLIES:

- *Yarns in a variety of colors and textures*
- *Small frame loom*
- *Shed sticks or 1-1½" (2.5-3.8cm) strips of cardboard*
- *Tapestry needle*
- *Weaving comb or fork*
- *Scissors*
- *Dowel*

STEP 1: Set Up the Loom
FIGS. 1, 2

Knot the yarn to the loom, and then wind it back and forth between the grooves to set up the warp. Once that's done, slide a shed stick between the yarns, alternating which are above or below it.

STEP 2: Weave the Weft
FIG. 3

Take the yarn of your choosing and thread it through the tapestry needle. Pull the yarn all the way through the needle or double it up, depending on the thickness you'd like to achieve. (Soraya made her yarns out of several different thinner yarns to create a marbled look.) You don't need to have enough thread to cover the entire section you plan to weave with that color; you can always leave the end loose on the back of the weaving and begin a new thread. At the end you will tie all loose ends together on the back side.

Begin weaving the needle under and over the warp threads. Pull the yarn taut, leaving a few inches of a tail that you can then weave back in the opposite direction. Push the yarn down with the weaving comb. Then weave the yarn, going back in the opposite direction, pushing it down with the comb every time you bring the yarn across the warp.

FIG. 1

FIG. 2

STEP 3: Add the Tassels

FIG. 4

You can add tassels throughout the length of your weaving, or just in one spot. When you get to a place where you'd like to add tassels, cut a bundle of yarn twice the length you want for the finished tassels. For example, for 3" (7.5cm) tassels, cut a bundle that is 6" (15cm) long. Depending on desired thickness and type of yarn you're using, I'd recommend using around 6 pieces of yarn for your tassel. Loop the bundle of yarn around two of the warp threads and pull from the middle of your yarn, between two warp threads, to create a loop. Take the ends of your yarn bundle and pull them through the center loop, creating a knot. Slide down the tassel so it is next to the rest of your weaving. Continue weaving the weft following the instructions in Step 2 and adding tassels where desired. Keep in mind while planning the spacing of your tassels that each one wraps around two warp threads.

project continues ■ ■ ■

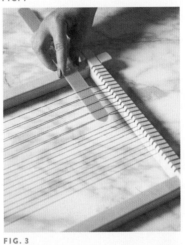

FIG. 3

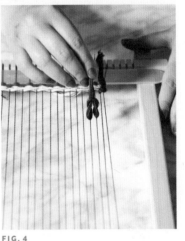

FIG. 4

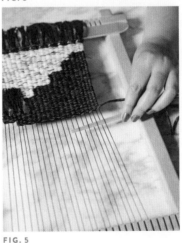

FIG. 5

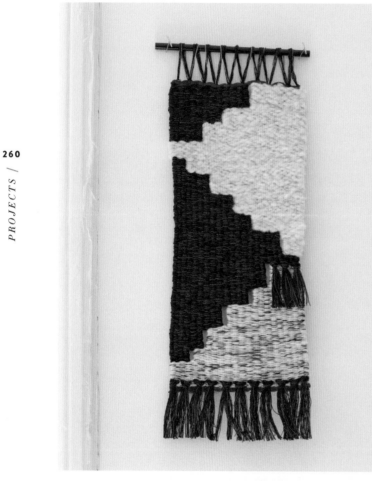

STEP 4: Finish

Once the tapestry is done, cut the warp off of the loom, leaving the threads as long as possible at both ends. Turn the tapestry over and tie together any loose ends or weave them back into the tapestry with the needle. I find it helpful to knot each loose thread together with the thread next to it.

STEP 5: Hang the Tapestry

Cut a decorative yarn of your choice into a length twice the width of your tapestry and tie a knot at one end. Thread the tapestry needle with your thread and knot one end. Pull the thread through the back of your tapestry so that the knot is on the back side. Then stitch from back to front, but instead of pulling the stitches taught as you would when sewing, leave loops at the top so that you can slide in a dowl to hang it from. You may find it helpful to stitch the loops around a dowel if you want a snug fit.

PAINTED TERRA-COTTA POTS

Terra-cotta pots are classic, inexpensive, and easy to find. Update them with a bit of paint for a look that is perfect indoors or out. You can also choose any color, but I prefer white for an aboriginal-inspired design.

SKILL LEVEL: Easy

SUPPLIES:

- Terra-cotta pots
- Soap
- White acrylic paint
- Flat- and round-tip paintbrushes, plus one for the shellac
- Shellac
- Apron or old clothes

STEP 1: Prep the Pots

Wipe pots and clean any dirt off surfaces with warm water and soap. Allow to dry completely.

STEP 2: Paint the Pots

FIG. 1

Paint dots, dashes, and stripes onto the pots as desired. Use the long, skinny end of the flat-tip paintbrush for the dashes and the round-tip paintbrush to create the dots. Allow the paint to dry completely.

STEP 3: Seal the Pots

Apply clear shellac over the entire outside of the pot to seal the paint. Allow to dry completely before potting your plants.

FIG. 1

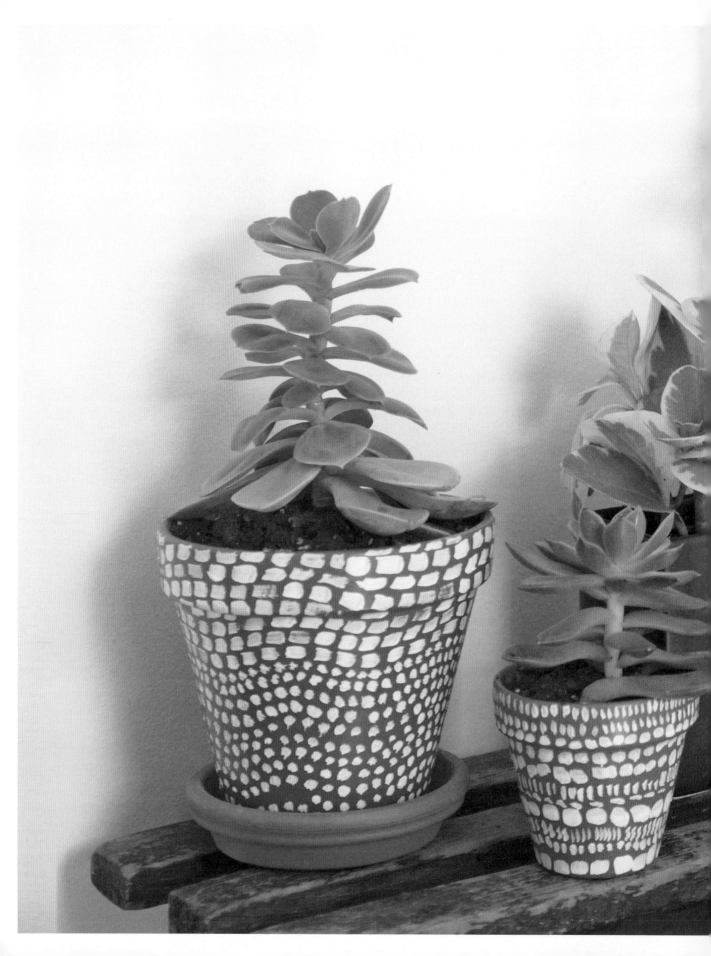

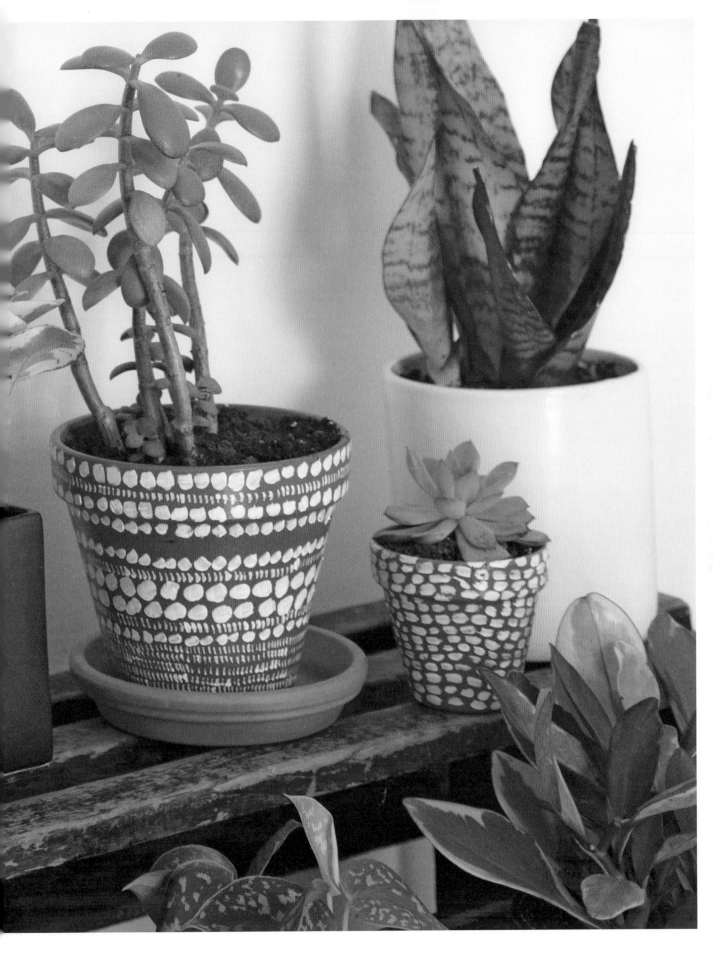

MARBLED WALL ART

Marbled papers are quite easy to make yourself. Here we're experimenting with suminagashi, a Japanese technique. Literally, the term means "floating ink." You can frame these papers as I've done, combining several pages to make a larger piece, or even just hang them up with T-Pins. It may take you a few tries to get the hang of it, so you can always use a cheaper paper like newsprint the first few times.

PROJECTS /

SUPPLIES:

- 2 *small containers for the ink and water*
- *India or Japanese sumi ink*
- *Photo-Flo solution*
- *Tray deep enough for 2–3" (5–7.5cm) of water (such as a photo tray, baking tray, etc.)*
- *Newsprint*
- *Small paintbrushes*
- *Absorbent matte-finish paper (rice, watercolor, printmaking, or even plain newsprint works well)*
- *Apron or old clothes*

STEP 1: Prepare the Supplies

In one small container, pour approximately 2 tablespoons (28 ml) of India ink and 2 drops of Photo-Flo; in a second container, pour 2 tablespoons (29.5ml) water and 2 drops of Photo-Flo.

STEP 2: Prepare the Marble Bath
FIGS. 1, 2

Fill the tray with a few inches of water and skim the surface with a strip of newsprint to remove any dust. Dip a brush into the ink and touch it to the surface of the water. If the ink is sinking to the bottom, add another drop or two of Photo-Flo. Experiment with the amount on the brush to achieve different tones of gray, but don't use so much that it's dripping. The paper you use will also determine the darkness of the colors, based on its absorbency. Dip a clean brush into the Photo-Flo water and touch it to the middle of where you've placed the ink. Continue this way, alternating between the ink and Photo-Flo solutions. You can create many concentric rings, and to manipulate the circles into a more rippled pattern, you can gently blow or fan the water.

STEP 3: Marble the Paper

Slowly lay a sheet of paper onto the surface of the water, allowing it to sit for a second, then lift it off. The ink will stay on the paper. Immediately but gently run the paper under cool water or carefully dip it in a pot of clean water to remove any excess ink, and lay it flat, face up, on newsprint to dry.

Repeat by adding more ink to the same pattern (you'll need more ink as you've just taken off most of it), or skim any excess color off the top of the water using the newsprint and begin again.

FIG. 1

FIG. 2

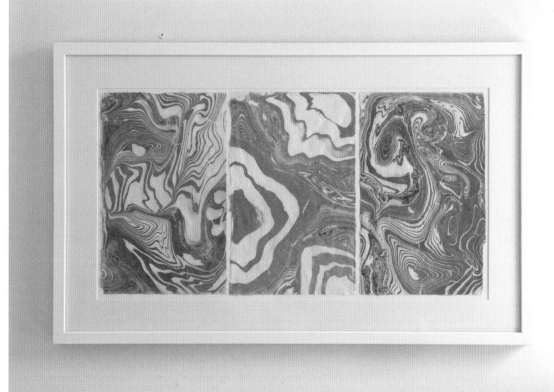

EMBROIDERED-GEOMETRIC EDGE PILLOWCASES

Pillowcases are easy to customize with a bit of embroidery. You can buy basic white ones or even embellish vintage ones that already have some detailing. Here, embellishment designer Sarah Laskow lends her expertise to create a simple geometric pattern. I love how the hand-stitching softens the geometric layout. This design is gender neutral and can layer into any bedding scheme. If you're ambitious, you can try this technique on your top sheet, too.

SKILL LEVEL: Medium

SUPPLIES:

- *Pillowcases in a plain color or simple pattern*
- *Erasable fabric pen or tailor's chalk*
- *Ruler (optional depending on design)*
- *Embroidery hoop*
- *Embroidery floss*
- *Embroidery needle*
- *Scissors*

STEP 1: Prep for the Embroidery
Plan your embroidery by lightly drawing a design on the pillowcase with an erasable fabric pen or chalk. Since the design we're doing is gridded, we used a ruler to lay out the size of each box.

STEP 2: Embroider the Boxes
FIG. 1
Now that you've got your framework, you're ready to start. Choose a section of the pillowcase and put the embroidery hoop on it to keep the fabric taut while stitching. Thread the needle with a doubled length of thread and tie a knot at the end. Begin stitching horizontal lines across the design. Fill the box drawn on the fabric with about four horizontal lines of stitching, which should fill the height of the box and create a square.

STEP 3: Embroider the Xs
Now is the time to go back with a second color and fill in the X motifs. Stitch one diagonal line and then cross over it with another. Continue until you've finished the design. Knot the thread when finished and snip any excess thread.

FIG. 1

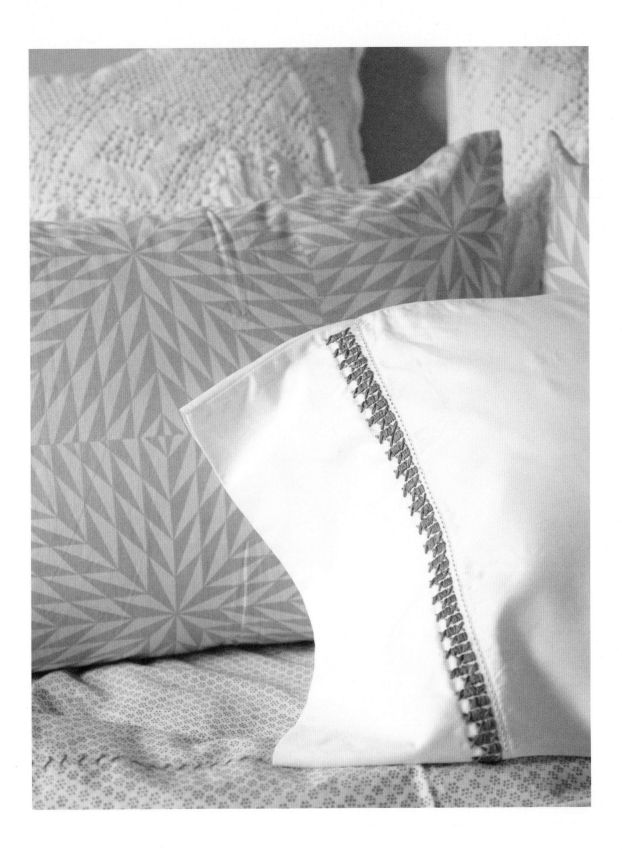

DIP-DYED EURO SHAMS

Dip-dyeing gives a soft ombré look that feels perfect for the bedroom. You can even use this technique on a much larger scale with your sheets, duvet, shower curtain, or curtains, but I recommend experimenting first on a smaller scale until you get the hang of it.

SKILL LEVEL: Easy

SUPPLIES:

- Plain white cotton Euro shams
- Pot or washing machine for scouring
- Measuring cups and spoons
- Soda ash (if using fiber-reactive dye)
- Synthrapol (pH-balanced soap)
- Dye in your choice of color
- Medium-size recyclable plastic or glass container for mixing dye
- Rubber bands
- Large, deep pot for soaking and dyeing shams
- Salt (if using all-purpose dye)
- Vinegar (if using all-purpose dye)
- Rit Color Stay Dye Fixative (if using all-purpose dye)
- Kitchen timer
- Drying rack
- Iron
- Apron or old clothes
- Rubber gloves

STEP 1: Scour the Euro Shams

See page 274.

STEP 2: Dye the Shams

FIGS. 1, 2

See page 275 for general dyeing instructions.

Put the shams into the dye only partway to achieve an ombré look. To fit them into the container, fold the shams in half perpendicular to the opening on the back of the pillow so you will have a longer, narrower shape.

Dip the shams in so that the dye covers about half their length. Occasionally move them a little bit farther into the container to get coverage in the top area and keep the pillowcases wet. Moving them helps create a more blurred line. Over the course of an hour you want less and less of the pillowcases to be in the dye so you get more saturated color at one end of the pillowcases. Slowly move the fabrics out of the container.

FIG. 1

FIG. 2

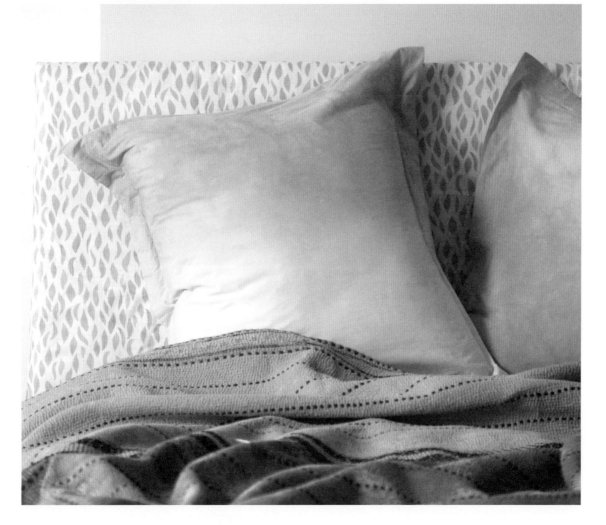

UPHOLSTERED HEADBOARD

A headboard is a great way to frame your bed and change the appearance of the room. You can find an inexpensive headboard option and reupholster it to suit your look. Here I've used a hand-dyed fabric, but the upholstery steps are simple, and you can use any fabric you'd like.

SKILL LEVEL: Easy

SUPPLIES:

- *Basic, inexpensive headboard (as an alternative, you can buy wood, cover it in foam, and follow the same steps)*
- *Scissors*
- *Batting or thin foam, if you need extra padding*
- *Fabric*
- *Staple gun and staples*

STEP 1: Prep the Headboard
Add batting or thin foam (optional, depending on the headboard you have). See instructions on page 277.

STEP 2: Stretch the Fabric
See instructions on page 277.

STEP 3: Finish
See instructions on page 277.

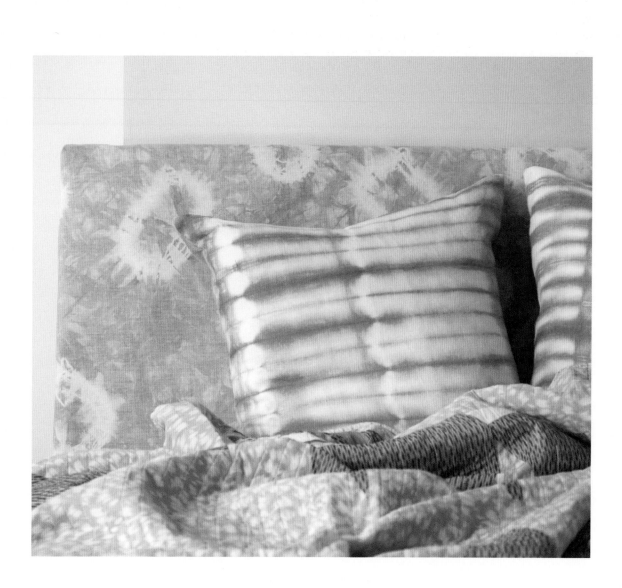

SPECKLE-PAINTED LAMPSHADE

Customizing a lampshade is an easy way to add pattern to your bedside table. This small accent may be just what you need if you have limited space. Here an organic pattern is painted on the shade to give it new life. If you're unsure about painting your own design, you can always go for a stripe. The pattern possibilities are endless, so sketch out a few ideas prior to starting.

SKILL LEVEL: Easy

SUPPLIES:

- *Lampshade*
- *Water-based paint, such as gouache or acrylic*
- *Brushes for painting and/or stenciling*
- *Stencils (optional)*
- *Lamp base*
- *Apron or old clothes*

STEP 1: Paint

Just dive in. Have fun and paint freely, or stencil the design of your choosing. Here I used blue and black gouache. Gouache gives a softer look than acrylic because it has a matte finish. I recommend using only a little bit of water. Simply wet your brush prior to dipping it in the paint. If your paint feels too thick, just add a little more water until you get a consistency you like. First I put down larger spots of a soft blue, followed by a second layer of smaller black spots.

STEP 2: Finish

Let the paint dry completely before fitting the shade on your lamp base. Light up your room!

PROJECT RESOURCES

DYEING FABRIC

Dyeing fabric is a great tool for customization, and while it may seem intimidating at first, it's actually quite achievable once you understand the basics. Choosing the right dye depends on the fabric you're working with. Natural fibers such as cotton, linen, and wool require different dyes than protein fibers like silk, and synthetic fibers use yet another type. I work with procion fiber-reactive dyes, as there is no better dye for natural fabrics, which is my preferred fiber. They come in a wide range of colors and are colorfast as well as economical, safe, and easy to use. All-purpose commercial dyes, such as Rit Dye, are mixtures of different kinds of dyes and will work on a range of materials; they are meant for dyeing fabrics with a blend of fibers. If you're dyeing just one type of fiber, you'll see the best results choosing a dye specified for it.

I've included dyeing instructions for both fiber-reactive dyes as well as all-purpose dyes. I do highly recommend using the fiber-reactive dyes, especially for shibori styles, as the pattern will not bleed over time and you will see better results overall.

Regardless of the type of dye you choose, always wear rubber gloves and an apron or old clothes. Both dyes are considered nontoxic, but they are still chemicals, so you should use common sense and avoid inhalation (as you would with any fine powder). Please use separate containers or measuring utensils than those you use for cooking and eating. You can measure out the water in a measuring cup you already have and mix the dye in a recyclable plastic container. For further safety instructions, please read the information that comes with your dye of choice.

SCOURING FABRIC

Prior to dyeing, thoroughly clean, or scour, your fabric so that the dye can take hold. It should be scoured with soda ash, which is essentially a very strong detergent; in a pinch, regular detergent will work on many fabrics, but it may not yield the best results. You can scour fabric on the stovetop or in the washing machine, depending on the amount of fabric. If scouring on the stovetop, place the fabric in a pot with water and approximately 1 tablespoon (12g) of soda ash plus a few drops of Synthrapol soap. Bring to a boil, reduce the heat, and allow to simmer for about 1 hour. Carefully drain and rinse the fabric thoroughly. If using a washing machine, put the soda ash in with the fabric and use the hottest water setting. Pour in about 1 tablespoon (14ml) of Synthrapol where liquid detergent goes.

SHOPPING RESOURCES

AMAZON
www.amazon.com

DHARMA TRADING CO.
www.dharmatrading.com

PRO CHEMICAL & DYE
www.prochemical.com

SUPPLIES

Fabric

Pot or washing machine for scouring

Measuring cups and spoons

Soda ash (for fiber reactive)

Synthrapol (pH-balanced soap)

Dye in your choice of color

Various sizes of recyclable plastic or glass containers for mixing dyes (choose a size appropriate for the scale of the project)

Container for soaking and dyeing fabric (choose a size appropriate for the scale of the project)

Salt (if using all-purpose dye)

Vinegar (if using all-purpose dye)

Rit Color Stay Dye Fixative (if using all-purpose dye)

Apron or old clothes

Rubber gloves

Large spoon for stirring dye bath

Small spoon for mixing dye

DYEING WITH PROCION FIBER-REACTIVE DYES

STEP 1: Mix the Dye

FIG. 1

Depending on the amount of fabric you're dyeing or the color you're trying to achieve, you may need to use more or less dye. About 1 tablespoon (7.5g) of powdered dye for 1 pound (450g) of fabric will result in a medium shade, but different dyes have different strengths, so be sure to read the labels. It's easiest to mix the dye if you first create a paste by adding a few drops of water to the powder in a recyclable plastic container. Then slowly mix the paste with 1 cup (240ml) of water. Be sure it is mixed thoroughly, otherwise you may end up with spots of various hues.

STEP 2: Prepare the Fabric

Soak your scoured fabric in water; the temperature doesn't matter. It will dye more evenly if the fabric is wet prior to being placed in the dye bath.

STEP 3: Prepare the Dye Bath

FIG. 2

Pour the prepared dye into a container large enough for the fabric to move freely and with enough room for it to be stirred without spilling. Add enough room-temperature water to your prepared dye that your fabric will be covered when placed in the dye bath. Stir the dye bath and then add your fabric. The recommended amount is 2½ gallons per pound (9.5L per 450g) of fabric; use less if your fabric is covered by the dye bath and you want a deeper color (and vice versa). For even results, stir the fabric continuously; if you prefer a more irregular look, leave it be.

STEP 4: Add the Fixative

Soda ash sets the color; without it, the dye will not be permanent. For 1 pound (450g) of fabric and a medium-strength color, use 5 tablespoons (60g) of soda ash. Dissolve it in 1 cup (240ml) of warm water. After the fabric has been in the dye bath for approximately 10 minutes, briefly remove the fabric from the dye bath, wearing gloves, and mix in the dissolved soda ash. Replace the fabric and stir occasionally. After approximately 60 minutes, take out the fabric.

FIG. 1

FIG. 2

project continues ■ ■ ■

STEP 5: Rinse and Wash the Fabric

Rinse the fabric under cool water until it runs clear, or soak it in a pot, changing the water until it runs clear. On the last rinse, add a drop or two of Synthrapol. Wash and dry the fabric in the machine *separately* at least once to remove any excess dye before mixing with your other laundry.

DYEING WITH ALL-PURPOSE DYES

STEP 1: Mix the Dye

You can buy premixed liquid dye; otherwise you'll need to mix the powdered dye with water. Read the directions on the packaging for the recommended amount of dye per pound.

STEP 2: Prepare the Fabric

Soak your scoured fabric in water; the temperature doesn't matter. The fabric will dye more evenly if it is wet prior to being placed in the dye bath.

STEP 3: Prepare the Dye Bath

Pour the dye into a container large enough for the fabric to move freely and with enough room for it to be stirred without spilling. Then add enough *hot* water (140°F [60°C]) to cover the fabric. The recommended amount is 3 gallons per pound (11.4L per 450g) of fabric; but use less if your fabric is covered in the dye bath and you want a deeper color (and vice versa). Wait 5 minutes and then add the following to the dye bath:

FOR COTTONS: 1 cup (273g) of salt dissolved in 2 cups (480ml) of hot water

FOR SILK, WOOL, OR NYLON: 1 cup (240ml) of white vinegar

Once the dye bath is mixed, add the damp fabric. For even results, stir the fabric continuously; if you prefer a more irregular look, leave it be.

STEP 4: Rinse and Wash the Fabric

Rinse the fabric under cool water until it runs clear. I recommend letting it soak in a pot and changing the water until it runs clear. On the last rinse, add a drop or two of Synthrapol. I always suggest washing and drying the fabric in the machine *separately* at least once before mixing with your other laundry to remove any excess dye.

Please note that all-purpose dyes are often not as colorfast as fiber-reactive dyes, and bleeding may occur. You may want to use an additional fixative, such as Rit Color Stay Dye Fixative, if you choose to use all-purpose dye. Please follow instructions on the bottle.

UPHOLSTERING

Reupholstering existing pieces, family hand-me-downs, or flea-market finds is a great way to update them to your personal taste. Patterned fabric can easily transform a simple bench, headboard, or chair. Look for pieces that have simple construction where the fabric can be stapled to the reverse side. More complicated projects may require sewing or working with a professional upholsterer.

STEP 1: Prep the Furniture for Upholstering
Take apart your furniture (legs, chair seats, etc.) to the extent possible to make it easy to work with. Remove any cording, piping, or finishing details from the furniture that might create a bump when covered.

STEP 2: Add the Batting
FIG. 1
Lay down enough batting to cover the furniture. Stretch the batting around to the back and begin to staple it in place. The bench I reupholstered on page 255 had divots where it was originally tufted, so we filled those in with fiberfill underneath the batting, as I wanted a cleaner look. If the piece of furniture requires more padding, consider a thin ½" (13cm) foam instead of batting. Be sure to keep it tight by alternating sides: staple one side and then move to the opposite side, pulling the foam tight in between each time you staple. Keep the corners neat and smooth, folding them like hospital corners on a bed.

STEP 3: Stretch the Fabric
FIG. 2
Follow the same directions for the batting, now using your fabric, stretching and alternating sides. If you have a pattern with a large repeat, you may want to center it first to make sure you're happy with the placement.

STEP 4: Finish (optional)
If you want a more finished look on the bottom or back of the furniture, cut a piece of fabric big enough to cover the unfinished parts, fold under the raw edges, and staple it neatly over the exposed area.

- *Furniture of your choice*
- *Batting*
- *Fiberfill (optional, depending on project)*
- *Staple gun and staples*
- *Fabric*
- *Scissors*

FIG. 1

FIG. 2

LINEN CARE

Now that you've spent so much time finding the right pieces for your home, you want them to last. That means taking care of them, and sometimes making the right choice can be confusing. I asked my friends at Method Home, a line of naturally derived, biodegradable, and nontoxic household cleaners, laundry, and soap products, for their top care tips. There's plenty of information out there besides what's listed below, but it's a good place to start.

- TRY COLD WATER WHEN DOING YOUR LAUNDRY. It's more energy efficient and also helps preserve colors longer. Plus, many detergents are now designed to work better in cold water. Use warm water for children's clothes, towels, and bedding. Hot water is best for keeping whites white, but high temperatures can make some fabrics shrink, so check the labels to be sure.

- USE CONCENTRATED LAUNDRY DETERGENT. It's less wasteful and saves water and money.

- MINIMIZE WASTE WITH EASY DOSING OPTIONS, like a pod, a small capful, or a pump of detergent. Many laundry caps are oversize, so you use more detergent than you need. Smaller capfuls and pumps help you avoid overdosing by dispensing just enough for your load. Better for your wallet—and for your clothes, too.

- WHEN YOU WANT TO BRIGHTEN YOUR WHITES, opt for a nontoxic, non-chlorine, biodegradable bleach. Try a peroxide-based bleach as an alternative. It can even be used to gently pretreat stains. Many peroxide-based bleaches are color safe, but please read the labels.

- CONSIDER FABRIC SOFTENERS THAT ARE BIODEGRADABLE and derived from plant-based ingredients. All fabric softeners leave a super-thin, slippery coating on fibers to keep fabric soft and supple, but traditional fabric softeners have some surprising ingredients in them—like beef fat! Overall, the coating can make fabric less absorbent, so you might not want to use fabric softeners on things like towels or workout clothes.

- WHENEVER POSSIBLE, LINE-DRY YOUR CLOTHING AND LINENS. Doing so not only will help you conserve energy, but it will also do less damage to your linens, and they will last longer. Plus, line-drying fabrics in the sun can help keep musty odors at bay—and the sun is a natural bleaching agent!

SHOPPING RESOURCES

I've included a shopping resources guide to give you ways to expand your search for the perfect patterned pieces beyond where you might normally look. Depending on what you're looking for, consider the time of year when shopping—you'll see more patterns with white grounds in summer and colored grounds in fall. And seasonal items meant for outdoors may not be available year-round where you live.

If you're struggling to find exactly what you want, consider customization. For items made with fabric, including pillows and furniture, find the fabric you love and follow our pillow sewing instructions (see page 248) or upholstering instructions (see page 277). If the project is beyond your skill set, work with a local seamstress or upholsterer. If you can't find the color combination you want, a fabric studio can create custom options for you. Sometimes it's worth it to get a special piece that will be the star of your home.

The list below is by no means exhaustive; it simply includes my favorites. I've left off most of the bigger brands, as they're easier to come by. I've also noted the sources used in the book.

ABC CARPET & HOME
www.abchome.com
A hallmark of New York City, with six floors of extravagant home décor items styled in an enchanting environment.

ANTHROPOLOGIE
www.anthropologie.com
A whimsical lifestyle store.

ANYON ATELIER
www.anyondesign.com
East Coast meets West in this fresh San Francisco home décor shop run by interior designer Lindsay Brier.

AVO
www.avoavo.com
Graphic hand-painted and hand-printed leather rugs and more.

BELLBOY NY
www.bellboynewyork.com
A contemporary furniture studio based in Brooklyn, creating furniture that is simple and imaginative. Mirror included in Entryway, page 79.

BLACK ROCK GALLERIES
www.blackrockgalleries.com
The largest estate liquidator in the NY, CT, and NJ area hosting in-person and online auctions.

BRIMFIELD ANTIQUE SHOW
www.brimfieldshow.com
A large, well-known flea market in Brimfield, MA.

BROOKLYN FLEA
www.brooklynflea.com
A New York attraction filled with vintage finds as well as items made by local artisans.

BURKELMAN
www.shopburkelman.com
Distinctive modern home wares online and in Cold Spring, NY.

CALICO WALLPAPER
www.calicowallpaper.com
Best known for their line of marbled wallpaper and designs based in ancient traditions. See their home and wallpapers, page 102.

CARAVANE
www.caravane.fr
One of my favorite furniture shops in Paris, France.

CAROLINE Z HURLEY
www.carolinezhurley.com
Graphic textiles by a painter. Napkins shown on page 156.

CHAIRLOOM
www.chairloom.com
A great resource for reupholstery of vintage furniture in Pennsylvania.

COUNTERPANE
www.counterpanestudio.com
Modern takes on quilts and pillows by Pauline Boyd hand-stitched by local Los Angeles artisans. Quilt shown on page 236.

DARKROOM
www.darkroomlondon.com
One of my favorite shops in London.

DILLI HAAT
www.dillihaat.net.in
A favorite market in Delhi, India.

EBAY
www.ebay.com
An online auction where you can find almost anything.

ELEPHANT CERAMICS
www.elephantceramics.com
Handmade textural ceramics from Maine with an inclination toward blue.

ELIZABETH RUSKIN
www.elizabethruskin.com
Happy patterned pieces made in Maine. Platter shown on page 155.

ERICA TANOV
www.ericatanov.com
Unique bohemian treasures.

ESKAYEL
www.eskayel.com
A New York–based design studio with an artistic and environmentally responsible approach to interior surface design. Pillow shown on page 236.

ETSY
www.etsy.com
An online marketplace specializing in handmade and vintage items and supplies.

FELT + FAT
www.feltandfat.com
A Philadelphia ceramicist duo creating tinted porcelain dinnerware. Plates shown on page 155.

FRITZ PORTER
www.fritzporter.com
A design emporium that offers high-quality, bespoke pieces in Charleston, SC.

GARDE
www.gardeshop.com
Modern, natural home accessories and gifts from Scotti Sitz in Los Angeles, CA.

HABLE CONSTRUCTION
www.hableconstruction.com
A surface design company with a fresh contemporary and colorful aesthetic by sisters Katharine and Susan.

HARBINGER
www.harbingerla.com
A design destination for fabrics, wallpaper, and beautiful home accessories in Los Angeles.

HAWKINS NY
www.hawkinsnewyork.com
A lifestyle brand based in Hudson, NY, that partners with independent designers.

HD BUTTERCUP
www.hdbuttercup.com
An eclectic home furnishings store. Multiple locations in CA.

HELEN LEVI
www.helenlevi.com
A Brooklyn-based potter and photographer. Mug shown on page 159.

JEREMY AYERS POTTERY
www.jeremyayerspottery.com
Simple, graphic, and earthy ceramics made in Vermont. Mug shown on page 159.

JOHN DERIAN COMPANY
www.johnderian.com
Best known for his decoupage pieces and East Village shop filled with curiosities and furniture.

JOHN ROBSHAW
www.johnrobshaw.com
Indian block-printed home textiles.

K COLETTE
www.kcolette.com
Artisan goods in Portland, ME.

KISKA
www.kiskatextiles.com
Unique block-printed textiles from India. Pillowcases shown on page 236.

LAYLA
www.layla-bklyn.com
A favorite shop in Boerum Hill, Brooklyn.

LIBECO
www.libeco.com
Responsibly produced, high-quality Belgian linen and home goods.

LIBERTY LONDON
www.liberty.co.uk
A must-visit in London.

LURU HOME
www.luruhome.com
Vintage and modern textiles exploring the vast scope of Chinese aesthetic design. Textiles shown on pages 125, 156, 159, 164, and 211.

MADELINE WEINRIB
www.madelineweinrib.com
Luxurious ethnic textiles that are sophisticated, timeless, and modern. Perhaps best known for her rugs.

MATTEO
www.matteohome.com
Solid garment-dyed bedding. My go-to for sheeting. Bedding shown on page 255.

MERCI
www.merci-merci.com/en/
A must-visit in Paris.

MOCIUN
www.mociun.com
A favorite in Williamsburg, Brooklyn.

MOONISH
www.moonishco.com
Magnetic tiles, as seen on page 136.

NICKY RISING
www.nickyrising.com
High-end interior design showroom in West Hollywood, CA.

OVO CERAMICS
www.ovoceramics.com
Delicate porcelain pieces with simple, elegant patterning.

PORTOBELLO ROAD MARKET
www.portobelloroad.co.uk
An antique market in London.

PROUD MARY
www.proudmary.org
Ethically sourced modern goods made by artisans around the globe. See founder Harper Poe's home on pages 120 and 152.

RECREATION CENTER
www.recreationcentershop.com
Playful patterned ceramics made in Brooklyn by Josephine Heilpern. Mug shown on page 159.

RUG EMPORIUM 240 ON EBAY
www.ebay.com/usr/rugemporium240
An eBay shop with beautiful rugs.

SCARGO POTTERY
www.scargopottery.com
A magical pottery studio in my hometown of Dennis, MA. Mug shown on page 159.

ST. FRANK
www.stfrank.com
Best known for beautifully framed textiles. Pillows shown on page 126.

STUDIO FOUR NYC
www.studiofournyc.com
A New York City textile design studio and showroom filled with fabrics and wallpapers from a unique assortment of designers as well as custom rugs. Rugs shown on page 130.

SUITE ONE STUDIO
www.suiteonestudio.com
A line of ceramics from Lindsey Emery known for organic shapes, feminine color palettes, and textural details. Ceramics shown on page 157.

SUMMERHOUSE
www.summerhousestyle.com
A favorite in Ridgeland, MS.

THE-COMMONS
www.the-commons.us
American-made goods for the home in Charleston, SC.

THE PRIMARY ESSENTIALS
www.theprimaryessentials.com
A favorite in Boerum Hill, Brooklyn.

TULU TEXTILES
www.tulutextiles.com
Colorful and unique printed textiles from Turkey.

WEST ELM
www.westelm.com
Contemporary furniture and home goods; company owned by Williams-Sonoma.

WORKADAY HANDMADE
www.workadayhandmade.com
A Brooklyn ceramicist known for unique hand-painted and hand-etched patterns. Ceramics shown on page 157.

WORKOF
www.workof.com
An online marketplace for the best in locally and independently made furniture and accessories.

WORLD MARKET
www.worldmarket.com
Affordable and unique home goods.

ZAK + FOX
www.zakandfox.com
Globally inspired textiles that derive from history and myth. Pillow shown on page 126.

ACKNOWLEDGMENTS

Writing this book has been an experience that has challenged and inspired me, and I could not have done it alone. I have grown through this process and learned so much because of each one of the people who was a part of it. I am thankful to have worked with such a great team.

First, I must thank my agent, Kimberly Perel, who provided unwavering support and guidance throughout the entire process. Without her, this book wouldn't exist.

Likewise, I can't imagine this project without the talented photographer and artist Emily Johnston. Her thoughtful nature made our long shoots a pleasure, and her eye for color and framing spaces resulted in these beautiful images.

Thank you to Nellie Laskow for helping me keep the business going through the craziness of the shooting and writing schedule. Her problem-solving superpowers and thoughtful eye on shoots are just a few of the reasons she is the best.

To Charlotte Hallberg, for her support with the writing process—especially helping me gather my thoughts, brainstorm, and laugh when it was feeling difficult.

To the whole team at Clarkson Potter, who worked so hard to make this book a reality. A very special thank-you to my editor, Amanda Englander, who saw my vision for this book and believed in it. Thank you to designer Danielle Deschenes for such a beautiful layout and for being such a creative partner. Thanks, too, to Kim Tyner, Patricia Shaw, Kathy Brock, Stephanie Davis, and Sean Boyles.

Thank you to my friends and family who supported this endeavor, and especially to those who helped me with their expertise for projects: Sarah Laskow, my aunt Jean, my great-uncle Ed, and Soraya Shah.

Thank you to my parents. They always have encouraged my passion for art and believed I could do anything. Lastly, thank you to my husband, Steve, for your constant support, love, and belief in me—it means everything.

CONTRIBUTORS

HOMES

The homes that fill this book truly inspire me, and so do the people who created them. Getting out of my bubble and visiting their homes has been an exciting experience that has shaped my viewpoint as a designer and opened me up to new ideas. A huge thank-you to everyone who opened their doors to help me make this book.

MICHELLE ARMAS
Atlanta, GA
www.michellearmas.com

SALLY KING BENEDICT
Atlanta, GA
www.sallybenedict.com

WENDY WURTZBURGER
BENTLEY AND CHRIS
BENTLEY
Philadelphia, PA
www.westelm.com/shop/
collaborations//roar-rabbit/

HUY BUI
Brooklyn, NY
www.plantincity.com

ANDREA CACCURO
AND NELSON DIAZ
Haverstraw, NY
www.casahudsonny.com

LINDSEY CARTER
Charleston, SC
www.troubadourclothing.com

NICK AND RACHEL COPE
Brooklyn, NY
www.calicowallpaper.com

KIKI DENNIS
New York, NY
www.dberke.com/people/kiki-dennis

KATE DOUGHERTY
Charleston, SC
www.katedeez.com

CHASSITY EVANS
Charleston, SC
www.looklingerlove.com

HASKELL HARRIS
Charleston, SC
www.gardenandgun.com/blog/
haskell-harris

ANGIE HRANOWSKY
Charleston, SC
www.angiehranowsky.com

OLIVIA RAE JAMES
Charleston, SC
www.oliviaraejames.com

EMILY JOHNSTON
New York, NY
www.emily-johnston.com

JENNY KEENAN INTERIORS
Charleston, SC
www.jennykeenaninteriordesign.com

KATE LOUDOUN-SHAND
Brooklyn, NY
www.kateloudounshand.com

BRIAN PAQUETTE
INTERIORS
Seattle, WA
www.brianpaquetteinteriors.com

WAYNE PATE
AND REBECCA TAYLOR
Brooklyn, NY
www.waynepate.com
www.rebeccataylor.com

STEPHANIE PESAKOFF
Brooklyn, NY
www.illustrationdivision.com
www.stampa.us.com

HARPER POE
Charleston, SC
www.proudmary.org

RENÉE SHORTELL
Philadelphia, PA
www.anonastudio.com

SWAY STUDIO
San Francisco, CA
www.sway-studio.com

PRODUCTS

Many products were needed to create this book, and I am especially thankful to those who loaned us beautiful, handcrafted items for the photo shoots: Anona Studio, Bellboy NY, Caroline Z Hurley, Counterpane, Elizabeth Ruskin, Eskayel, Felt + Fat, Heather Taylor Home, Helen Levi, Jeremy Ayers Pottery, Kufri Life Fabrics, Layla, Luru Home, Matteo, Ovo Ceramics, Proud Mary, Recreation Center, Scargo Pottery, St. Frank, Studio Four NYC, Suite One Studio, The Sill, Workaday Handmade, Zak + Fox.

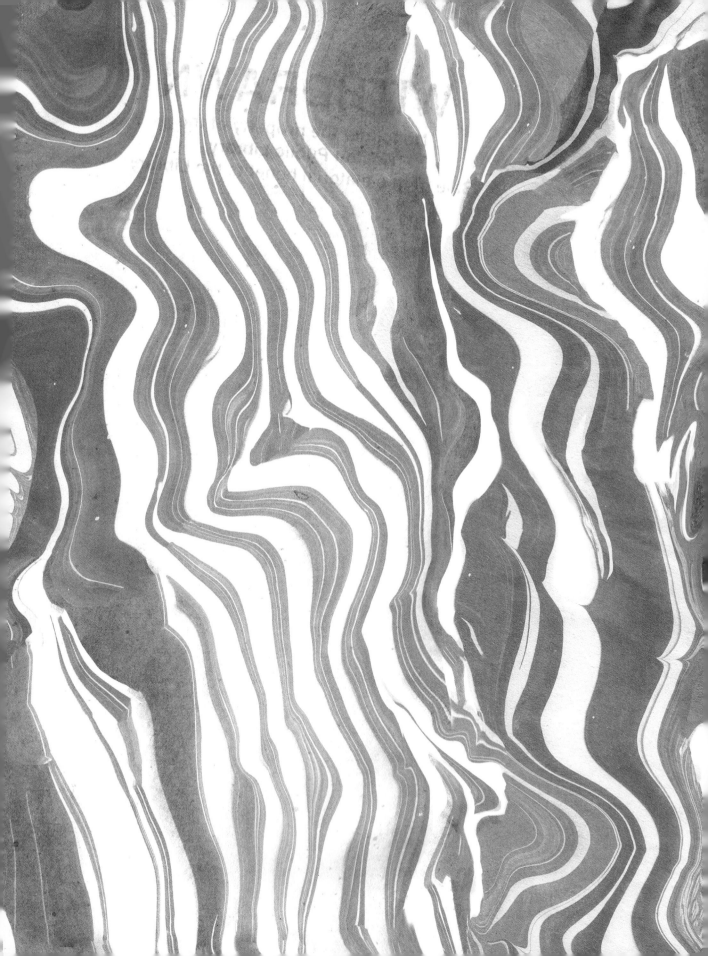